GENIUS & GRACE: FRANÇOIS BOUCHER AND THE GENERATION OF 1700

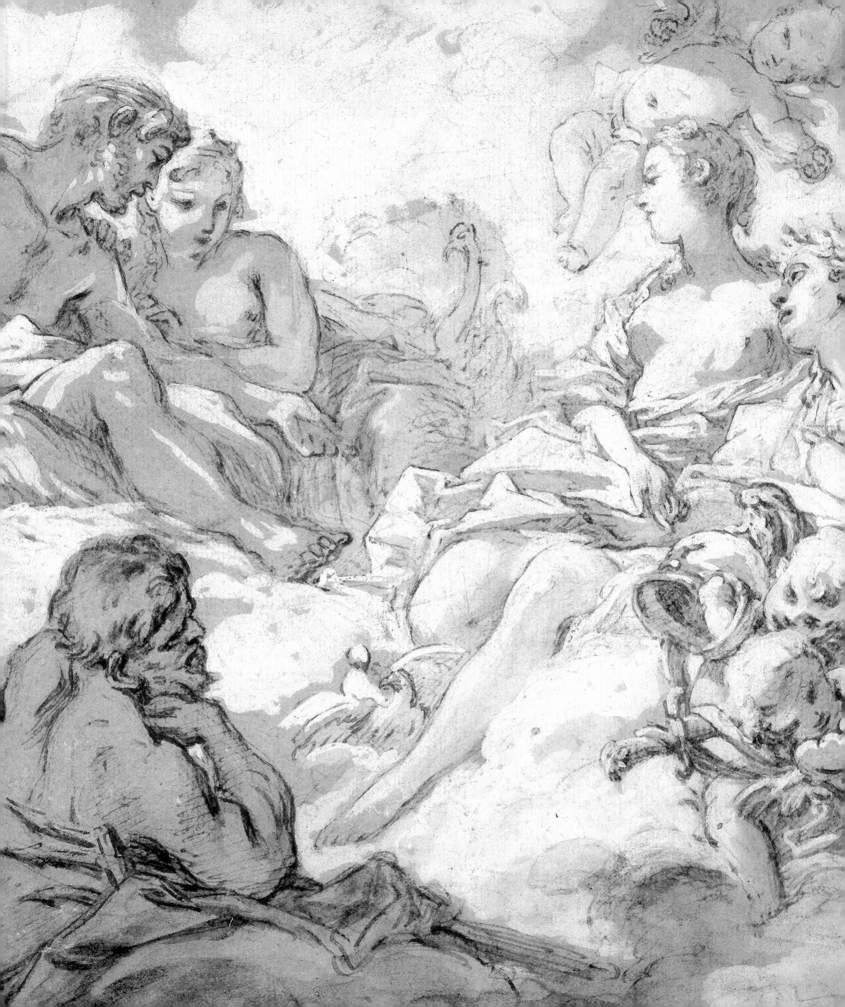

Genius & Grace

FRANÇOIS BOUCHER AND THE GENERATION OF 1700

ALVIN L. CLARK, JR.

with essays by ESTHER BELL *&* FRANÇOISE JOULIE

THE HORVITZ COLLECTION BOSTON 2014

Genius & Grace: François Boucher and the Generation of 1700
is the catalogue of an exhibition organized by The Horvitz Collection, Boston.

Cincinnati Art Museum
March–May 2014

Ackland Art Museum, The University of North Carolina at Chapel Hill
January–April 2015

ILLUSTRATION CREDITS
All photography for The Horvitz Collection (plates and comparative figures): Boston,
© The Horvitz Collection; photos: Michael Gould (except Studio TKM: plates 31, 36, 50, 62, and 73).
Pp. 28, 38, Cambridge, Harvard Art Museums/Fogg Museum © The President and Fellows of Harvard
College; p. 30, Ottawa © National Gallery of Canada; pp. 36, fig. 1, 39, Los Angeles © The J. Paul Getty
Museum (courtesy of the Getty's Open Content Program); p. 36, fig. 2, © private collection;
photo: Rob Deslongchamps; p. 37, fig. 3, Paris © Bibliothèque Nationale de France.

PUBLICATION COORDINATOR: Alvin L. Clark, Jr.
COPY EDITOR: Carolann Barrett
TRANSLATOR (Joulie essay): Jane MacAvock
PRINTER: Puritan Capital
Composed in Arno type and printed on PhoenixMotion Xantur, an acid-free paper
PRINTED IN THE UNITED STATES
ISBN-13: 978-0-9912625-0-2 (paperback)
LIBRARY OF CONGRESS CONTROL NUMBER: 2013921984

COVER: François Boucher, *Juno Commanding Aeolus to Release the Storm Winds*, cat. no. 13 (detail)
FRONTISPIECE: François Boucher, *Venus Presenting Aeneas to Jupiter and Juno*, cat. no. 23 (detail)
OPPOSITE: François Boucher, *Young Travelers*, cat. no. 25 (detail)

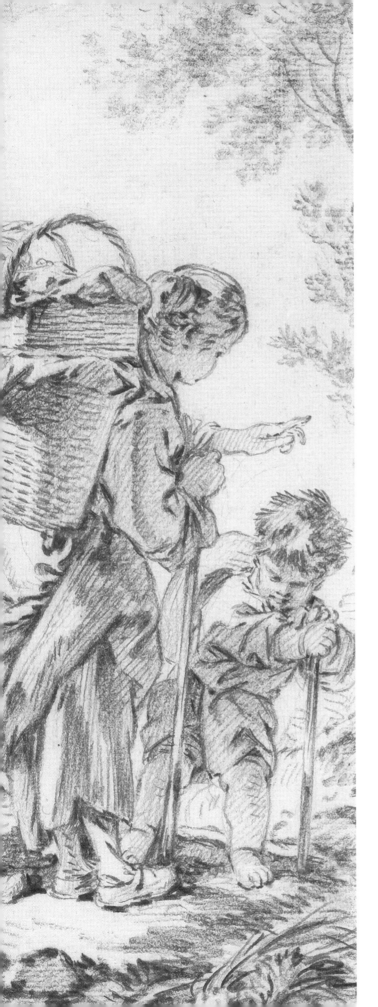

CONTENTS

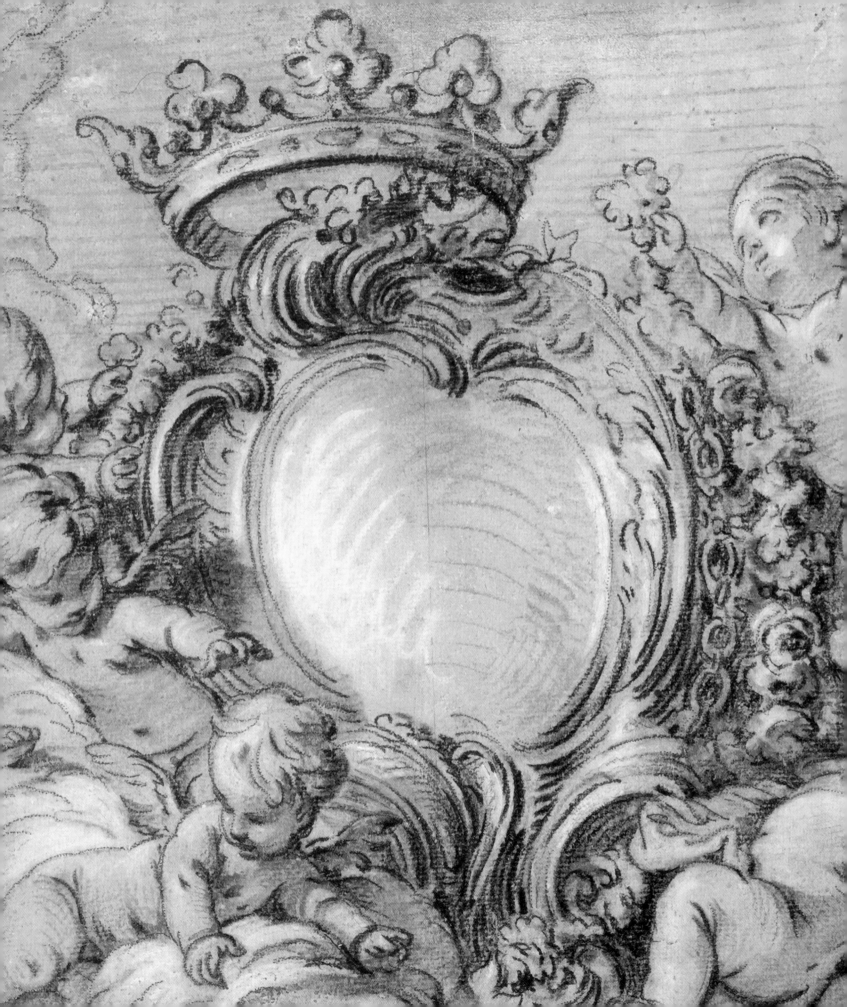

For Jeffrey and Carol

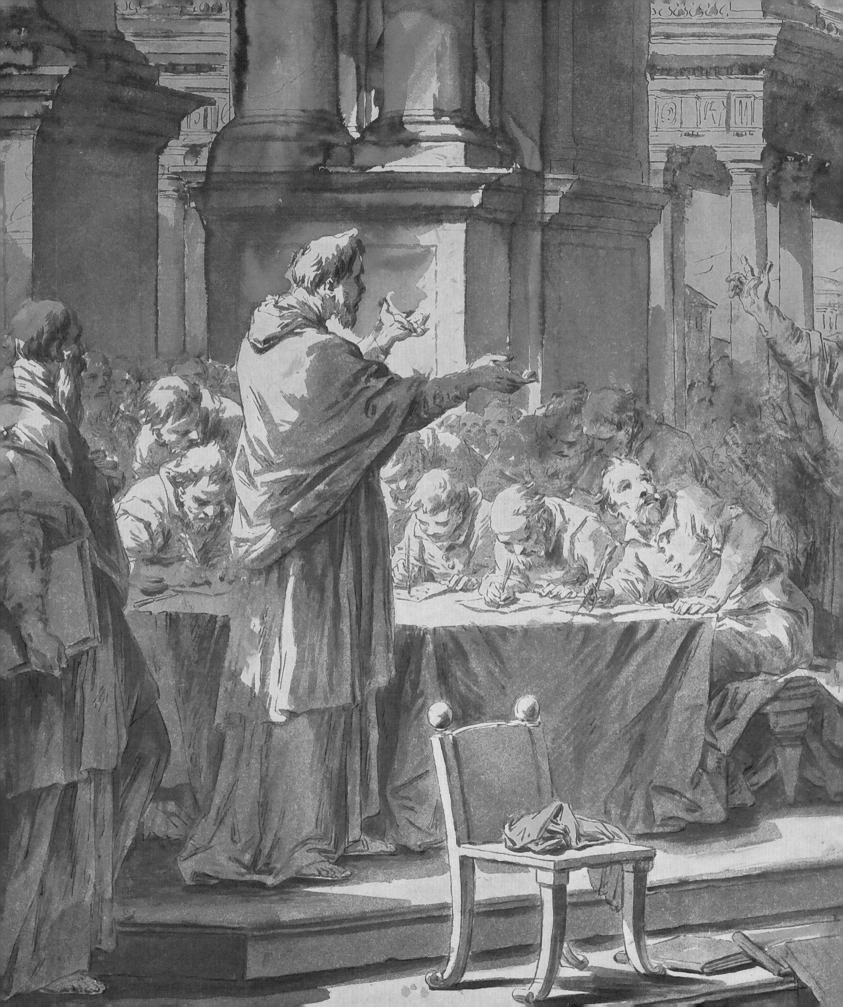

PREFACE AND ACKNOWLEDGMENTS

*T*his is the first of a series of exhibitions drawn from The Horvitz Collection, which now includes more than 1,600 French drawings, paintings, and sculptures dating from the end of the sixteenth to the middle of the nineteenth century. A number of ideas to document the extraordinary growth of the collection have been generously offered over the last decade, but most provided little understanding of the collection as a whole, and they did not enhance our thinking about early modern French art. My goals for this project include: focusing on the significance and influence of specific artists or groups of artists; highlighting aspects or concentrated periods of French draftsmanship from the late sixteenth to the mid-nineteenth century; illustrating major themes in French art, culture, and history; and increasing the number, variety, and geographic location of exhibitions on early French art in North America. Most of the projects will focus on drawings, but they will frequently be supplemented by oil sketches, paintings, and sculptures. Many of the exhibitions will be moderate in scale so as to make them accessible to institutions with midsized gallery spaces, and in order to move the series along, catalogues will often contain only essays and annotated checklists. Although a number of the projects will be generated by the present author, other specialists will be invited to contribute, and some exhibitions already being prepared will be curated by guest scholars.

The scale of this project could not be envisioned without the support, enthusiasm, and understanding of Jeffrey and Carol Horvitz. I deeply treasure their friendship and sincerely appreciate their confidence in me and in this endeavor. They are living proof that the only thing in the art world better than ambitious collectors are ones whose passion expands and enriches the visibility and appreciation of what they acquire.

The initiation of this series owes a tremendous debt to Aaron Betsky, director, and Esther Bell, curator of European art, at the Cincinnati Art Museum. A fortuitous gap in their schedule coincided with the genesis of this exhibition and resulted in a truly delightful collaboration, and perhaps it is appropriate that the series is initiated in the city of Carol Horvitz's birth. Thanks must also be extended to Emily Kass, director, and Peter Nisbet, chief curator, at the Ackland Art Museum at The University of North Carolina at Chapel Hill, the second venue of the exhibition.

I am particularly grateful to Esther Bell and Françoise Joulie (chargée de mission, Département des Arts Graphiques, Musée du Louvre) for their contributions to the catalogue. Thanks must also be offered to Carolann Barrett for her incomparable skill in shaping our texts to be even better than they were; Christopher Kuntze for the basis of the catalogue design; Michael Russem for final design details and oversight of the catalogue to completion; Stephen Stinehour and the staff of Puritan Capital for their efficiency and skill with color proofing, printing, and binding; T. K. McClintock, Lorraine Bigrigg, and Deborah LaCamera of Studio TKM for help in making collection care a pleasure; William F. O'Connor of ASI and the staff of Artex-Boston for their proficiency with all matters concerning shipping and crating; Francesco Buccella and Valerie Neilson for their crucial office assistance; Eric Harrington and Ellen Young for their careful attention to all of the details of matting and framing; and Diane Malarik, Steven Feather, Natalie Neuhoff, Amy Goden, Joyce Griffin, and Milissa Putnam for their administrative assistance.

ALC

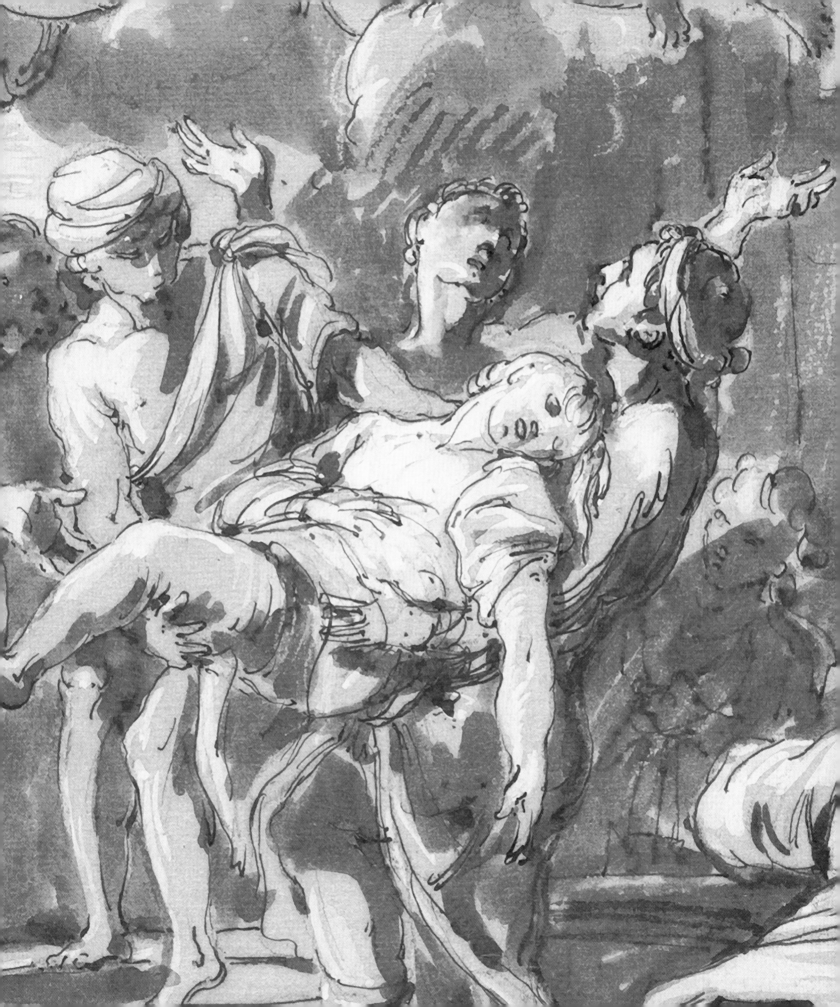

INTRODUCTION

The generation of artists born around 1700 dominated the world of French art for the ensuing three-quarters of the eighteenth century and included curators of the royal collections; three premier peintres du roi; three directors of the Académie Royale de Peinture et de Sculpture; two directors of the École Royale des Élèves Protégés; a director of the Académie in Marseilles; a director of the Académie de France à Rome; a royal silversmith; an early art historian; and draftsmen for the chambre and cabinet du roi, the Menus-Plaisirs, and the Académie des Inscriptions et Belles-Lettres. All of the members of the Generation of 1700 discussed here were born from c. 1694 to 1706, and they include Edme Bouchardon, François Boucher, Jean-Baptiste-Siméon Chardin, Charles-Antoine Coypel, Michel-François Dandré-Bardon, Maurice-Quentin de La Tour, Juste-Aurèle Meissonnier, Charles-Joseph Natoire, René-Michel Slodtz, Pierre-Hubert Subleyras, Pierre-Charles Trémolières, and Carle Vanloo. Their vision, combined with their enormous technical skill, ensured the full realization of the rococo.

My interest in this fascinating group of artists originated from reading Pierre Rosenberg's essay in the catalogue of the Boucher exhibition held in New York, Detroit, and Paris in 1986.[1] This led to a talk by the present author on the wealth of related material in The Horvitz Collection at the National Academy Museum, New York, in 1999. Since then, Rosenberg and others have continued to publish on aspects of the subject in journals and European exhibition catalogues.[2] This will be the first time viewers in North America have the opportunity to examine an assemblage of works by this talented group of artists.

The exhibition begins with a small selection of works by Jean-Antoine Watteau, Jean-Baptiste Oudry, François Le Moyne, and other immediate and influential predecessors to the Generation of 1700. Then we present the largest group of drawings in the exhibition, by François Boucher, the most outstanding and well-known artist of this generation and the talented genius who led the way toward a bold and graceful new manner. The selection includes drawings from almost all stages of his brilliant career and works that were executed in virtually every medium Boucher used.[3] These objects serve as the connective fibers to smaller groups of drawings in the exhibition by other artists, typically representing the most significant phases of their work. After an essay that introduces the artists and some of their works, Françoise Joulie's study offers

Figure 1

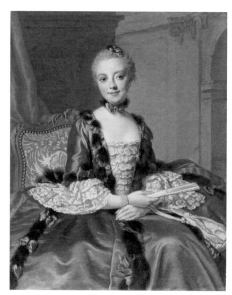

Figure 2

insights related to the formation and influences evident in the early works of Boucher and his associates, and Esther Bell's essay focuses on the often-forgotten significance of Charles-Antoine Coypel, the most senior member of the group. This is followed by a section of plates and an annotated checklist and bibliography that guide visitors and later users of the catalogue to further reading on both the general topic and the specific objects.

Although this exhibition is focused on drawings—including one oil sketch on paper (cat. no. 39)—The Horvitz Collection also contains paintings and sculptures by the Generation of 1700 as well as works by their younger and older contemporaries. The former group includes Louis-Michel Vanloo's *Geneviève de Malboissière as Melpomene* (fig. 1),[4] Pierre Allais's *Seated Lady in a Blue Dress* (fig. 2),[5] Boucher's *Rustic Landscape with Farmers at Rest* (fig. 3),[6] and Natoire's *Allegory of the Lyric Arts* (fig. 4).[7]

ALC

NOTES

1. See Pierre Rosenberg, "The Mysterious Beginnings of the Young Boucher," in New York et al. 1986, pp. 41–55.

2. See Rosenberg 1976; Rosenberg 1999; Pierre Rosenberg, "Ignorance et incompréhension réciproque: Un point de vue sur les difficiles relations artistiques entre la France et l'Italie au XVIIIe siècle," in Lyon and Lille 2000, pp. 17–23; Méjanès 2001; Françoise Joulie, "Formation de François Boucher" and "L'Album Cazes," and Jean-François Méjanès, "Le séjour de François Boucher en Italie (1728–1731)," in Paris 2003, pp. 24–32 and 33–43; Françoise Joulie, "Une formation à l'école des coloristes," in Dijon and London 2004, pp. 29–58; Rosenberg 2004a; and Marianne Roland Michel, "From Watteau to Boucher: The Making of a Manner and of a Genre"; Françoise Joulie, "Training and Culture of François Boucher: 'Whose Disciple Was He Then?'"; and Pierre Rosenberg, "Boucher and the 1700 Generation," in Sydney 2005, pp. 38–45, 76–87, and 172–79, respectively.

3. The one exception to this is pastel.

4. Louis-Michel Vanloo, *Geneviève de Malboissière as Melpomene*. Oil on canvas, 92 × 72 cm. Boston, The Horvitz Collection, inv. no. P-F-39. See Mathews 1994, pp. 101–2.

5. Pierre Allais, *Seated Lady in a Blue Dress*, 1751. Oil on canvas, 99 × 79 cm. Boston, The Horvitz Collection, inv. no. P-F-96.

6. François Boucher, *Rustic Landscape with Farmers at Rest*. Oil on canvas, 85 × 135 cm. Boston, The Horvitz Collection, inv. no. P-F-4. See Alastair Laing in New York et al. 1986, cat. no. 20, pp. 141–5; and Françoise Joulie in Versailles 2004, under cat. no. 28n1, p. 64.

7. Charles-Joseph Natoire, *Allegory of the Lyric Arts*. Oil on canvas, 87.5 × 147.5 cm. Boston, The Horvitz Collection, inv. no. P-F-119. See Caviglia-Brunel 2012, cat. no. P.107, pp. 289–90.

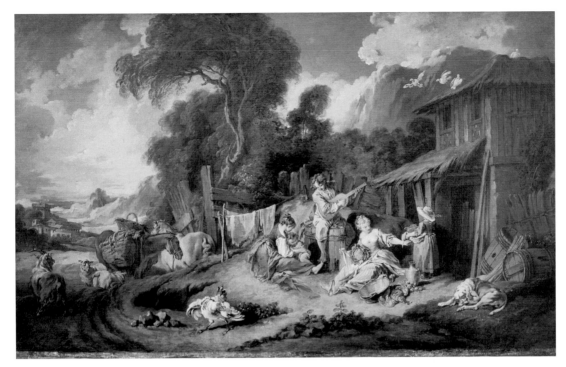

Figure 3

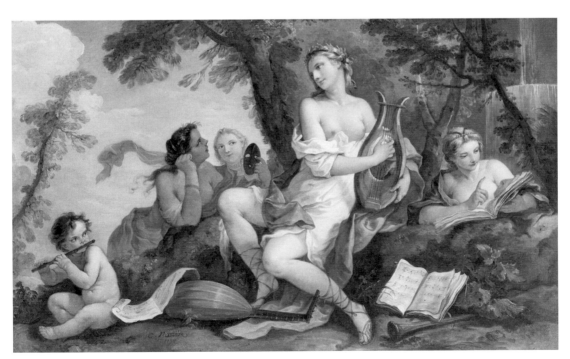

Figure 4

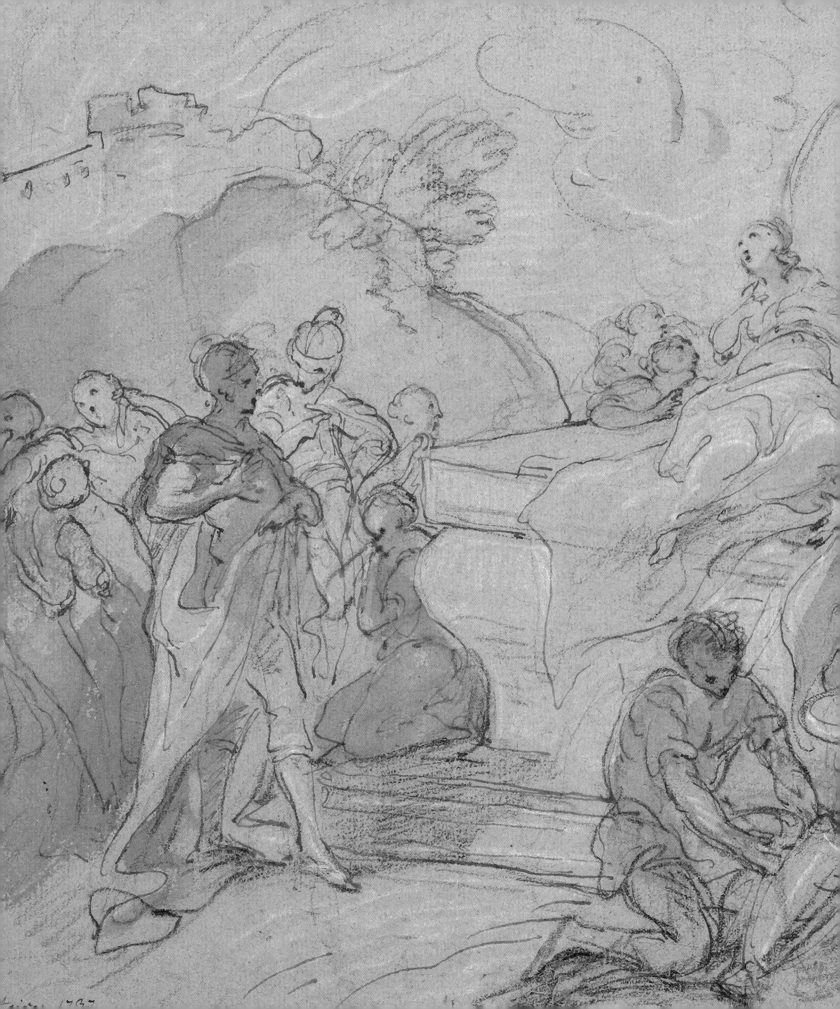

The Generation of 1700: Draftsmen, Drawings, and Questions

ALVIN L. CLARK, JR.

In memory of Jean-François Méjanès (1942–2012)[1]

This exhibition is comprised of eighty drawings by twenty-nine artists. It contains thirteen works by a select number of immediate and influential precursors of the Generation of 1700 and sixty-seven sheets by twenty-two artists born between 1694 and 1706, including a focused group of nineteen drawings by François Boucher. After a short discussion of the work of the predecessors, this essay provides concise chronological introductions to the lives and draftsmanship of the members of the Generation of 1700, and it concludes with a brief consideration of some of the questions and issues raised by the works and careers of this ambitious group of artists.

The thirteen drawings presented here by the seven immediate precursors to the Generation of 1700 reveal some of the many trends that attracted and inspired their students.[2] The three studies by Jean-Antoine Watteau display the subtlety of his touch, the poise of his figures— usually drawn spontaneously after individuals he encountered during the course of his day—and the refinement of his *mise-en-page* that make him one of the most admired draftsmen of the Western tradition (cat. nos. 78–80). In addition, Watteau's admittance to the Académie as a painter of *fête galantes* introduced a new genre of image making. The three drawings by the prolific portraitist, landscapist, and animal painter Jean-Baptiste Oudry remind us of his frequent use of varying shades of blue paper for his amusing book illustrations, his careful observation of flora, and his popular designs for painted and woven scenes of animals in combat (cat. nos. 56–58). These papers served as the middle tone for studies that are generated by drawing with

black ink, black chalk, or black ink wash and highlighted with white chalk, gouache, or pastel. Continuing this interest in color, the delicate and charming watercolor by the ornament and architectural painter Jacques de Lajoüe reminds us of the crucial role the decorative arts played in the genesis of the rococo (cat. no. 44). The three drawings by François Le Moyne demonstrate why this impressive history painter became the premier peintre du roi (cat. nos. 46–48). His blend of Flemish and northern Italian traditions resulted in a supple and rhythmic use of line that seems to effortlessly render form and unify complex compositions. Executed with a blend of red chalk and red chalk wash, Hyacinthe Collin de Vermont's *Feast of the Gods* suggests he was attempting to realize his mythological designs with a soft and fluid approach (cat. no. 27). Although he used figural awkwardness for dramatic effect, Jean Restout was also interested in flowing compositions; his *Pygmalion and Galatea* is a perfect example of his small-headed figures with long, sweeping contours and large, open gestures that glide across the plane of the sheet (cat. no. 69). In contrast with these varying approaches to lithe and lyrical designs, the emphatically energetic and bold drawings of Charles Parrocel reveal his heavily contoured and massive forms as well as the dynamism for which he was so admired (cat. no. 59).

As Esther Bell discusses in her essay, Charles-Antoine Coypel (b. 1694; cat. nos. 28–32a and b) was a respected artist, an ambitious curator, and a successful playwright. He was also a competent administrator who helped to found the École Royale des Élèves Protégés in order to

help revive history painting. As the four drawings included here—particularly the pair related to his *Hercules Brings Alcestis Back from the Underworld to Her Husband, Admetus* (cat. nos. 32a and b)—demonstrate, he was a subtle draftsman who preferred fluid contours and a dramatic approach to gesture and expression derived from a personal blend of influences that included Nicolas Poussin; Charles Le Brun; his father, Antoine; and the theater.

Juste-Aurèle Meissonnier (b. 1695) trained with his father, Étienne, and arrived in Paris from Savoy in 1714. He received a royal appointment as a master of the Corporation des Marchands-Orfèvres-Joailliers in 1724, and two years later, he was selected dessinateur de la chambre et du cabinet du roi, a post charged with designing all court celebrations. Meissonnier's technical brilliance enabled him to make an enormous contribution to the rococo; he is justifiably celebrated for his ability to make solid silver seem as malleable as clay. His drawings are rare, and like the study included here related to the reliquary of St. Aignan for the royal church dedicated to the saint at Orléans (cat. no. 49), his large sheets are often executed with black and white chalk on blue paper. They also suggest that Gian Lorenzo Bernini and Pietro da Cortona were key points of reference.

Jean-Baptiste-Joseph Pater (b. 1695) became Watteau's only known pupil after studying with his father and another local artist in their native Valenciennes. Pater's style never deviated far from that of his master, whose influence is particularly evident in Pater's red chalk figure studies (cat. no. 64). In 1728, Pater was received into the Académie as a painter of *fêtes galantes,* the category that had been invented for his celebrated teacher.

After initially following in the path of his father as an architectural engineer, Jacques-André Portail (b. 1695) came to the attention of Philibert Orry, comte de Vignory and directeur des bâtiments du roi, who brought him to Versailles. In 1738, Portail was appointed dessinateur du roi, and two years later, he was appointed garde des tableaux; 1740 was also the year he was curiously relieved of his royal duties with a pension. Portail directed a studio of draftsmen to make views of the royal chateaus and gardens. He also decorated reception rooms in the Louvre. He was admitted to the Académie as a painter of flowers and fruits. Since virtually all of his canvases have disappeared, Portail is

known today as a draftsman of exquisitely crafted landscapes, still lifes, and depictions of everyday life of elegant sitters in interiors (cat. nos. 66–68).

Étienne Parrocel, called Stefano le Romain (b. 1696), studied with his uncle Pierre, with whom he traveled to Rome in 1717. As with so many artists from the South of France, it is not certain that he visited the French capital before his departure for Italy. Instead of absorbing as much Italian art and culture as he could and returning to France like most of his compatriots, Étienne chose to remain in the Eternal City and became known as Stefano le Romain. He received numerous commissions for altarpieces and portraits and became a member of the Accademia di San Luca. Like his colleague Pierre-Hubert Subleyras, Stefano never succumbed to the extremes of the rococo. Instead, as his solidly drawn figure studies reveal, he preferred the sober brand of baroque classicism popular in Rome in the middle of the eighteenth century (cat. nos. 60 and 61).

Edme Bouchardon (b. 1698) was the most celebrated French sculptor active in the middle of the eighteenth century. He studied with his father and Guillaume Coustou the Elder, won the Prix de Rome in 1722, and traveled to Italy in 1723 with the sculptor Lambert-Sigismond Adam. Bouchardon returned to Paris in 1733, became dessinateur de l'Académie des Inscriptions et Belles-Lettres in 1736, and was received into the Académie in 1745. Distinguished critics such as the *amateur* Pierre-Jean Mariette, the encyclopedist Denis Diderot, the administrator of the arts and secretary of the Académie Charles-Nicolas Cochin the Younger, and the antiquarian Anne-Claude-Philippe de Pestels de Lévis de Tubières-Grimoard, comte de Caylus, all considered him to be one of the greatest draftsmen of their time. His known oeuvre consists of more than 1,000 sheets, most of them flawlessly executed in red chalk. Although the function of each drawing must be taken into account, Bouchardon gradually replaced the soft and rhythmic tendencies seen often in his earliest works (cat. nos. 2 and 5) with a severe but nuanced linearity that hyperactivates blank portions of the sheets and suggests as much as it describes (cat. nos. 3 and 4).

Jean-Baptiste-Siméon Chardin (b. 1699) was a student of Pierre-Jacques Cazes and Noël-Nicolas Coypel. Despite his training in Paris, he never traveled to Italy and chose to

focus on his enormously popular still lifes and genre scenes. He was received into the Académie in 1728, served as its treasurer for two decades, and often organized the installation of the Salon. Only a couple of his drawings are known, but around 1770, when Chardin encountered problems with his eyes, he avoided painting with oils (which produced irritating fumes) and began working in pastel. Unlike most other contemporary pastelists, Chardin treated the medium like a painter, layering media on a dark ground, which enabled him to simultaneously exploit the incomparable density of the medium and experiment with textural juxtapositions of sketchily applied bright colors on the top layer. Just over a dozen of these impressive works are extant (cat. no. 26).

Hubert-François Gravelot (b. 1699) was one of the most successful and prolific book illustrators of his century. After a slow start and fourteen years in London (1732–45), he returned to Paris as an accomplished artist and remained in great demand in both England and France for the balance of his career. Gravelot began his painstaking method of drawing only after absorbing the text to be illustrated. Each image was realized with multiple graphite studies of posed mannequins before the final design was carefully rendered in pen and ink. Most of his drawings, like the two included here (cat. nos. 41 and 42), are either squared, incised, or darkened on the verso to assist him in transferring elements of his design to the next sheet. His scenes of contemporary life are his most admired works, and his *Good Mother* (cat. no. 41) has the added benefit of displaying two ladies conversing in a rococo boudoir.

Orphaned at an early age, Étienne Jeaurat (b. 1699) was placed under the protection and tutelage of Nicolas Vleughels, who was appointed director of the Académie de France à Rome in 1724. Jeaurat traveled with him to Italy, returned to France in the early 1730s, and was accepted into the Académie in 1733. He was an extremely active member, rising to the level of chancellor by 1781. Despite his acceptance as a history painter, Jeaurat is most remembered for his carefully staged and popular depictions of Parisian street life and domestic interiors (cat. no. 43). His figure studies and compositions are rendered in a straightforward manner with gently faceted contours and hatching in black chalk that is enlivened by touches of red and white chalk.

Alexis Peyrotte (b. 1699) was a highly esteemed designer and painter of interior decors. He also provided designs for furniture, embroidery, carriages, and fans. He probably received his initial training with his father in his native Comtat Venaissin. After working in Lyon in the 1730s, Peyrotte arrived in the French capital in the mid-1740s and produced interiors for several royal chateaus. In 1749, he was admitted to the Académie and received the post of peintre du roi et dessinateur au garde-meuble de la couronne. The drawing included here is undoubtedly related to one of his many popular decors chinois that were destroyed during the nineteenth century (cat. no. 65). As a draftsman, his nervous pen work, animated with a generous application of wash, reflects his southern French heritage and links him to artists such as Dandré-Bardon and Meissonnier.

After training with Antoine Rivalz in Toulouse, Pierre-Hubert Subleyras (b. 1699) moved to Paris and won the Prix de Rome in 1727, and then traveled to Italy with Louis-Gabriel Blanchet, Michel-Ange Slodtz, and Pierre-Charles Trémolières. Subleyras's early draftsmanship reflects the dynamism seen in the works of his teacher (cat. no. 72). Unlike his travel companions, Subleyras chose to remain in Italy, where, like his compatriot Étienne Parrocel, he developed a style that avoided the extremes of the rococo. He often used black and white chalk on blue paper for his composition studies, as he did for the early drawing related to his Prix de Rome exhibited here (cat. no. 71).

Michel-François Dandré-Bardon (b. 1700) came to Paris in 1720 intending to study law, but a pastime turned into a vocation, and he initiated his studies with Jean-Baptiste Vanloo and Jean-François de Troy. Dandré-Bardon won second prize in the Prix de Rome competition of 1725 and financed his own trip to Italy, where he was lodged at the Académie de France à Rome and later gained a stipend. Upon his return to France in 1730 or 1731, he worked on decorations for the Hôtel de Ville in his native Aix (1731–33) before returning in 1734 to Paris, where he was received into the Académie in 1737. Four years later, Dandré-Bardon left the capital again and spent more than a decade on royal and civic commissions in Marseille (1741–52), where he helped to found the municipal academy before returning to Paris and assuming his post as a professor at the Académie. Later in life, as Dandré-Bardon's administrative duties multiplied

and his painting decreased—he became director of the academy in Marseille (1754) and a professor at the École Royale des Élèves Protégés (1755), where he produced a number of well-received publications.[3] Dandré-Bardon was a prolific draftsman, whose origin, training, and frequent contact with artists from the South of France ensured the survival of the tendencies of that region in his work throughout his career. These include his nervous line; his strong diagonals in multiple and often intersecting planes; and his energetic use of wash, which plays a role equal to or greater than line. These characteristics generated active figures and draperies and animated compositions that often simulate the flicker of Venetian drawings (cat. nos. 33–36).

Charles-Joseph Natoire (b. 1700) commenced his studies with his father before working in Paris with Louis Galloche and François Le Moyne. After winning the Prix de Rome, Natoire arrived in 1723 in the Eternal City, where he won first prize in the competition at the Accademia di San Luca. Following an extended period in northern Italy, he returned to Paris in 1730, where he was received into the Académie in 1734. Natoire was a prolific artist whose success with major commissions led to his appointment as director of the Académie de France à Rome (1751–75), where his interest in landscape led to a number of sheets delicately finished with watercolor that beautifully captured the luminosity of the Roman *campagna* and led to his encouragement of plein-air landscape drawing by his students (who included Hubert Robert and Jean-Honoré Fragonard). Natoire's sinuous and gracefully finished compositions reveal him to be a true disciple of Le Moyne (cat. no. 54), and the beauty and natural elegance of his female nudes are the only ones to challenge those of Boucher (cat. no. 51). The exhibition includes an early drawing from the late 1720s (cat. no. 54); a study after an Italian master (cat. no. 55); one of his late landscapes (cat. no. 52); and an early idea for his commission for San Luigi dei Francesi, the official French church in Rome (cat. no. 50).

The son of a sculptor and brother of an architect, Jacques Dumont, called Dumont le Romain (b. 1701), began his studies with the landscapist Antoine Lebel. Dumont spent five years studying in Italy, and he was received into the Académie upon his return in 1728. He was appointed governor of the newly founded École Royale des Élèves Protégés in 1748, and in 1763 he was named honorary

director of the Académie. Only a small number of his paintings are known, but his numerous drawings—including many red chalk copies after Italian masters—reveal his commitment to a classicizing style similar to that achieved by Bouchardon, Slodtz, and (slightly later) the engraver Charles-Nicolas Cochin the Younger (cat. no. 38). However, his *académies* typically blend that mode with a softer approach that enables him to manipulate shading to evoke volume (cat. no. 37).

François Boucher (b. 1703) was a precocious talent trained by his father and Le Moyne before working with the printmaker Laurent Cars. Boucher earned the Prix de Rome in 1720 while still in his teens, but he did not embark for Italy until five years later when he traveled with Carle Vanloo. He remained in Italy for five years, returned to Paris in 1731, and was admitted into the Académie in the same year. After achieving the levels of professor and rector of the Académie, Boucher was appointed director of the Gobelins Manufactory in 1755 and premier peintre in 1765. He was a prolific painter and draftsman who produced genre works as well as history paintings. He also designed for the Beauvais and Gobelins manufactories and was one of the early artists to produce finished drawings for the market. The nineteen drawings by Boucher in the exhibition provide an opportunity to see a wide variety of his styles and themes in a number of different types of studies produced over the course of his long career. Early sheets like the *Hippolytus Thrown from His Chariot* and the *Feast of Belshazzar* (cat. nos. 12 and 10) from the late 1720s and early 1730s reveal the pulsating exuberance of his rhythmic faceting and hatching, discussed in the essay by Françoise Joulie. As the *Large Family Before a Farmstead with Animals* demonstrates (cat. no. 15), in the mid- to late 1730s, this energy is moderated and redirected toward a quest for volume. Drawings from the 1740s and early 1750s such as the female nudes, the crowned escutcheon, *Chief of the Eunuchs*, *Adoration of the Shepherds*, and *Venus Presenting Aeneas to Jupiter and Juno* (cat. nos. 18, 19, 9, 8, 7, and 23) display the confident, graceful contours and complex designs of Boucher's middle years. The last two works (cat. nos. 7 and 23) also show his skill at manipulating various media in order to produce highly finished and painterly drawings. The *Heads of Two Young Ladies*, *River Landscape with Figures*, and *Seated Male*

Nude with Armor from the early to mid-1750s (cat. nos. 11, 20, and 21) disclose Boucher's incomparable mastery of chalk; the latter is a particularly brilliant example of his dexterity with red chalk, a medium that is almost impossible to correct. Drawings from the late 1750s and the 1760s such as *Peasants and Animals in a Landscape, Lady Attended by a Handmaiden, Virgin with Angels, Tobit Burying the Dead*, and *Juno Commanding Aeolus to Release the Storm Winds* (cat. nos. 16, 14, 24, 22, and 13) all reveal the grand gestures, rich chiaroscuro, and opulence of Boucher's late works.

Pierre-Charles Trémolières (b. 1703) was trained in Paris by Jean-Baptiste Vanloo. After gaining second prize at the Académie in 1726, he traveled to Rome in 1728 with Blanchet, Slodtz, and Subleyras. Trémolières returned to Paris in 1736, when he was received as *agréé* by the Académie. However, after working with Boucher, Natoire, and Carle Vanloo at the Hôtel de Soubise, Trémolières died suddenly in 1739. His rare drawings, like those of Natoire, are rendered with an easy elegance and refinement, but occasionally, as in the drawing included here (cat. no. 73), Trémolières also displays a fluidity, delicacy, and lightness of touch unequaled by his contemporaries.

Maurice-Quentin de La Tour (b. 1704) was the pre-eminent pastelist of the eighteenth century and is frequently referred to as the "prince of pastelists." The scale of his greatest portraits and the variety of techniques he used took the medium to a new level. He began his studies in 1719 with the little-known painter Claude Dupouch before ceasing to work in oils in 1722. His turn to pastel may have been for reasons of health or an attraction to the medium influenced by Rosalba Carriera's visit to Paris (1720–21). His painstaking technique began with monochromatic sketches of contours and then proceeded to colored studies such as the one exhibited here (cat. no. 45). A full-scale portrait would be initiated only after these series were completed. The final manipulation of the pastel to suggest tone, skin, hair, and different fabrics and furnishings dazzled his contemporaries and ensured innumerable commissions. He was received into the Académie in 1746 and made a peintre du roi in 1755.

Joseph-Ignace-François Parrocel (b. 1704) was from Avignon, which was then the capital of the Comtat Venaissin, an independent county governed by the Holy See. He was a member of the impressive Parrocel dynasty that produced at least nine successful artists active from the beginning of the seventeenth through the middle of the nineteenth century. His uncle, Charles (cat. no. 59), was an important precursor for him and his cousin Étienne (cat. nos. 60 and 61). After studying with his father, Pierre, Joseph visited Rome with Étienne in 1716 but soon returned to Paris to pursue his studies. Although he did not win the Académie's Prix de Rome, he became a pensioner and traveled to Rome again in 1736. He returned to France in 1740 in the entourage of Cardinal de Rohan, by whom he was retained in Strasbourg. Joseph settled in Paris in 1749; he was received as agréé by the Académie de Peinture et de Sculpture, but he was never admitted as a full academician. His numerous drawings display his spirited and slightly angular style (cat. nos. 62 and 63).

Little is known about Louis-Gabriel Blanchet (b. 1705). He won second prize at the Académie in 1727 and traveled to Rome with Subleyras (who won first prize) in 1728. Like his compatriot, Blanchet remained in Rome, where he attained notable success as a portrait painter, despite fierce competition from his contemporary Italian colleague Pompeo Girolamo Batoni. Although he is reputed to have been an impressive draftsman, few sheets remain linked to his name. Fortunately, the one exhibited here (cat. no. 1) was interpreted as a crayon-manner engraving by the Lotharingian printmaker and publisher Jean-Charles François. Blanchet's drawing reveals a use of heavy contours in red chalk similar to the manner of Carle Vanloo.

René-Michel, called Michel-Ange Slodtz (b. 1705) was born into a family of artists and began his studies with his father. He won second prize in two Prix de Rome competitions (1724 and 1726) and departed for Rome in 1728 with Blanchet, Subleyras, and Trémolières. Slodtz was resident at the Académie de France à Rome for the surprising length of eight years and then remained in the Eternal City to work on several portrait commissions for another decade. When he returned to France in 1746, Slodtz discovered that even his tempered baroque mode diverged from the classicism preferred by the influential comte de Caylus. Slodtz was received as agréé by the Académie in 1749, but he was never admitted as a full academician and failed to complete royal commissions. However, when his friend

Charles-Nicolas Cochin the Younger was appointed administrator of the arts, Slodtz was granted a royal pension and succeeded his brother as dessinateur du cabinet du roi in 1758. Most of Slodtz's late work was connected with the Menus-Plaisirs, the division of the royal household devoted to royal entertainment, which included official royal and state events, music, theater, wardrobe, gifts, and some aspects of the applied arts. Like Bouchardon and Cochin, Slodtz preferred a controlled and classicizing mode, but unlike them, he was not averse to manipulating the chalk in various ways to evoke texture (cat. no. 70).

Charles-André, called Carle Vanloo (b. 1705), was the most eminent member of a remarkable dynasty of artists. He was born in Nice, which was then part of the independent duchy of Savoy. He joined his brother and first teacher, Jean-Baptiste, in the Savoyard capital of Turin upon the death of their father in 1712. Carle traveled to Rome with Jean-Baptiste and studied drawing with the painter Benedetto Luti. The brothers returned to France around 1720 and worked together on the restoration of the Galerie François Ier at the Château de Fontainebleau. Carle won the Prix de Rome in 1724 and left for Italy with Boucher and the two sons of Jean-Baptiste in 1727. He remained there until he departed for his native Savoy in 1732, where he worked in the Palazzo Reale in Turin for Charles-Emmanuel III, sovereign duke of Savoy and king of Sardinia. Carle returned to Paris in 1734, where he was received into the Académie in 1735. He enjoyed enormous popularity and success in France. His numerous appointments included professor at the Académie (1737); director of the École Royale des Élèves Protégés (1749); premier peintre du roi (1762); and finally, director of the Académie (1763). Carle Vanloo was considered a superb draftsman in all media. His oeuvre is marked by heavy contours and energetic but somewhat classicizing compositions that always retain a measured distance from the most decorative extremes of the rococo. The majority of Vanloo's earliest drawings have been lost. However, except for some energetic hatching and rounded rendering of drapery, from the *Fantasy Figure* executed in Rome around 1730 as a pensioner at the Académie de France (cat. no. 74) to his celebrated composition depicting the famous tragedienne Clairon in her greatest role produced toward the end of his career in the late 1750s (cat. no. 75), Vanloo's style seems to have changed very little.

Although he was born near Paris, little trace remains of Antoine de Favray (b. 1706) in France during his early years. He is first documented in the Roman atelier of Jean-François de Troy during the latter's tenure as director of the Académie de France. He was granted a year as a resident at the institution and then departed for Malta in 1744, where—except for a nine-year stay in Constantinople (1762–71)—he spent most of the rest of his career. He maintained connections with France, became a member of the Académie in 1762, and frequently sent paintings to the Salon. Most of Favray's work remains in Malta, where he was the preeminent artist for more than four decades. Portraiture forms the majority of his oeuvre, but he also produced landscapes and religious paintings. As a draftsman (cat. no. 40), he seems to blend some of the linear delicacy of Natoire and Trémolières with some of the bold volumes seen in the work of artists such as Carle Vanloo.

A number of questions and issues are raised on the occasion of any exhibition that focuses on the Generation of 1700. I mention five that seem particularly relevant. First, one of the key concerns is the astonishing similitude of form and composition seen in the early works of these artists (e.g., cat. nos. 10, 54, 71 by Boucher, Natoire, and Subleyras). Given their common training, work, and travel together from adolescence through early adulthood in Paris and Rome, perhaps this should not be a surprise. Their shared mastery of the human figure, perspective, composition, and theme was the stunning culmination of more than seventy years of effort by their forebears and contemporary superiors to raise the level of their education to a high and standardized level of achievement. Some early influences, such as seventeenth-century northern and contemporary Venetian art, are frequently cited, but other potentially important sources are not. For example, the mannerism of the sixteenth century—particularly that of Fontainebleau—continued to be a source of study for many generations of French artists but is rarely discussed in connection with the art of the early eighteenth century, despite many indications

that it did matter to the group. Carle Vanloo assisted his uncle with the restoration of the frescoes at Fontainebleau, and both the foreground figure and the compositional structure for works such as Dandré-Bardon's *Supper at Emmaus* (fig. 1) are perfect examples of the attention these artists paid to this important moment in the history of French art.[4]

Second, if we are studying a generation of artists during their careers, why are the moments when each of these artists developed their own independent personalities never discussed as an aspect of their group dynamic? Studying the possible artistic or career-related reasons for these changes during their mature years is no less significant than understanding the ties that linked them in earlier years. Or, when we speak of the Generation of 1700, are we actually thinking of another topic, namely, "Paris 1725–35"?

Third, when considering issues of individual manner during the genesis of the rococo, did classicizing artists such as Bouchardon, Subleyras, and Carle Vanloo consider that

Figure 1

this rubric met the challenges posed by designs for all types of religious and mythological themes? Did that understanding suggest a system in which subjects determined a variety of decidedly different stylistic options? Could that have been part of their training?[5] And could some of the answers to these questions suggest that the issue of eclecticism, discussed by Bell in connection with Coypel, might be expanded to additional artists?

The fourth issue concerns media. Pastel was not new to the artists shown here, but they worked at a time when it was maturing to a level of independence. In addition to artists who blended it with other media, experimented, or occasionally exploited the potential of this medium, artists such as La Tour now worked exclusively in pastel (cat. no. 45). One might inquire how this affected painting in oil for both patrons and artists.

The last issue concerns regional influence. The art history of early modern France often suggests a unidirectional system for the spread of ideas emanating from Paris. However, given that Dandré-Bardon is from Aix, Natoire and Subleyras are from Nîmes, Peyrotte and the Parrocel are from the Comtat Venaissin, and Carle Vanloo and Meissonnier are from the duchy of Savoy, perhaps we might consider the reverse and ask what influence their traditions had on art in Paris. This small exhibition cannot aspire to present the answers to these questions, but it can offer another opportunity to ponder these issues.

NOTES

1. See Clark and Morgan Grasselli 2012.

2. General references to the work and careers of the artists discussed in this essay can be found in the literature sections of the Annotated Checklist.

3. These include a two-volume *Traité de peinture … suivi d'un catalogue des artistes le plus fameux de l'École française* (1765); a three-volume *Histoire universelle traitée relativement aux arts de peinture et de sculpture … * (1769); and a three-volume *Costumes des anciens peuples* (1772).

4. Michel-François Dandré-Bardon, *Supper at Emmaus*. Oil on canvas, 68 × 55 cm. Boston, The Horvitz Collection, inv. no. P-F-43. This unpublished early painting is probably the one mentioned in the artist's death inventory. A related drawing is in a private collection in Aix-en-Provence. See Chol 1987, pp. 97–98.

5. This last question emanated from a conversation with Esther Bell, 2 December 2012.

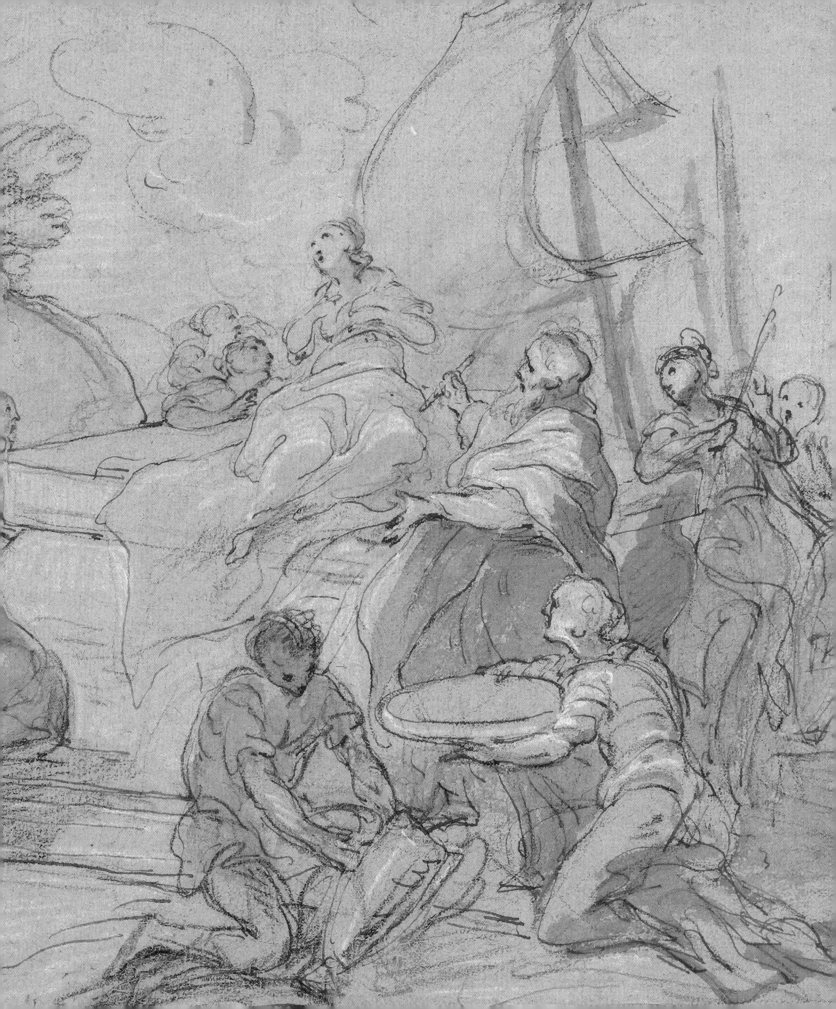

Reflections on the Early Drawings of Boucher and His Contemporaries

FRANÇOISE JOULIE

When one thinks of French art in the middle of the eighteenth century, François Boucher immediately comes to mind. He was a member of a group of artists born between 1694 and 1706, often referred to as the Generation of 1700, that produced the Louis XV, or rococo, style around 1730. Although the history of art traditionally and understandably prioritizes Boucher's name for this movement, a number of his young colleagues, such as Michel-François Dandré-Bardon, Charles-Joseph Natoire, Pierre-Charles Trémolières, and Carle Vanloo, also made crucial contributions to the genesis of the rococo. Many of these contributions emanated from the continuous flow and exchange of ideas these artists shared with one another during their early years as students and young professionals in Paris and Rome. This essay will explore aspects of that visual conversation, with particular emphasis on the links between the works of Boucher and Dandré-Bardon and some of the more significant influences that sparked the imagination of all of these artists.

Boucher was born at the end of the long reign of Louis XIV. He was the only son of the master painter Nicolas Boucher and Elisabeth Lemesle; his mother came from a milieu of men of law who would be Boucher's first clients after 1730. Born into near-poverty on 29 September 1703, he probably began his artistic education with his father and lived in the area close to the Hôtel de Ville.[1] In the early 1720s, Boucher and his young associates were completing their education in the studios of important painters and, most importantly, at the Académie Royale de Peinture et de Sculpture, where, thanks to its famous prize, they could aspire to go to Italy as pensioners of the king. Boucher is mentioned for the first time in 1721 in the entourage of his teacher, Francois Le Moyne.[2]

At the Académie, Boucher and his contemporaries studied the work of celebrated seventeenth-century French predecessors such as Sébastien Bourdon, Laurent de La Hyre, Charles Le Brun, Eustache Le Sueur, Nicolas Poussin, and Simon Vouet.[3] As tastes slowly changed, around 1700, the work of the immediate successors of those icons—Louis de Boullogne, Jean Jouvenet, Charles de La Fosse, and Antoine Coypel—was also incorporated into the canon.[4] That group of artists had lived through the debate between the advocates of the primacy of line (André Félibien and the Poussinists) vs. color (Roger de Piles and the Rubenists). Victory leaned more toward the colorists: De Piles entered the Académie in 1699; La Fosse became its new director in 1701; and Boullogne, who became director of the institution in 1725, embodied a transitional style that blended classical academicism and the new colorist tendencies. Boucher began to paint in the mid-1720s, and his interest in color, particularly that seen in seventeenth-century Dutch and Flemish art, forms part of the framework for his process and one of the strong points of his private collection of paintings and drawings.[5] In addition, one of the greatest historical influences on Boucher and others in the Generation of 1700 was the Franco-Flemish Jean-Antoine Watteau, who died just before they came of age. His interest in color was combined with a return to a focus on nature. Boucher and several of his colleagues were given an opportunity to study Watteau's work in great depth by reproducing

his drawings as etchings that became part of the extraordinary collection known as the Recueil Jullienne.[6]

The interest in color popular at the turn of the century influenced Boullogne, Le Moyne, Jean-François de Troy, Jean-Baptist Oudry, Louis Galloche, and Jean-Baptiste Vanloo, all of whom led active studios in Paris around 1720. Reinforcing Watteau's return to nature, Galloche brought his students to the countryside to observe the beautiful effects produced by the different seasons.[7] This renewed attention to nature also led many of the young artists to later draw with Oudry in the gardens of Arcueil. Jean-Baptiste Vanloo played an important and understudied role with the younger generation.[8] In his biography on the artist, Dandré-Bardon wrote, "To the principles of composition, [he] joined those of color. Titian, Van Dyke, Rubens, Correggio … are the models he suggested to his pupils."[9]

Figure 1

The close connections between the drawings of Boucher and his immediate contemporaries in the mid- to late 1720s have led to innumerable issues of attribution. Some of the reasons for this include their common training in the studios of the teachers mentioned above. Boucher's links with Carle Vanloo are particularly strong: In 1726, they produced two mythological paintings as pendants, and in 1728, they traveled to Italy together with the two sons of Jean-Baptiste Vanloo, François and Louis-Michel. After Boucher and Carle returned to France, they worked on the same royal projects, and they developed a common approach to drawing that was probably rooted in the forceful angularity evident in the draftsmanship of artists such as Jouvenet. Boucher's flexibility and sinuosity of line and his strong hatching in red chalk (cat. no. 12) can also be seen in works like Trémolières's *Hagar and the Angel* (cat. no. 73). Last, one should also mention similarly turbulent compositions by Natoire (cat. no. 54) and Subleyras (cat. no. 71), which contain figures with strongly defined attitudes and emphatic gestures.

The strongest parallels between the artists of this generation occur in the early works of Boucher and Dandré-Bardon, who was also a pupil of Jean-Baptiste Vanloo. They probably met in Vanloo's studio in 1721, before Dandré-Bardon moved to the de Troy atelier. They encountered each other again in 1726, when they were both in Rome. The stylistic similarities in the early drawings by the artists are further complicated by inscriptions and signatures. For example, two versions of *Atreus Serving Thyestes the Bodies of His Own Children at a Feast* are known, one of which was sold as Dandré-Bardon while the other is signed by Boucher (fig. 1).[10] At first sight, the treatment of the red chalk is comparable to other works by Dandré-Bardon.[11] Both artists emphasize theatrical gestures and carefully manipulate the chalk to structure their compositions by hatching large sections of the sheet. However, Boucher's work is significantly more pictorial and more attentive to perspective and the perception of depth. Clarity is also elusive when it comes to the artists' studies in pen and ink. Boucher's *Feast of Belshazzar* (cat. no. 10) is a monumental and spectacular sheet that presents all the characteristics of Boucher in the early 1730s, but the dynamism and busy linearity evident in the sheet led to its earlier incorrect attribution to Dandré-Bardon,[12] even

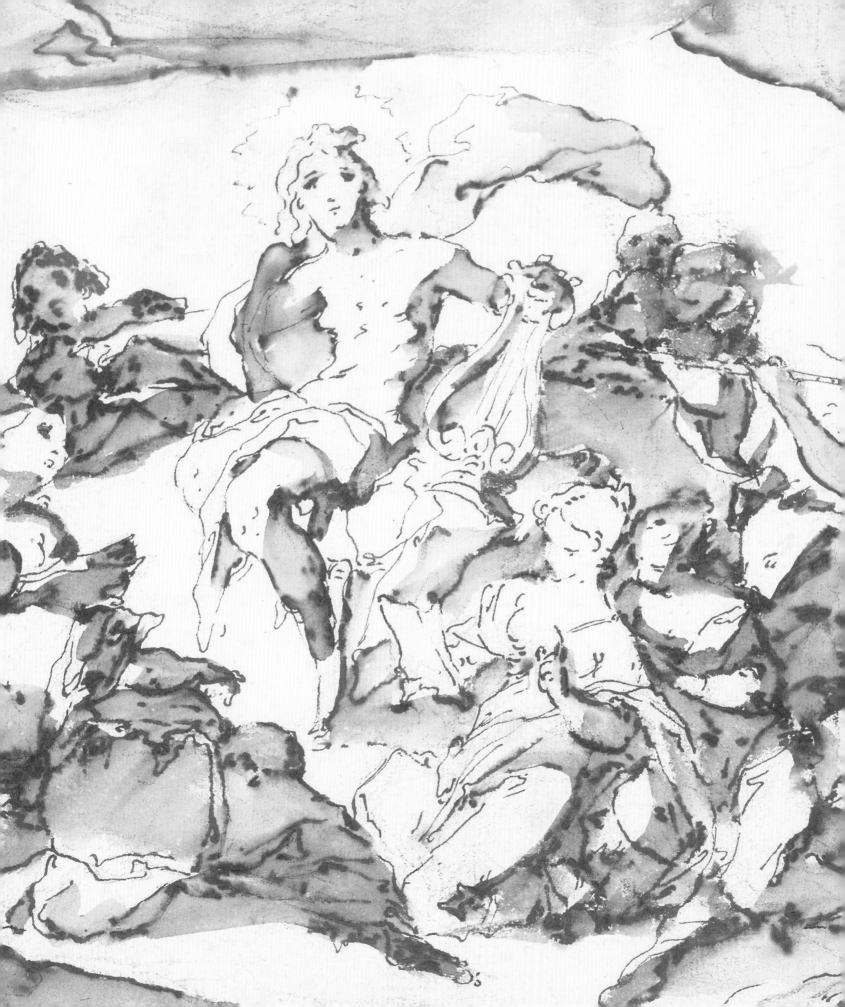

though his characteristic shadows in flat planes, arbitrary foreshortening, lost profiles, and insubstantial figures were all absent.

Another major influence on the artists of the Generation of 1700 was the art of Venice. Several artists and theorists such as de Piles held Titian to be the master of color ahead of Dutch and Flemish artists, and as Boucher knew from his experience with the Recueil Jullienne, slightly earlier contemporaries such as Watteau revealed an interest in the Venetian school by making copies after Titian, Campagnola, Veronese, and Bassano. If artists did not travel to La Serenissima or if they were not satisfied with the amount of time they had to study its art during their stays in Italy, they also had access to a number of works by northeastern Italian masters in Parisian collections.[13] Although the initial reason for the study of earlier Venetian art was its incomparable coloristic tradition, the exuberant vitality and sharp sense of movement seen in the work of contemporary artists from the Veneto proved to be equally significant. This influence was strengthened by the presence of some of these artists in the French capital. Marco and Sebastiano Ricci passed through Paris in 1712 and 1716. During his stay, Marco sold landscape drawings to the distinguished collector Pierre Crozat, and in 1720, at the instigation of the same collector, Giovanni Antonio Pellegrini was invited by the regent to decorate the ceiling of the recently established Mississippi Bank. Accompanied by Marco Ricci and Count Antonio Maria Zanetti, Pellegrini arrived in Paris in the spring of 1720, and before his departure a year later, he would be joined by his sister-in-law, the pastelist Rosalba Carriera, who was invited and housed by Crozat. As the swirling lines and powerful angles of Boucher's *Judgment of Susannah* demonstrate (fig. 2),[14] both the convulsive rhythms and emphatic gestures in the paintings of Pellegrini and the forceful chiaroscuro and lost profiles in the works of Marco Ricci played a major role in the emergence of the Louis XV style. Indeed, the influence of Pellegrini on Boucher's early work is so profound that it is tempting to speculate that the young artist may have been an apprentice to the Italian master during his stay in Paris.[15]

The blend of color featured in works of the northern school with the unique combination of color, dynamism, and contrasted lighting found in Venetian art explains much of the fervor evident in the early compositions produced by artists of the Generation of 1700. In addition to many artists working in the same studios and studying together in the academies in Paris and Rome, this Venetian influence created confounding similarities in their work during the later 1720s and 1730s; the draftsmen of the Generation of 1700 present the same spirited effects, the same sinuosity of forms, and the same strong *contrapposto*, all of which are so close that it is sometimes difficult to distinguish the different hands. However, the passage of the Venetians through Paris around 1720 seems to have given Boucher, even more than all the others, an especially keen feeling for the body in movement. His forms were often rendered with a rhythmic, melodic line and placed in swirling, unbalanced compositions, and his synthesis was immediately adopted by other artists of his generation. As Pierre Rosenberg observed, "From around 1740 Boucher occupied the limelight, and symbolized in his own person a new and original style that had broken with the past, rather as Simon Vouet had done in the previous century."[16] Having rapidly absorbed the developments in Paris and key aspects of foreign traditions, François Boucher used that information to generate a new paradigm that placed him among the greatest artists of his time.

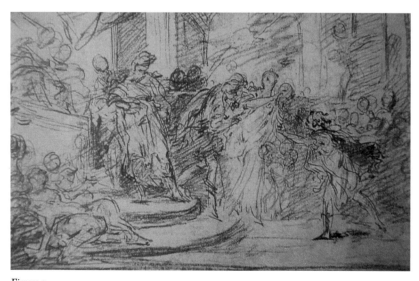

Figure 2

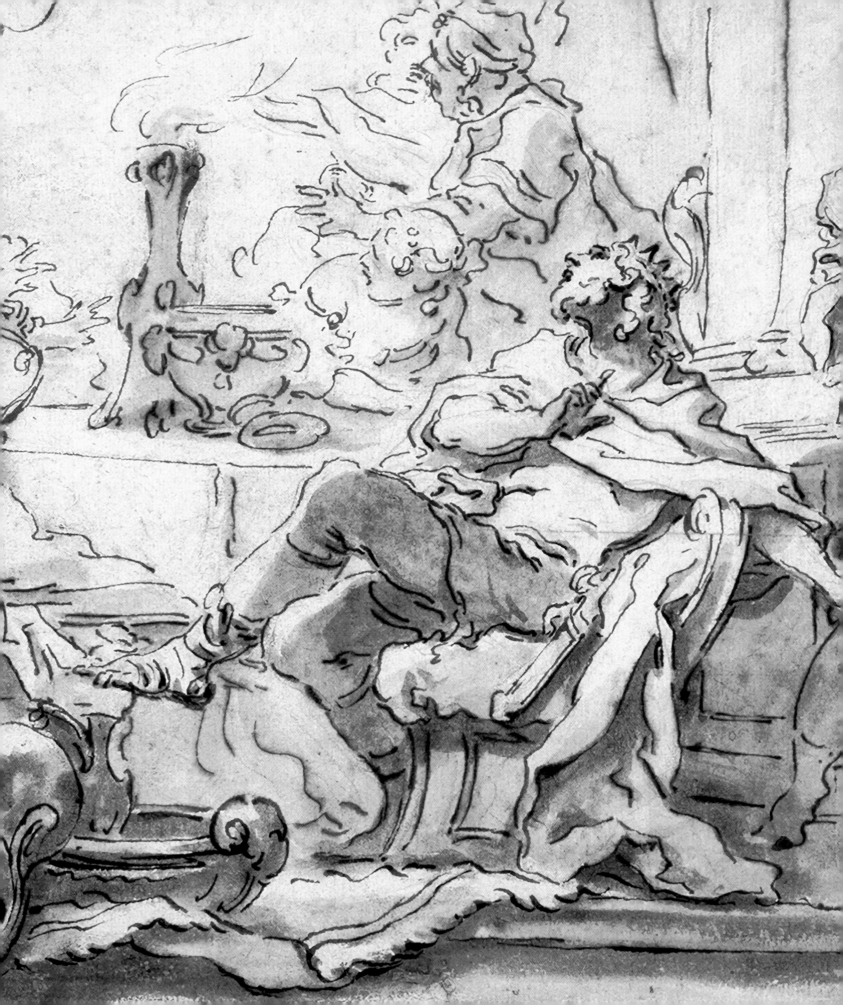

1. Pierre 1788, p. 236.

2. This is the date when Boucher presented Le Moyne with his first documented painting, *The Judgment of Susannah* (Ottawa, National Gallery of Canada, inv. no. 38549). See Bailey 2000.

3. Contrary to popular opinion, the interest in Le Brun continued through the first quarter of the eighteenth century. Indeed, between 1723 and 1731, thirty-two artists under the direction of Jean-Baptiste Massé—including Bouchardon, Boucher, Galloche, and Natoire—produced more than fifty finished drawings interpreting Le Brun's work in preparation for the book *La Grande Galerie de Versailles* of 1751. Additionally, Sébastien Bourdon is an often overlooked but notable innovator. The lyricism of his historical compositions, the poetry of his genre scenes (often inspired by Genoese artists such as Giovanni Benedetto Castiglione), and his Venetian-inspired use of color were very influential. *Noah Entering the Ark* and the *Sacrifice of Noah*, painted by Boucher for the distinguished collector Jean de Jullienne, are inspired by figures in Bourdon's *Departure of Jacob* now at the Museum of Fine Arts in Houston (inv. no. 80.16). See Alastair Laing in New York et al. 1986, cat. nos. 10 and 11, pp. 114–17, and Jacques Thuillier in Montpellier and Strasbourg 2000, cat. no. 15, p. 163.

4. One particularly good example of their influence, still *in situ*, is Jean Jouvenet's innovative work in the Chapel of Versailles that was completed in 1710. See Maral 2011.

5. This predilection for a northern approach to color would survive in Boucher's generation as a sort of archaism until well into the third quarter of the eighteenth century. See Françoise Joulie, "Une formation à l'école des coloristes," in Dijon and London 2004, pp. 29–32. Natoire's landscapes produced in Rome through the end of his career provide another example of the use of this color system by a member of the Generation of 1700; he continued to embellish them with bright watercolor even when taste had shifted to more sober effects of color, line, and light during the genesis of neoclassicism. For more on Boucher as a collector, see Françoise Joulie, "François Boucher collectionneur de peinture nordique," in Dijon and London 2004, pp. 17–28.

6. Watteau occupied a specific place in Boucher's education between 1722, the date of his recruitment by Jean de Jullienne, and November 1726, when the first volume of the Receuil Jullienne was published with a frontispiece by Boucher as *Les figures de différents caracteres, de paysages, et d'etudes dessinées d'après nature par Antoine Watteau*

peintre du roy en son Académie Royale de Peinture et Sculpture gravées à l'eau-forte par les plus habiles peintres et graveurs du temps, tirées des plus beaux cabinets de Paris. The second volume, which appeared in 1728, also has a frontispiece by his hand. In this enterprise, Boucher was associated with fourteen young draftsmen and printmakers, some of whom—Laurent Cars, Pierre-Charles Trémolières, and Carle Vanloo—were especially close to him. See Jean-Richard 1978, pp. 33–66 and Tillerot 2010, pp. 274–79.

7. See Gougenot 1767.

8. After lengthy study in Florence, Jean-Baptiste Vanloo must have imparted some of the latest innovations seen in contemporary Italian art. His role may have been critical in connecting Dandré-Bardon, Trémolières, Carle Vanloo, and Boucher. Although his art is not well known, he passed on to these young artists, and principally to Boucher around 1725, technical brilliance in pen and ink drawing. See Andréa Zanella, "Jean-Baptiste Vanloo 'niceensis,'" in Nice 2000, pp. 27–38. It is highly likely that a drawing now in the École Nationale Supérieure des Beaux-Arts, Paris (*Flagellation*, inv. no. PM2542) can be attributed to Jean-Baptiste's hand.

9. Ibid., p. 35.

10. François Boucher, *Atreus Serving Thyestes the Bodies of His Own Children at a Feast*. Red, brown, and pink chalk with graphite on cream antique laid paper, 358 × 247 mm. Jean Montague Massengale Collection, Harvard Art Museums/Fogg Museum, inv. no. 2010.625.

11. For a comparable drawing, see Dandré-Bardon's *Flight of Medea*, Musée des Beaux-Arts, Nancy, inv. no. 983.

12. At the Sotheby's, New York, sale on 10 January 1995, the drawing was incorrectly attributed in lot 172 to Dandré-Bardon.

13. In addition to the royal collection (curated by Charles Coypel—see Bell essay in this volume), the most well-known example was the renowned collection of the financier Pierre Crozat. See Hattori 2003.

14. François Boucher, *Judgment of Susannah*, c. 1721. Red and black chalk, 240 × 324 mm. National Gallery of Canada, Ottawa, inv. no. 38550. See Sonia Couturier in Ottawa et al. 2004, cat. no. 19, pp. 58–59.

15. This seems all the more plausible given that the site of the bank was very near Boucher's home.

16. Pierre Rosenberg, "The Mysterious Beginnings of the Young Boucher," in New York et al. 1986, p. 54.

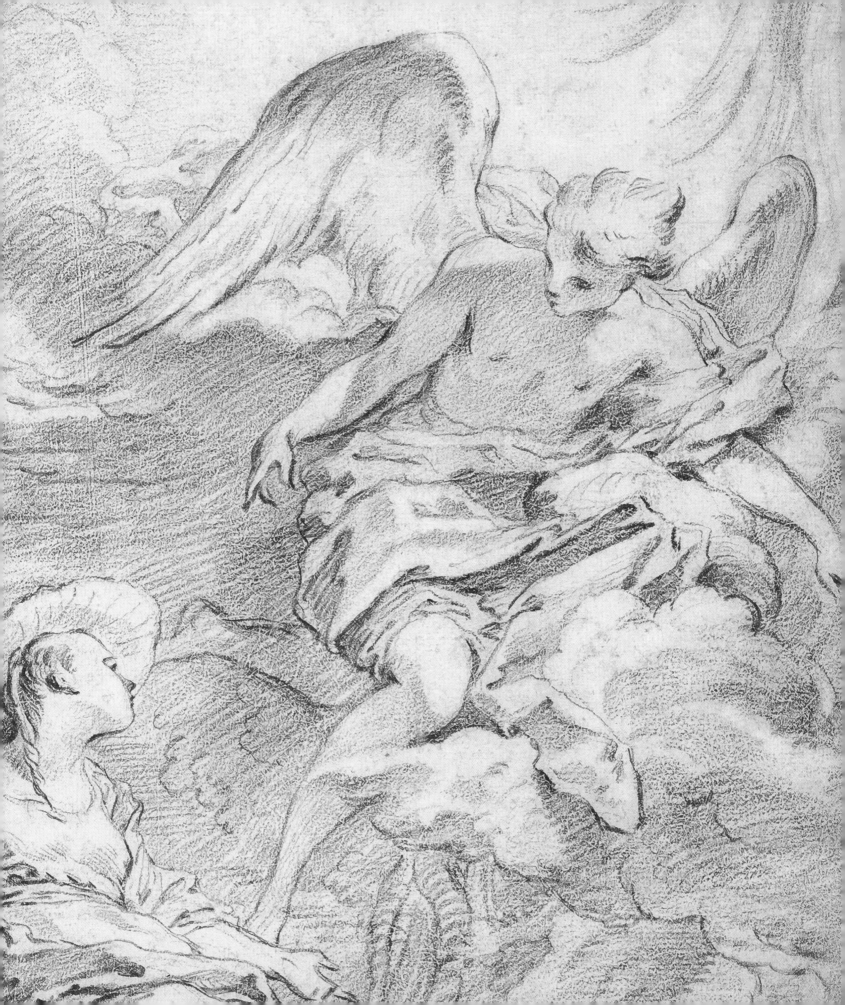

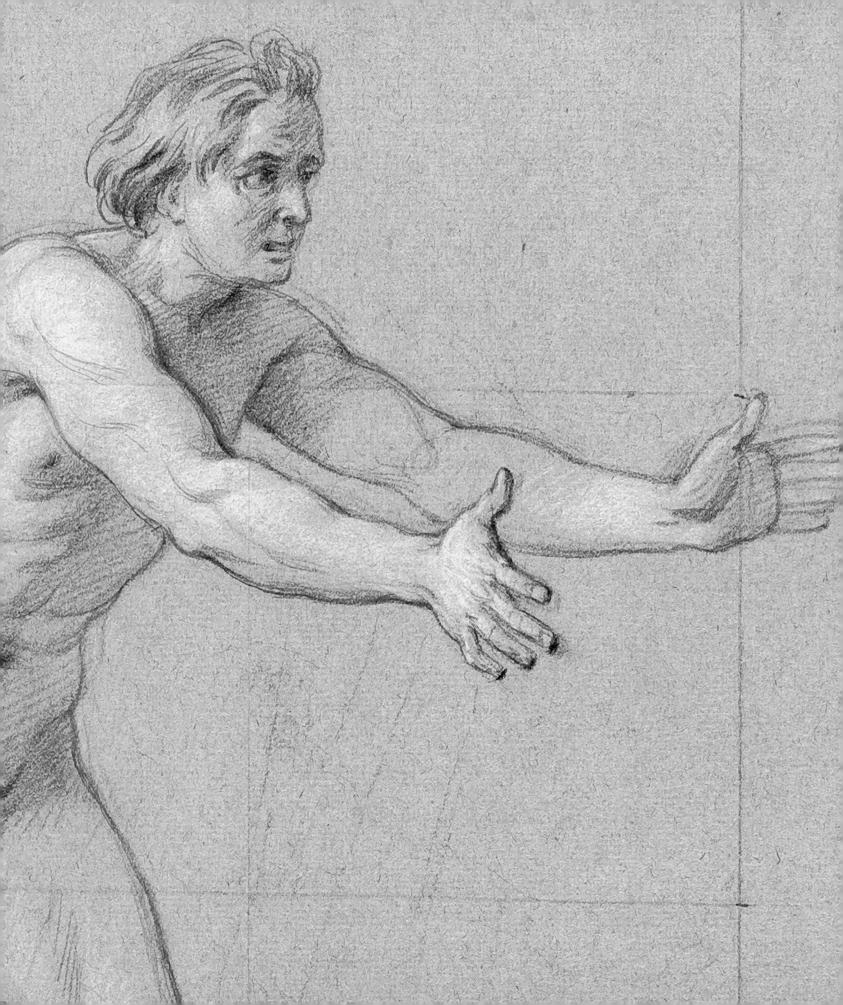

Charles Coypel and the Age of Eclecticism

ESTHER BELL

In almost all of Charles Coypel's known self-portraits, the artist appears with his *porte-crayon* and *portefeuille* rather than his palette and brushes.[1] And judging by the pastel of 1734 in the J. Paul Getty Museum in Los Angeles (fig. 1),[2] he championed his identity as a draftsman and his privileged role as garde des tableaux et dessins du roi. Coypel is pictured with a portfolio of drawings, his left hand grasping the object's edge, his index finger pointing to the curling blue and white papers at the right. His porte-crayon rests precariously at the table's edge, the sharpened chalk having been used for the underdrawing of the canvas in the background. This is a grandiose portrait made for the artist's brother; Coypel is exquisitely dressed in a velvet waistcoat with gossamer lace cuffs. His shoulders are dusted with the powder from his perruque, and we may surmise that he drew those dust-covered shoulders with an implement and chalk similar to what he depicts in the foreground.

Coypel's deliberately theatrical manner was his distinct contribution to eighteenth-century art. The Generation of 1700 accepted and even promoted eclecticism—on matters of style and in the artistic and philosophical approach to one's craft.[3] Coypel's unique mode comprised his theatrical subjects and their "staged" movements, and the Getty pastel reflects this theatricality. With his arm outstretched, palm open, and fingers curling, Coypel posed himself as an actor about to deliver his opening monologue.[4]

In addition to being a history painter, Coypel was a playwright who penned comedies and tragedies for the public and private stage. Although his literary efforts have been largely forgotten, approximately forty of his plays were performed, many to favorable comment, over the course of his life.[5] His dramatic writings shaped his paintings, drawings, and prints, which were distinguished by their references to contemporary performance practice. Unlike Jean-Antoine Watteau, who used drawing as a way of note taking and who sketched figures from life with no particular subject in mind, Coypel posed his models and made drawings after them with thoughtfully choreographed scenes.[6] In fact, the artist's death inventory revealed that he kept several small models of *petits théâtres* in his studio, presumably to aid him in posing individuals and groups of what he refers to as "actors" in ambitious compositions.[7] Drawing for Coypel was as deliberate and measured as his comedies and tragedies, and this essay will explore these very correspondences.

Charles Coypel was a prolific draftsman, perhaps even more than has been previously surmised,[8] and his father, Antoine Coypel (1661–1722), emphasized the value of the study and the practice of drawing. Born into a preeminent family of history painters, Charles benefited from an extreme career advantage because of the dynastic organization of painting, which was paid great credence within the Académie Royale de Peinture et de Sculpture. He was the ultimate insider, a fact that did not go unremarked by his contemporaries. Jean-Baptiste Massé wrote that Coypel was practically raised in the Palais Royale (the regent, Philippe II d'Orléans, and his daughter, the princesse de Conti, were the godparents of Coypel's younger brother, Philippe, who later became ecuyer du roi),[9] while Sécretaire Perpétuel of the Académie Charles-Nicolas Cochin the Younger complained following Coypel's death to the marquis de Marigny, directeur-général des bâtiments du roi, that he believed Coypel took advantage of his family's elite status.[10] This criticism may be the result of several unusual factors: Coypel never took the requisite trip to Italy—the training ground of most young academicians—yet he had the rare distinction of being *agréé*

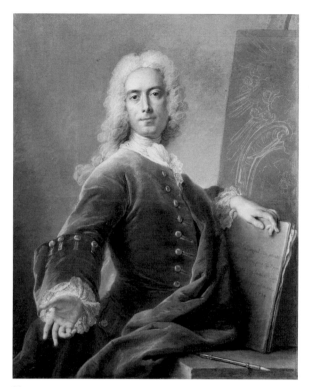

Figure 1

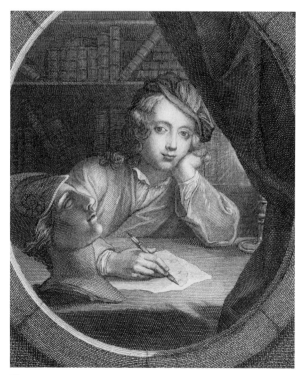

Figure 2

and *réçu* on the same day;[11] he lived in the Louvre from the age of three and inherited one of its largest studios when his contemporaries were still pursuing apprenticeships; and, following in the footsteps of his father and his grandfather, Noël (1628–1707), Charles ascended to the posts of premier peintre du roi and director of the Académie. However, it must be said that Coypel fully embraced his responsibilities; and his lifelong dedication to the Académie—especially through his many *Conférences,* reforms, and the controversial establishment of the École Royale des Élèves Protégés—facilitated the successes of others.[12] As the consummate insider with a network of powerful supporters, Coypel was a leader of the Generation of 1700.

During his comparatively privileged training, Coypel was made to understand from an early age the importance of drawing to the overall success of the artistic enterprise. When he was twelve, he was awarded third prize in the drawing competition that took place every three months at the École de l'Académie. In January 1707, after scrutinizing the drawings with care, Surintendant des Batîments du Roi Jules Hardouin-Mansart bestowed the awards "despite age or recommendations."[13] *Le Mercure Galant* reports:

> The young Coypel only 12 years old, being called from his row to receive the prize he had earned, presented himself before the Surintendant, his drawing in hand, and won the general approval of the assembled crowd. The small size of the young man, and the grand manner that one saw blooming in this drawing, surprised Mr. Mansard.[14]

His award at the tender age of twelve was likely, at least in part, Mansart's acknowledgment of the artist's powerful father, but Coypel was a talented draftsman, and the Académie was known to recognize exceptionalism.

Coypel's first self-portrait was produced around 1704, not long before the aforementioned competition.[15] This lost work is recorded in an engraving by Nicolas-Henri Tardieu (fig. 2)[16] that depicts Coypel's long youthful curls spilling out from underneath his toque as he sketches a head of Minerva by candlelight in what is presumably his father's study. This quiet scene reflects the common practice of a young apprentice drawing a plaster cast (*dessiner d'après la bosse*), which was considered a necessary transition from two-dimensional objects to the live model.[17] More importantly, this engraving exposes Coypel's nascent iden-

tity as a draftsman. The scene recalls Jean-Baptiste-Siméon Chardin's comment: "The chalk holder is placed in our hands ... at the age of seven or eight.... After crouching over our portfolios for a long time, we are set in front of the *Hercules* or the *Torso*."[18]

The centrality of drawing was a fundamental precept within the pedagogical structure of the Académie, and Antoine Coypel's *Conférences* reinforced this notion. Three days before his son Charles received the prize from Mansart, Antoine first delivered his *Épître à mon fils*.[19] Charles wrote that because his father could not "take the chalk from the hands of his oldest son," he decided to write a summary of principles addressed to his child.[20] In this *Conférence*, Antoine, who in his youth had been a fierce Rubenist, implored his fellow academicians, and his son, to do away with the rigid conventions espoused by the opposing Rubenists and Poussinists. He now promoted a middle way between design and color, the ancients and the moderns.[21] He also advocated the study of drawings and, above all, the copying of the old masters:

> The *grand goût* [or, manner] for drawing is different than so-called corrections. One can be exact and consistent, and draw in the *petit goût.* Like Lucas [van Leyden], Albrecht Dürer, and many others. One can also draw on a large scale without being strong, as seen in most things by Correggio. This great character of design, which is the genius of the painter, is not easy to determine.... Consider Michelangelo, Leonardo de Vinci, Raphael, and the Carracci: They provide the antidote to Lucas, Albrecht, and Pietro Testa.[22]

The instructions in the *Épître à mon fils* not only reminded the academicians to study and copy old master drawings but also made subtle reference to Antoine's prestigious position as garde des tableaux et dessins du roi.[23] Charles Coypel in turn inherited the post in 1719, and he, like his father, stored the king's collection of more than 8,000 drawings on the third floor of his living quarters at the Louvre.[24]

A rite of passage to this important collection was offered to selected *amateurs*, fellow artists, and special guests. This is clearly documented through an ambitious project in which Coypel and Anne-Claude-Philippe de Pestels de Lévis de Tubières-Grimoard, comte de Caylus and *amateur honoraire* at the Académie, made copies after the finest sheets. Caylus was a noteworthy participant in Coypel's private theater

Figure 3

called the Souper des Quinze Livres, and he, like Coypel, exemplified the intersection between the theater and the arts. Coypel invited Caylus into his drawings domain, and together they selected a group that best exemplified the royal collection.[25] As Caylus noted in his *Discours sur les desseins* of 1732: "Nothing so excites the genius of a Painter, or gives him that inner fire so necessary to composition, as the examination of a fine drawing."[26]

Coypel and Caylus worked alongside each other on a series of etchings after drawings in the royal collection, including the *Study for a Medici Tomb in San Lorenzo* in Paris in the Musée du Louvre, once ascribed to Michelangelo.[27] Etching was the form of printmaking most aligned with that of drawing, for an artist sketched directly onto a copper plate covered with a special ground, thus making the process relatively unmediated.[28] In an etching in the Bibliothèque Nationale de France, Paris (fig. 3),[29] the inscription, *C. Carolus que* C[oypel], links the Italian master to the draftsman Coypel and the etcher Caylus. One wonders if

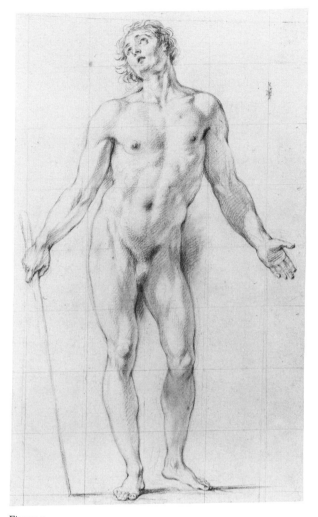

Figure 4

portfolio which is in the bottom of the armoire is a drawing by the Carracci and one by Giulio Romano."[30] Caylus's etchings after drawings in Coypel's private living and work space linked him to the curator/draftsman and also served as a pointed promotion of Coypel's elite position as keeper of the most illustrious drawings in all of France.

As noted above, Coypel's original creations combined his facility with drawing with his theatrical interests. In doing so, he in no way violated the strictures of the Académie, which was never a monolithic institution. From the time of Charles Le Brun, it was possible to bend or even break the rigid system of rules and hierarchy in order to express new ideas, and artists with decidedly different—or eclectic—aesthetic and philosophical values coexisted amicably. Coypel remarked in a letter of c. 1738–40 to his close friend Charles d'Orléans, l'abbé de Rothelin, that several people even tried to dissuade him from his theatrical pursuits because they were "robbing" him from time that should have been spent in the studio. To this, he gave an intellectual and clearly sufficient response:

> I only worked on my comedies during the times I allotted myself for leisure or paying visits, and I spoke the truth. I added that it appeared to me that the study of the interior of mankind was suitable for someone who desired to paint their exterior with finesse.[31]

Coypel's distinct style also represented a new aesthetic that appealed to the developing taste of the Parisian public. Such taste was partially rooted in public theater, which during Coypel's lifetime began to move away from traditional heroic, mythological, and historical themes toward an emphasis on the lighthearted pleasures of comedy. The manner in which he conceived his compositions was informed by both performance practice and the act of participating in a theatrical audience, and the subjects of his works were often direct allusions to comedies, dramas, ballets, and operas, if not explorations of meta-representation, artificiality, and spectatorship. The theater was not off-limits for eighteenth-century academicians, as demonstrated by Coypel's predecessors Claude Gillot and Jean-Antoine Watteau. However, no other artist of this generation so consistently evoked the theatrical experience regardless of subject. This distinction points to Coypel's form of "eclecticism" in that he uniquely borrowed from the stage in order

they also discussed the attributions or the aesthetic merits of the royal masterpieces during these printmaking sessions. At the exact moment of this project, Coypel was attempting to reorganize the drawings into various schools, and then, within each school, to divide the drawings by project or commission. It seems that questions of attribution certainly did arise, as evidenced by one of the many inscriptions Coypel added to a manuscript now in Paris in the Fondation Custodia that described his inventory of the collection: "The King's drawings . . . and the copies [after them] were jumbled in old portfolios and unfortunately the number of copies is, without comparison, more considerable than those that are original." He continues: "Located in this

to engage his viewers. He was also eclectic in the narrower sense as promulgated by Diderot in the *Encyclopédie*—a questioning thinker "who tramples underfoot prejudices, tradition,… universal assent, authority, in a word, everything that captivates the mass of minds, who dares to think for himself."[32] Charles Coypel's brand of eclecticism evidenced his own experience as both academician and playwright, thereby demonstrating his participation in and enrichment of the greater Enlightenment.

Coypel recognized an international currency in the visual possibilities of the theater, and this currency provided him with a central talking point in his many Conférences. He repeatedly invoked the metaphor of the stage when instructing his students how to present effective narratives.[33] In *Standing Male Nude with Outstretched Arms* (cat. no. 32a) and *Four Young Ladies* (cat. no. 32b), both studies for *Hercules Brings Alcestis Back from the Underworld to Her Husband, Admetus* (a modello for the Dresden Tapestries of 1750), Coypel staged his models as actors.[34] He concentrated, foremost, on their expressive movement and squared the sheets for transfer. Coypel's subject was taken from Jean-Baptiste Lully and Philippe Quinault's *Alceste, ou le triomphe d'Alcide* (1674).[35] The five-act lyrical tragedy was repeatedly revived through the early eighteenth century in Paris, Marseilles, Lyon, Strasbourg, and Brussels, inspiring parodies in Paris at the Théâtre Italien and the foire Saint-Germain.[36] Coypel even penned his own three-act tragedy in verse entitled *Alceste*, which was performed at the Collège Mazarin on 20 August 1739 by students in the annual oratory competition.[37] Another related sheet in the Harvard Art Museums in Cambridge featuring Hercules (fig. 4)[38] is a conflation of the customary nude male figure study, or *académie*, and a study of dramatic expression and gesture. Coypel's interest in expression goes beyond the Le Brunian compendium of the passions, for he does not limit the expression of emotion to the face: He extends it to the positioning of the body and, in multifigure compositions, to the dynamic tension between figures and even elements of the setting.

With the three drawings mentioned just above, as well as a cartoon in the Musée de Grenoble,[39] Coypel answered the accusation of some contemporaries, including his friend and harsh critic Pierre-Jean Mariette, who disparaged his "theatricalized" works, by boldly responding that he *intended*

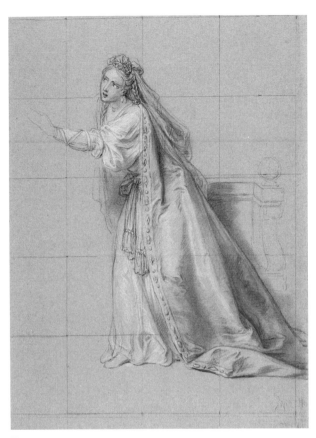

Figure 5

to portray the stage version of the subject.[40] Coypel essentially codified the prevailing theories of the Académie, which had been earlier expounded by de Piles, his father, and the abbé Du Bos, that "expressive movement is the life blood of all painting."[41] Much like the Horvitz figure studies, a preparatory drawing in the J. Paul Getty Museum in Los Angeles (fig. 5)[42] indicates how Coypel positioned a live model in his studio using specific dramatic choreography. The woman with her arms outstretched later appeared in Coypel's *Cleopatra Swallowing the Poison*.[43] That work, also part of the Dresden Tapestries, featured in the final scene of Corneille's five-act tragedy *Rodogune*, in which the characters gather on stage to witness Cleopatra's demise. The theater provided a convincing representation of action, and an artist who could imitate actors performing with full articulation and with an economy of expression could create powerful visual narratives. The drawing is careful and deliberate with its characteristically confident contours. Coypel's lifelong

effort to graft theater to the visual arts was arguably his greatest contribution to eighteenth-century art.

On 6 March 1745, seven years before the artist's death and less than one year before he would be annointed premier peintre and director of the Académie, Coypel asked permission to replace his *morceau de réception, Jason and Medea* (Berlin, Schloss Charlottenburg)[44] with his *Sacrifice of Abraham* (private collection).[45] It was quite unusual to exchange paintings, and in 1748, he also replaced his grandfather Noël's morceau de réception, *God Appearing to Cain after the Death of His Brother, Abel*, with another canvas of the same subject.[46] Unmarried and childless, Coypel was the final artist born into the family dynasty, and his substitutions for these paintings demonstrate his institutional power, and perhaps a moment of introspection, at the twilight of his career. Along with the *Sacrifice of Abraham*, Coypel also offered a *Self-Portrait* that was received with unanimous gratitude and displayed in the Salon of 1746.[47] The drawing in the Horvitz Collection for this late portrait (cat. no. 31) reveals the deliberate articulation of his porte-crayon and drawing board. Despite the charm of his dimpled chin and his piercing, dark eyes, the artist's face is noticeably worn by middle age. But most importantly, in the only self-portrait he would leave to the institution to which he had devoted his entire life, Coypel depicted himself as a draftsman.

The author wishes to thank Alvin L. Clark, Jr., and Elizabeth Rudy for their comments and Anne Buening, Jennifer Hardin, and Galina Lewandowicz for their research assistance in the preparation of this essay.

NOTES

1. Lefrançois 1994, pp. 135–40.

2. Charles Coypel, *Self-Portrait*, 1734. Pastel, 98 × 80 cm. Los Angeles, J. Paul Getty Museum, inv. no. 97.PC.19.

3. This can be seen in Meissonnier's pulsating rocaille forms (cat. no. 49), Portail's painstakingly delicate depictions of his absorbed sitters (cat. nos. 67 and 68), and Boucher's strident strokes of the pen or chalk in the grandest of manners (cat. nos. 13 and 21).

4. See Riccoboni 1728 for Coypel's illustration of Mezzetin (a treatise that details contemporary performance practice).

5. Esther Bell in Nantes 2011, pp. 54–67.

6. Colin Bailey in New York and Ottawa 1999, p. 70.

7. "Item quatre montant la decoration en petit Theatre prisés la somme douze livres." Paris, Archives Nationales de France, Minutier Centrale, ET/76/337. Charles Coypel writes: "J'ay fait mes efforts pour distribuer ma Scene par grandes parties, de façon que l'on pût démêler d'abord les differentes passions qui agitent mes Acteurs." Coypel 1729, p. 1293.

8. Several auctions during the last decade have included recently discovered caches of Coypel drawings. Most recently, sixteen drawings appeared at a sale in Rouen [Normandy Auction, Hôtel de Bourgtheroulde (Fremaux-Lejeune)], lots 85–101, 9 December 2012.

9. Massé 1752.

10. "Il est vray que M. Coypel abusait un peu à mon égard du crédit de sa famille." Furcy-Raynaud 1903, p. 134.

11. Joining the Académie was a two-stage process. After being approved by their seniors by submitting a sample of their work, they became agréé. At that point, they presented a morceau de réception on a given subject within a predetermined period of time, customarily one year. It was rare to be agréé and réçu on the same day, although there are several notable examples, such as Chardin.

12. On Coypel and his reforms at the Académie and his instrumental role in the establishment of the École Royale des Élèves Protégés, see Courajod 1874.

13. On Jules Hardouin-Mansart and the Académie, see Lichtenstein and Michel 2009.

14. "Le jeune Coypel agé seulement de 12. ans, etant appellé dans son rang pour recevoir le Prix qu'il avoit merité, se presenta devant Mr le Surintendant, son Dessein à la main, & chargé de tous les suffrages de l'Academie. La petite taille du jeune homme, & la grande maniere qu'on voyoit éclore dans ce Dessein surprirent Mr Mansard." In fact, Charles Coypel received third prize for the third quarter of October 1705, although Mansart's ceremony took place later. Anonymous 1707, pp. 383–87.

15. Coypel was to win third prize again in 1707 and received his award on 1 December 1708 from le duc d'Antin, surintendant des bâtiments du roi. Montaiglon 1875, vol. 4, p. 73.

16. Nicolas-Henri Tardieu, after Charles Coypel, *Self-Portrait*, c. 1704. Engraving, 26 × 20.5 cm. Private collection.

17. Princeton 1977, p. 20.

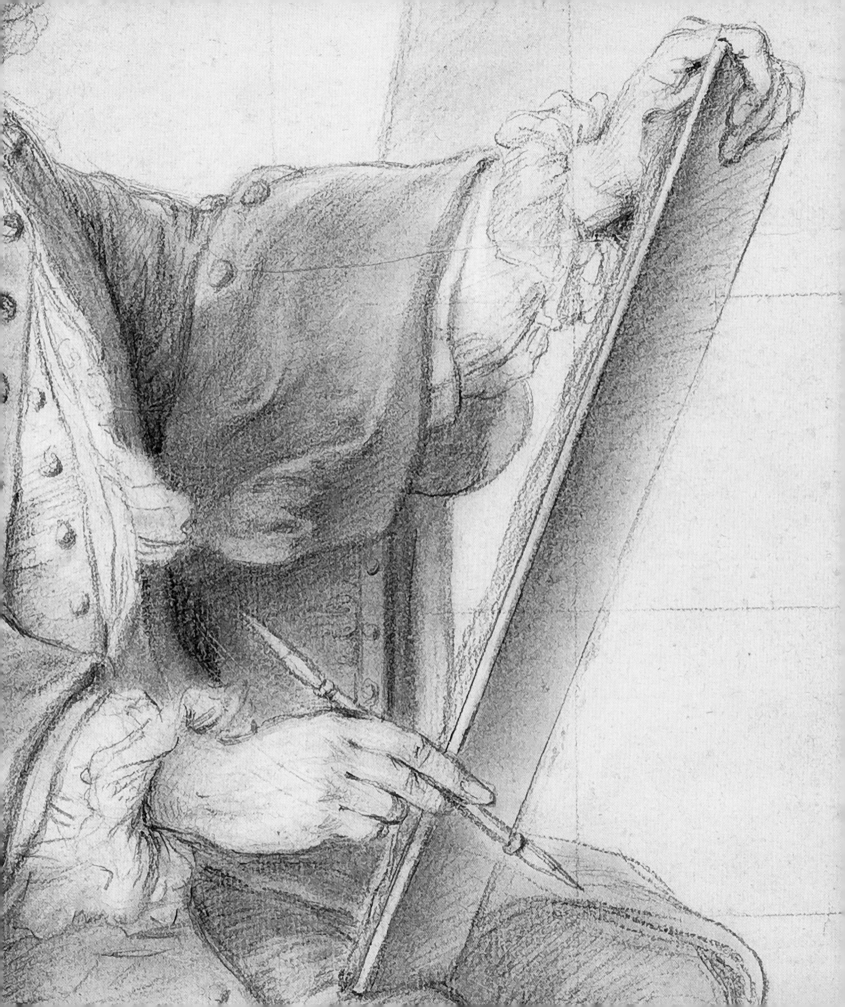

18. Pierre Rosenberg in New York and Ottawa 1999, p. 51.

19. The *Épître* was repeated no fewer than twelve times through 1719. On *Épître à mon fils* and "idéologie Coypellienne," see Henry 2002.

20. Lépicié 1752, p. 22.

21. Garnier 1989, p. 67.

22. "Le grand goût du dessin est différent de ce qu'on appelle correction. L'on peut être exact et régulier, et dessiner d'un fort petit goût. Tels sont les Lucas, les Albert Dürer, et beaucoup d'autres. L'on peut aussi dessiner d'un grand goût sans être fort correct, comme on le voit dans la plupart des choses du Corrège. Ce grand caractère du dessin, qui est dans le génie du peintre, n'est pas aisé à déterminer.... Consultez Michel-Ange, Léonard de Vinci, Raphaël et les Carrache, il portent le contre-poison des Lucas, des Albert et des Piètre-tête." Mérot 2003, p. 457.

23. This position was first filled by Charles Le Brun in 1664, then René-Antoine Houasse in 1690, Gabriel Blanchard in 1699, Houasse again in 1704, and Antoine Coypel in 1710.

24. Lefrançois 1994, pp. 91–94.

25. Many of the drawings had been acquired during the great Jabach sale of 1671.

26. "Rien n'excite le génie d'un Peintre et ne lui donne cette chaleur de teste si nécessaire pour la composition, que l'examen d'un beau Dessein." Caylus 1732, p. 320. See also Colin Bailey in New York and Ottawa 1999, pp. 68–92. Roger de Piles also argued the merits of copying the old masters: "Des dessins des grands Maîtres, est très-utile encore pour nous instruire de la maniere dont les plus habiles Peintres ont tourné leurs pensées, dans leurs compositions en géneral, & dans leurs figures en particulier ... les bons Desseins, sont encore très capables d'échauffer notre genier, & de l'exciter à produire quelque chose de semblable.... Il est bon d'en copier." De Piles 1708, pp. 408–9.

27. Attributed to Michelangelo, *Study for a Medici Tomb in San Lorenzo*. Paris, Musée du Louvre, inv. no. 838.

28. Madeleine Viljoen in Philadelphia et al. 2006, pp. 53–73; see Perrin Stein in New York 2013, pp. 3–13.

29. Charles Coypel and Caylus, after a drawing attributed to Michelangelo, *Study for a Medici Tomb in San Lorenzo*. Etching and engraving, 30.5 × 19.8 cm. Paris, Bibliothèque Nationale de France, inv. no. Ed. 98b, in fol., p. 415.

30. "Les desseins du Roi ... et les copies étoient pêle-mêle dans de vieux portefeuilles et malheureusement le nombre des copies est sans nulle comparaison plus considérable que celui des originaux.... Il se trouve dans ce portefeuille qui est dans le bas de l'armoire un dessin du Carrache et un de Jules Romain." Paris, Fondation Custodia, inv. no. 9555. The author wishes to thank Hans Buijs.

31. "Je ne donnois à mes comedies que les momens qu'il me seroit permis d'employer à jouer ou a faire des visites, et je disois vrai. J'ajoutai qu'il me paroissoit que l'étude de l'interieur des hommes etois convenable à quelqu'un qui désoiroit peindre leur exterieur avec finesse." Bell 2010, pp. 369–70.

32. "L'éclectique est un philosophe qui foulant aux piés le préjugé, la tradition, l'ancienneté, le consentement universel, l'autorité, en un mot tout ce qui subjuge la foule des esprits, ose penser de lui-même." "Eclectisme," in Diderot and d'Alembert 1751, vol. 5, p. 270.

33. "Si l'on veut vous representer, par exemple, la mort de Jules Cesar, n'êtes-vous pas à portée de juger, si le Peintre a rendu l'image de cette scene? N'en jugeriez-vous pas au théâtre?" Coypel 1730, p. 81.

34. Thierry Lefrançois in Cambridge et al. 1998, pp. 196–97; a figure study of Hercules from the series (see fig. 4) is in Cambridge, Harvard Art Museums/Fogg Museum.

35. Lefrançois 1994, pp. 366–69.

36. Parfaict 1767, vol. 1, pp. 38–39.

37. Coypel's *Alceste* departed from Euripides' original plot, as well as Lully and Quinault's, by removing all female characters (including the lead character Alceste) as was required by the Collège Mazarin. Therefore, Coypel's tragedy did not include the moment pictured in the modello and the cartoon. Bell 2010, pp. 341–44; Rondel 1914; Jamieson 1930, pp. 139–46; Compère 2000.

38. Charles Coypel, *Hercules*. Black chalk with touches of red chalk on cream antique laid paper, laid down on cream antique laid paper decorated with dark blue antique laid paper borders, 43.4 × 26 cm. Cambridge, Harvard Art Museums/Fogg Museum, Gift of Jeffrey E. Horvitz, inv. no. 1999.21.

39. *Hercules Brings Alceste Out of the Underworld*, 1750. Grenoble, Musée de Grenoble, inv. no. 566; Lefrançois 1994, pp. 367–68.

40. Mariette blasted Coypel's oeuvre, saying it too much resembled the "jeu des meilleurs acteurs, que des grimaces, des attitudes forcés, des traits d'expression arrangés avec art." Mariette 1750, vol. 2, pp. 30–31.

41. Lee 1940, p. 218.

42. Charles Coypel, *Study of a Woman*, c. 1749. Black chalk and white chalk squared in black chalk, 17¼ × 12¹⁵⁄₁₆ in. Los Angeles, J. Paul Getty Museum, inv. no. 97.GB.32.

43. Charles Coypel, *Cleopatra Swallowing the Poison*, 1749. Grenoble, Musée de Grenoble, inv. no. 567.

44. Charles Coypel, *Jason and Medea*, 1715. Berlin, Schloss Charlottenburg, inv. no. GKI 3840. A related preparatory pastel, *Medea*, c. 1715, is in the collection of New York's Metropolitan Museum of Art, inv. no. 1974.25. On Coypel's morceau de réception, see Stein 2001, p. 223.

45. Coypel's *Sacrifice of Abraham* (1746, private collection) was "reçu avec plaisir de la Compagnie." Lefrançois 1994, 337–38; Montaiglon 1875, vol. 6, pp. 5, 37.

46. Lefrançois 1994, p. 119; there are few other documented incidents in which the morceau was switched at a later date. Jean-Jacques Bachelier would also replace his *Death of Abel* (1763) with *Roman Charity* (1764).

47. Charles Coypel, *Self-Portrait*, 1746. Versailles, Musée National du Château, inv. no. MV.5813. Montaiglon 1875, vol. 6, p. 37.

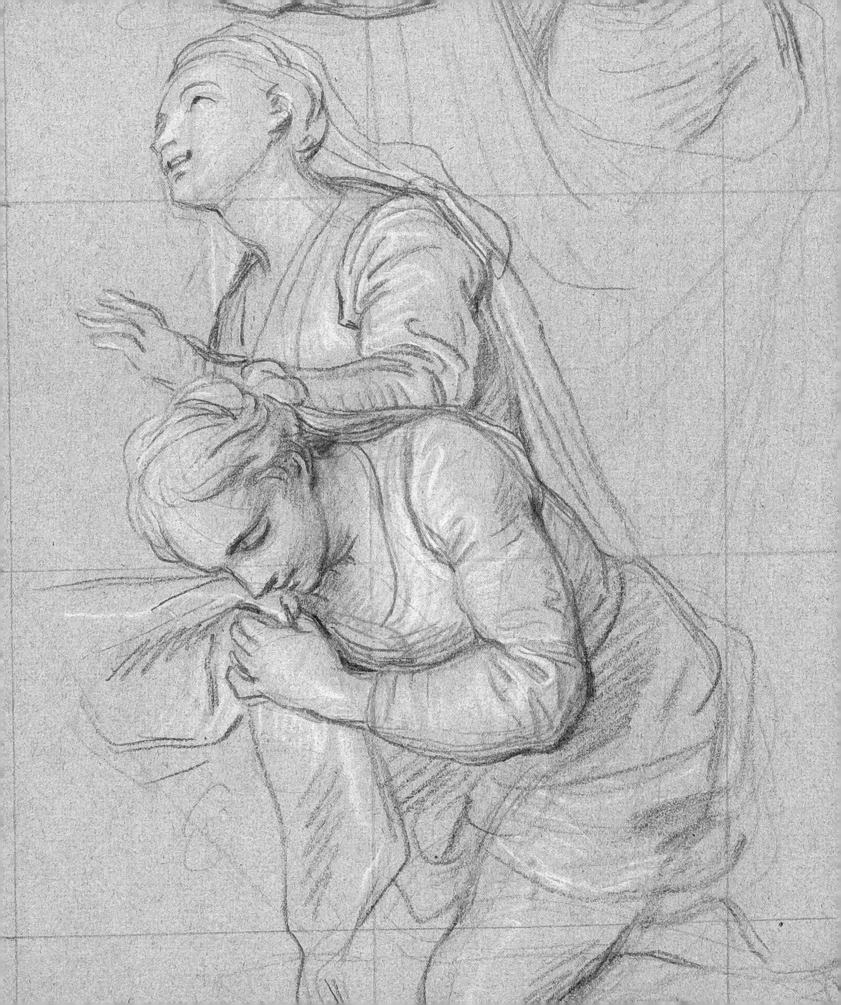

PLATES

NOTE TO READERS: Plates are in rough chronological order, with a few exceptions made to feature visual relationships. Checklist items are arranged alphabetically by artist name.

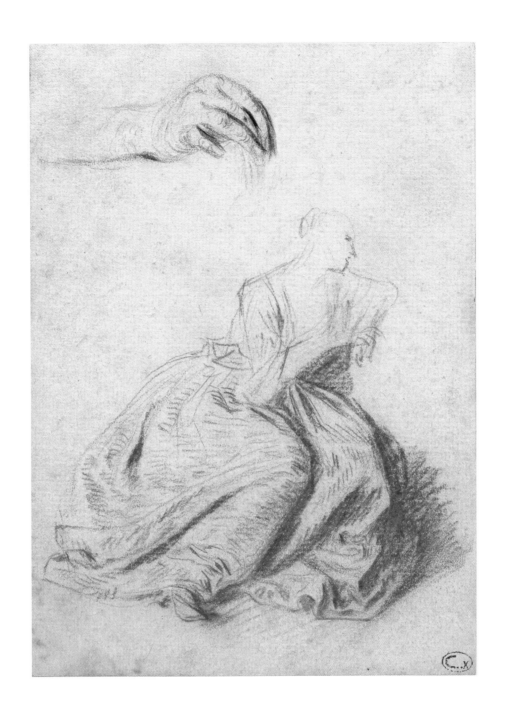

PLATE 1 | *Watteau* (cat. no. 80)

45

PLATE 2 | *Watteau* (cat. no. 79)

PLATE 3 | *Watteau* (cat. no. 78)

PLATE 4 | *Lajoüe* (cat. no. 44)

PLATE 5 | *Oudry* (cat. no. 56)

49

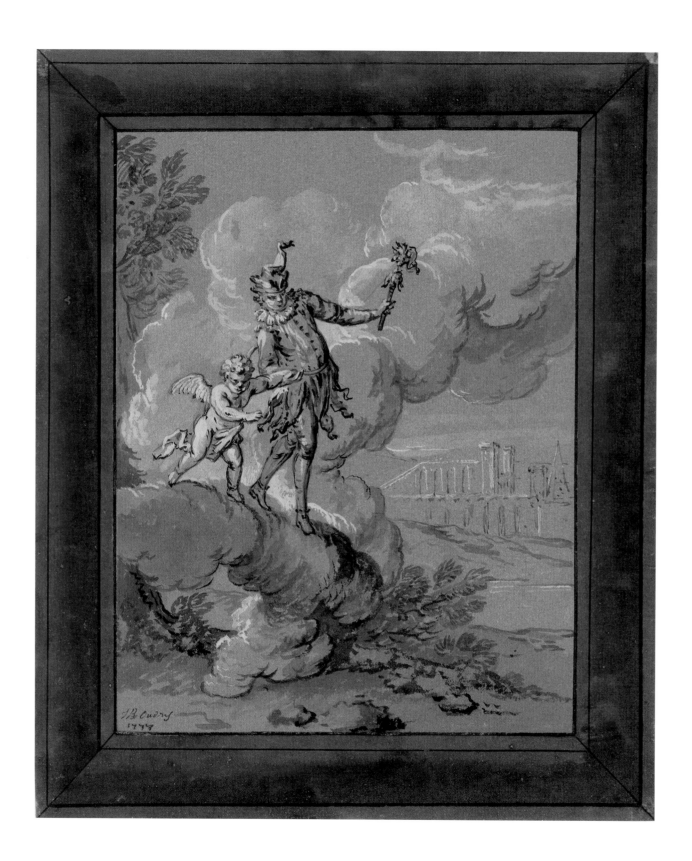

PLATE 6 | *Oudry* (cat. no. 57)

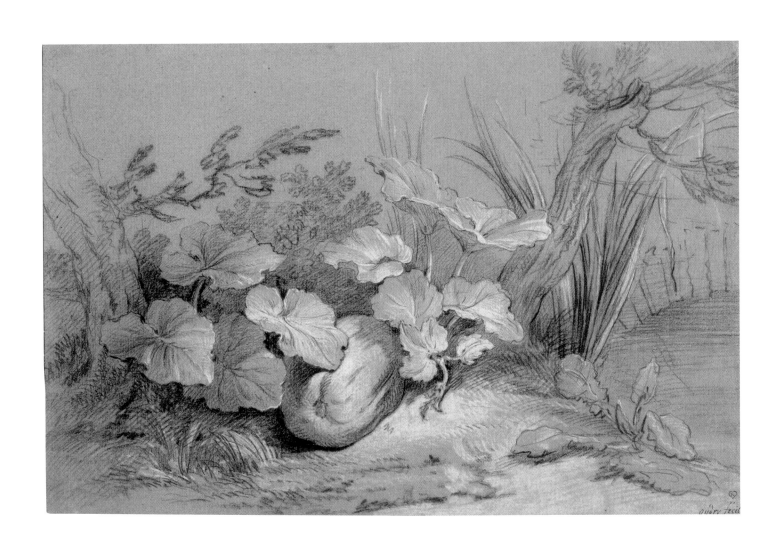

PLATE 7 | *Oudry* (cat. no. 58)

51

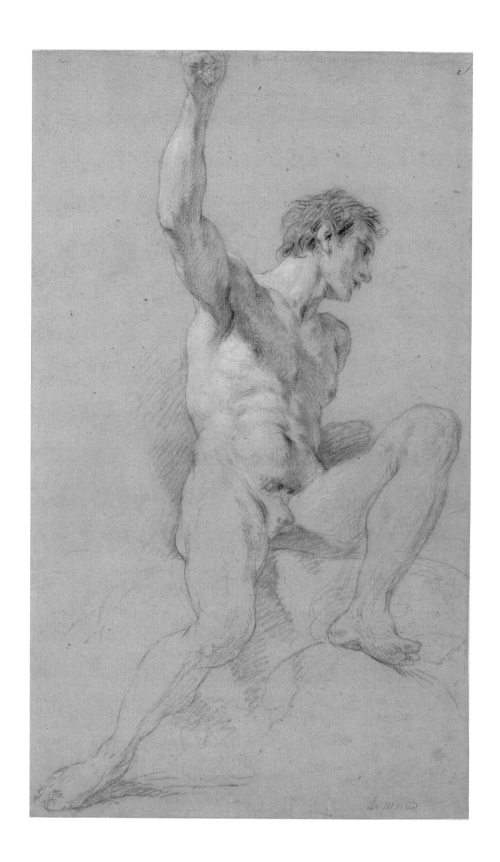

PLATE 8 | *Le Moyne* (cat. no. 48)

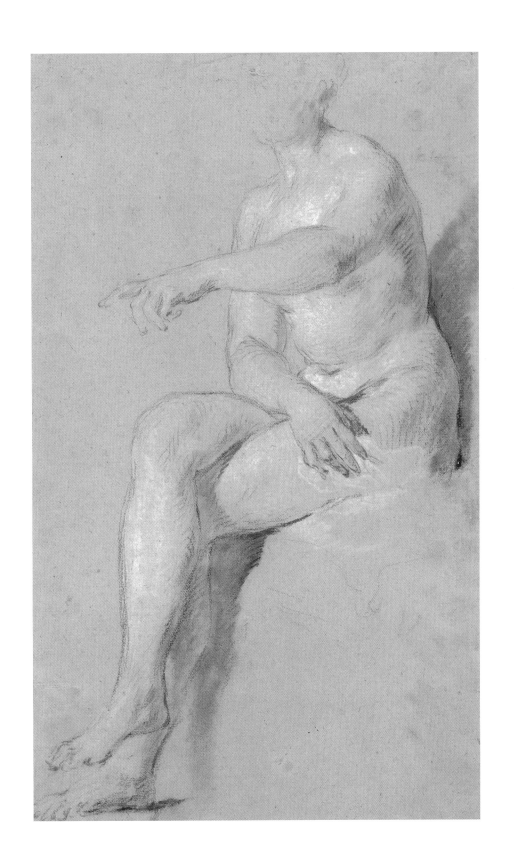

PLATE 9 | *Le Moyne* (cat. no. 47)

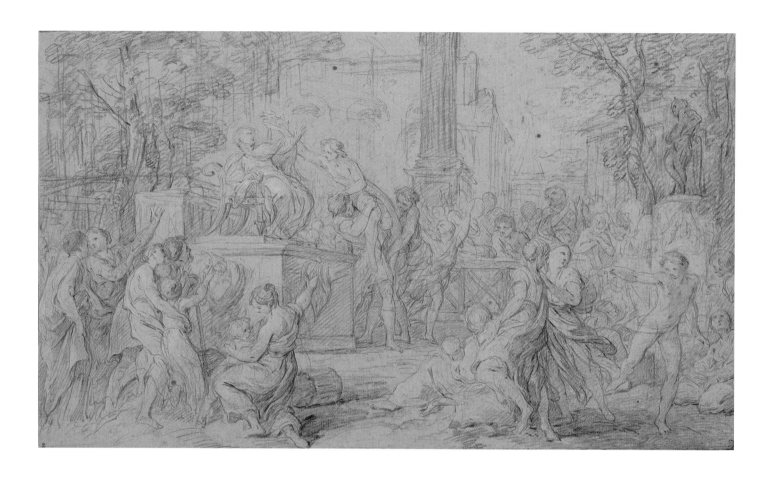

PLATE 10 | *Le Moyne* (cat. no. 46)

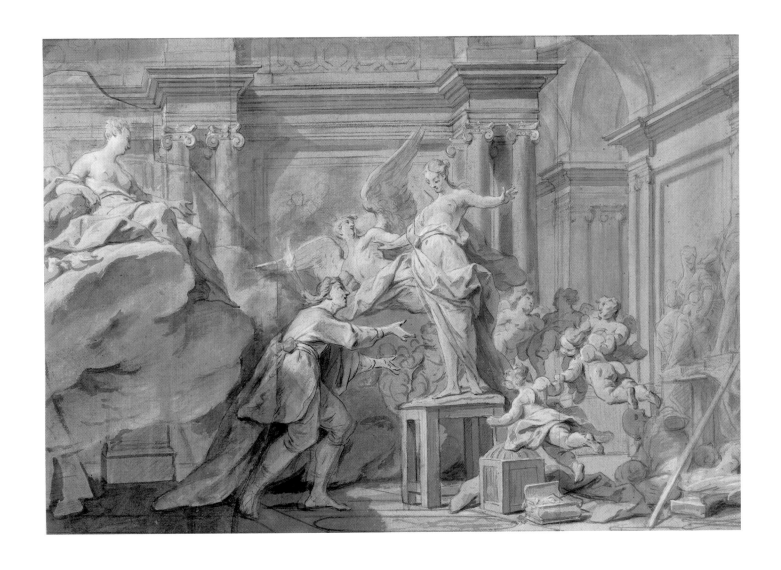

PLATE 11 | *Restout* (cat. no. 69)

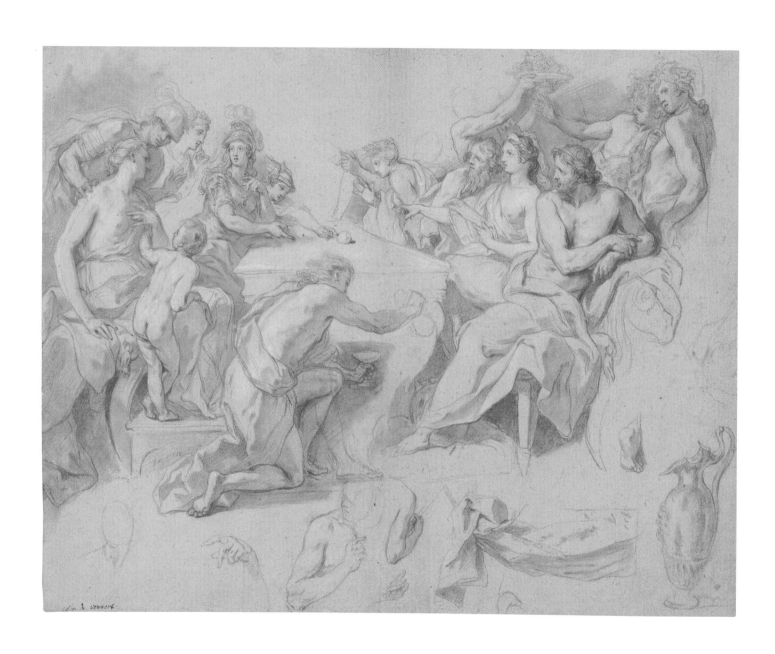

PLATE 12 | *Collin de Vermont* (cat. no. 27)

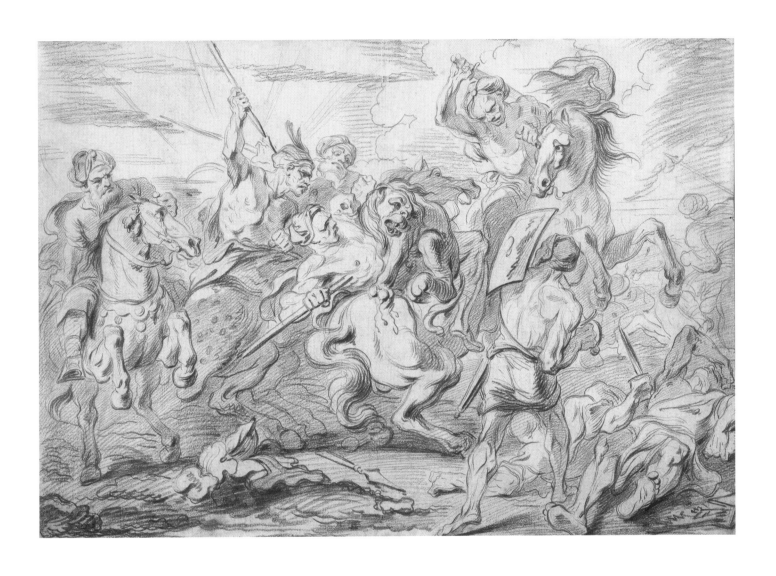

PLATE 13 | *C. Parrocel* (cat. no. 59)

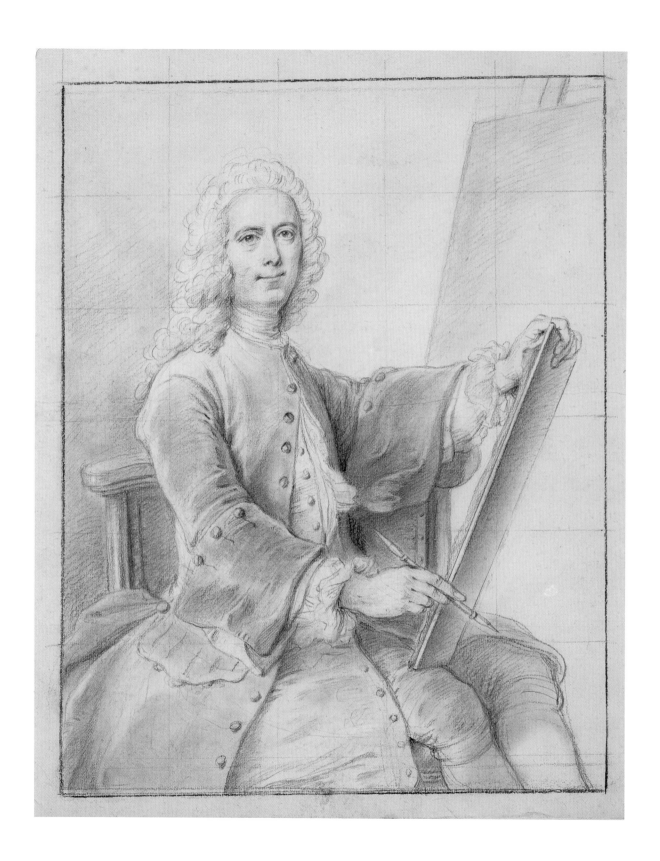

PLATE 14 | *Coypel* (cat. no. 31)

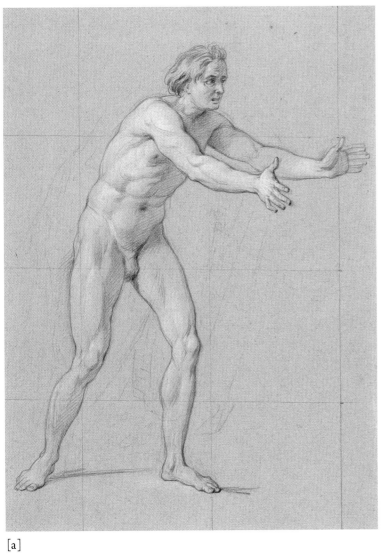

[a]

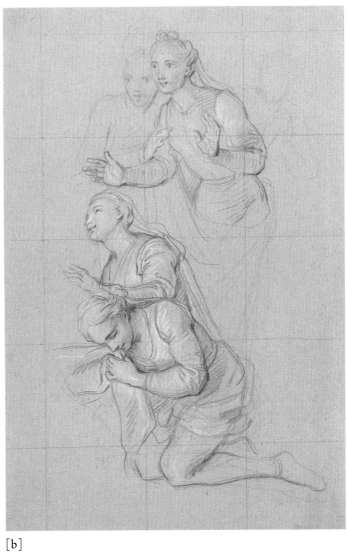

[b]

PLATE 15 | *Coypel* (cat. nos. 32a and b)

59

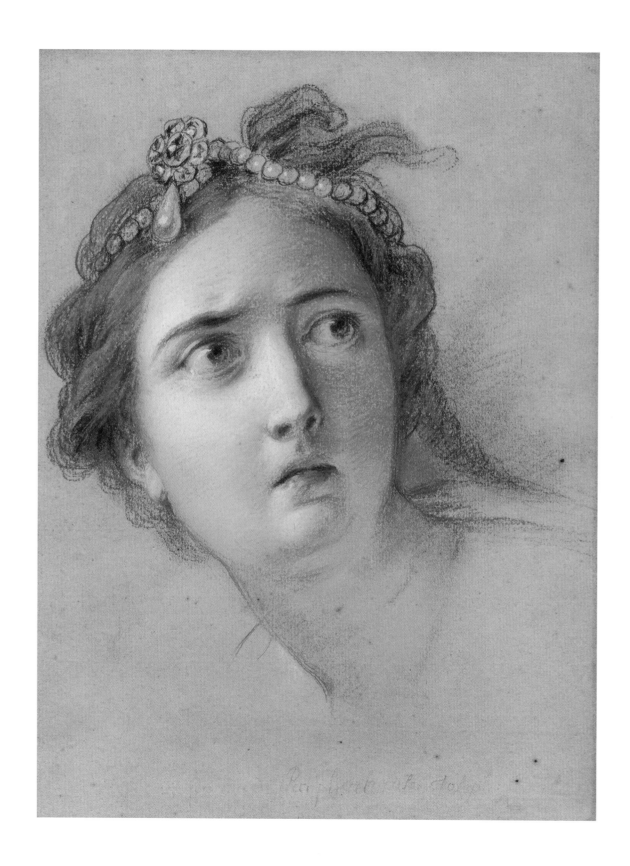

PLATE 16 | *Coypel* (cat. no. 28)

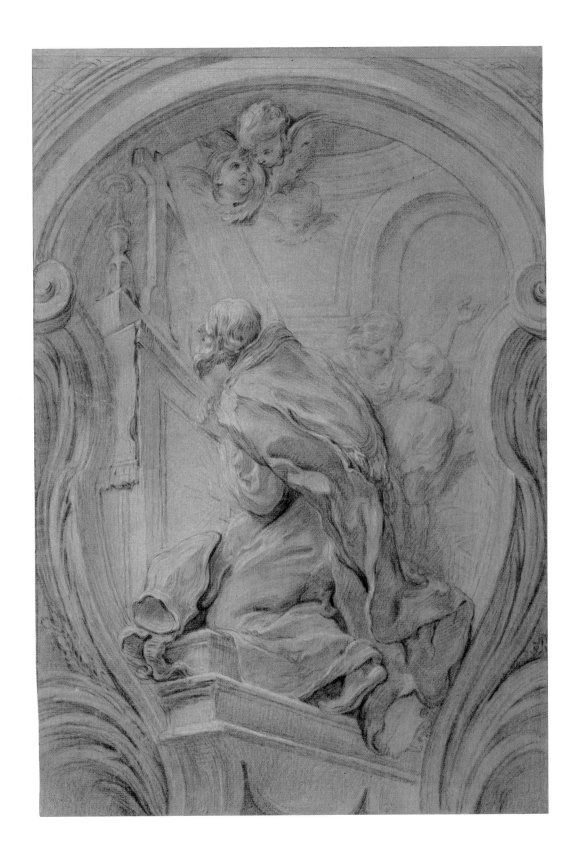

PLATE 17 | *Meissonnier* (cat. no. 49)

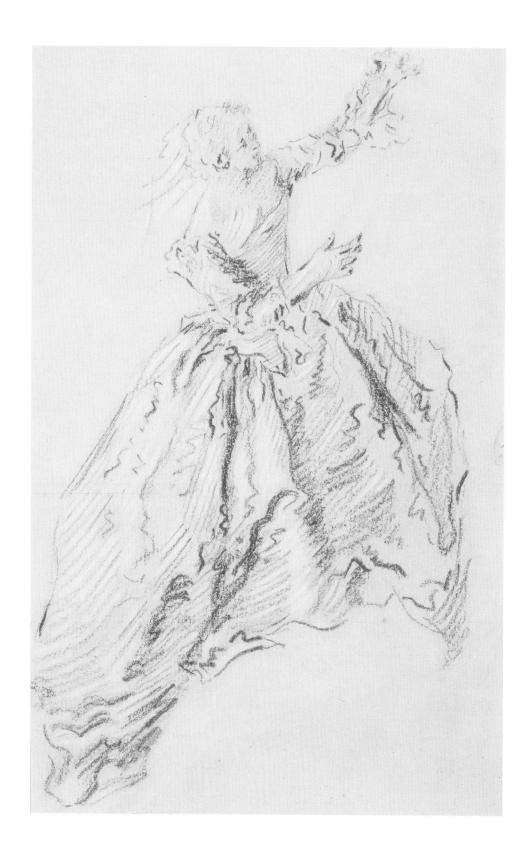

PLATE 18 | *Pater* (cat. no. 64)

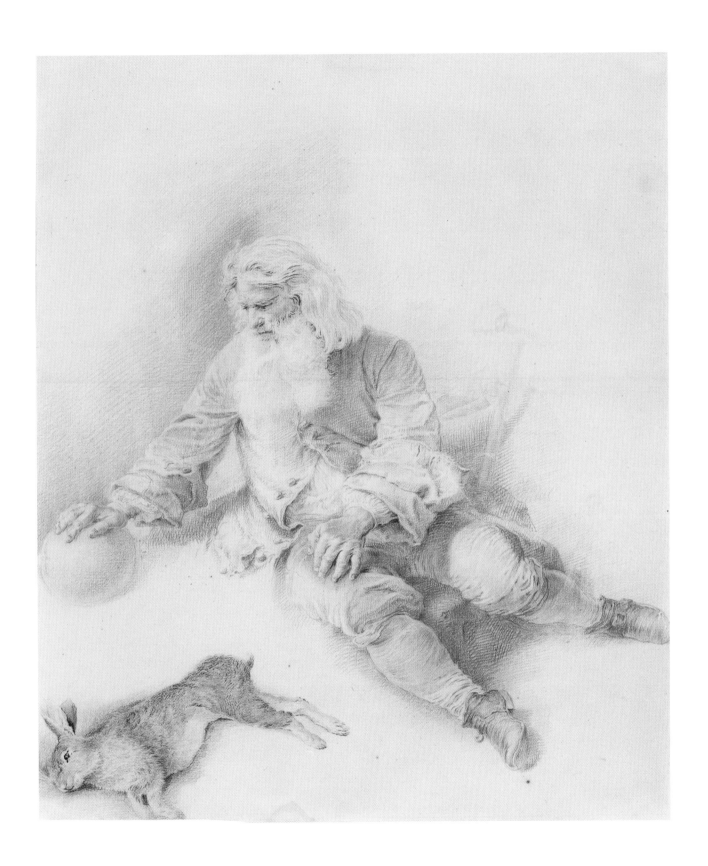

PLATE 19 | *Portail* (cat. no. 67)

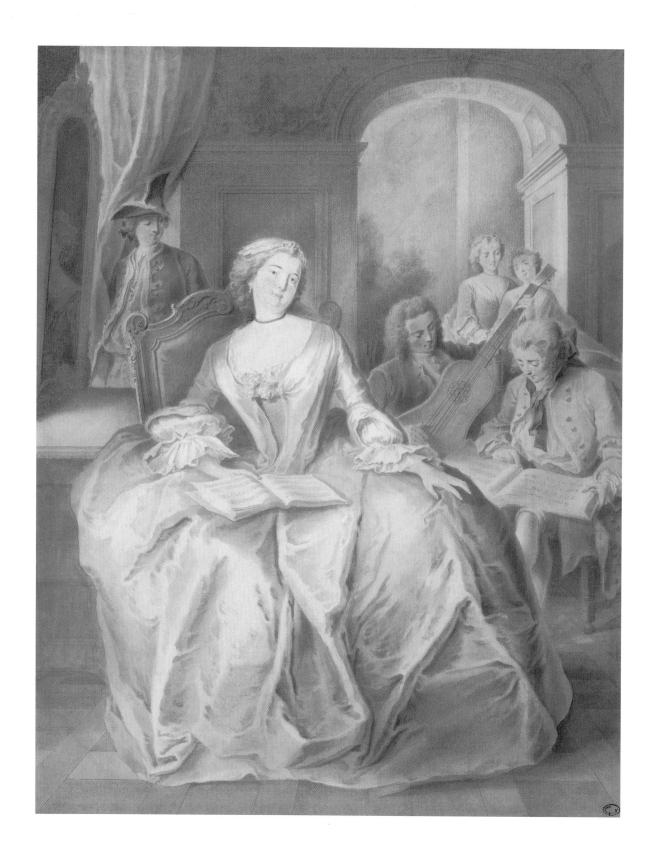

PLATE 20 | *Portail* (cat. no. 66)

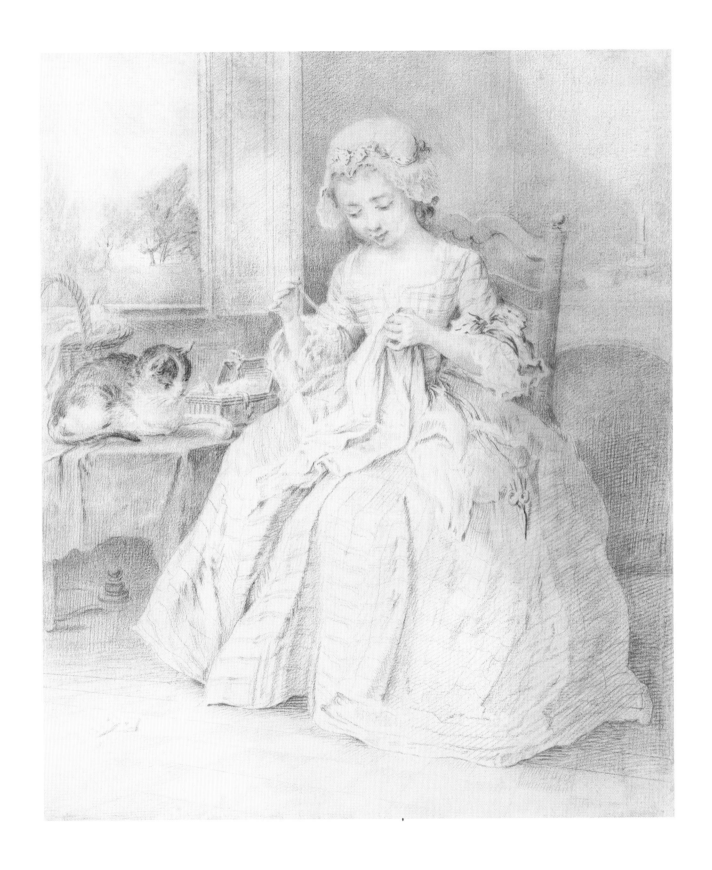

PLATE 21 | *Portail* (cat. no. 68)

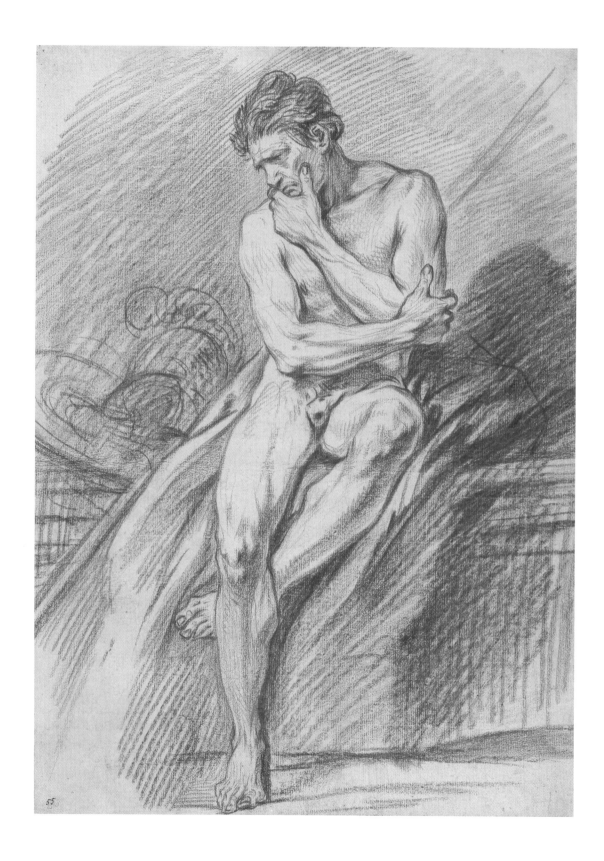

PLATE 22 | *Boucher* (cat. no. 21)

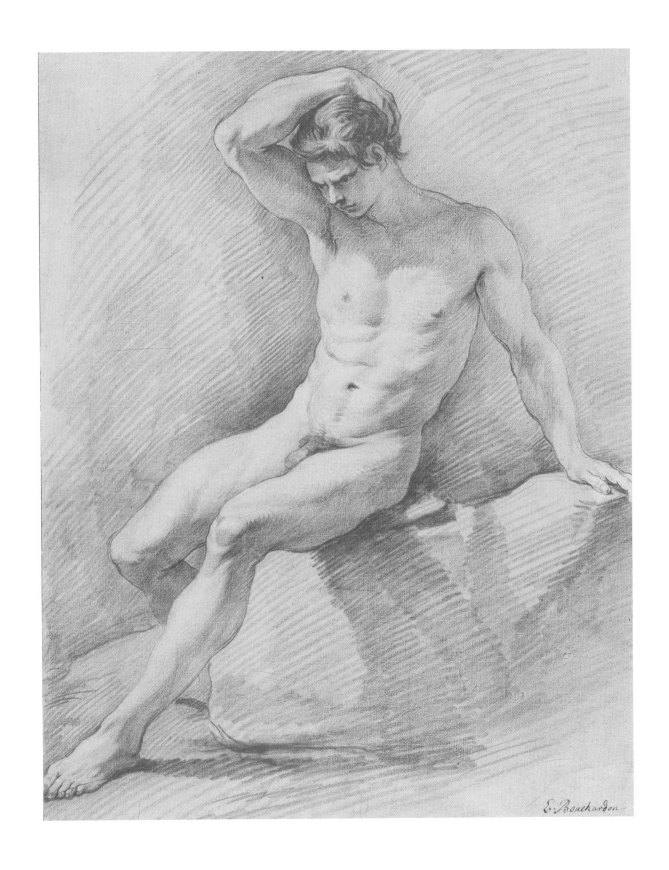

PLATE 23 | *Bouchardon* (cat. no. 5)

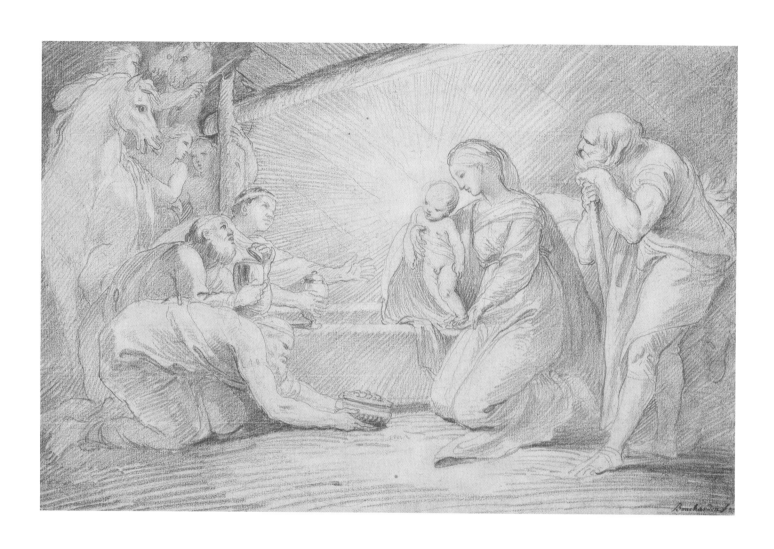

PLATE 24 | *Bouchardon* (cat. no. 2)

PLATE 25 | *Bouchardon* (cat. no. 4)

PLATE 26 | *Bouchardon* (cat. no. 6)

PLATE 27 | *Gravelot* (cat. no. 42)

PLATE 28 | *Subleyras* (cat. no. 71)

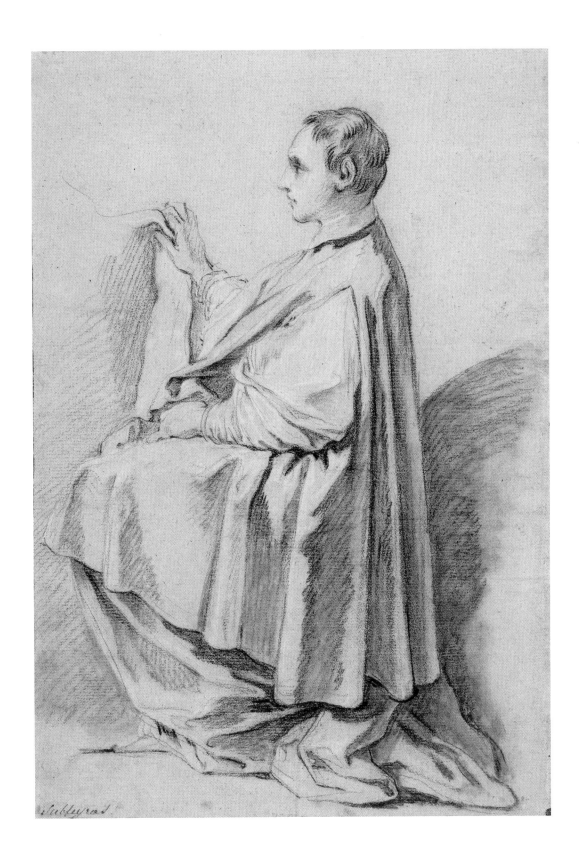

PLATE 29 | *Subleyras* (cat. no. 72)

73

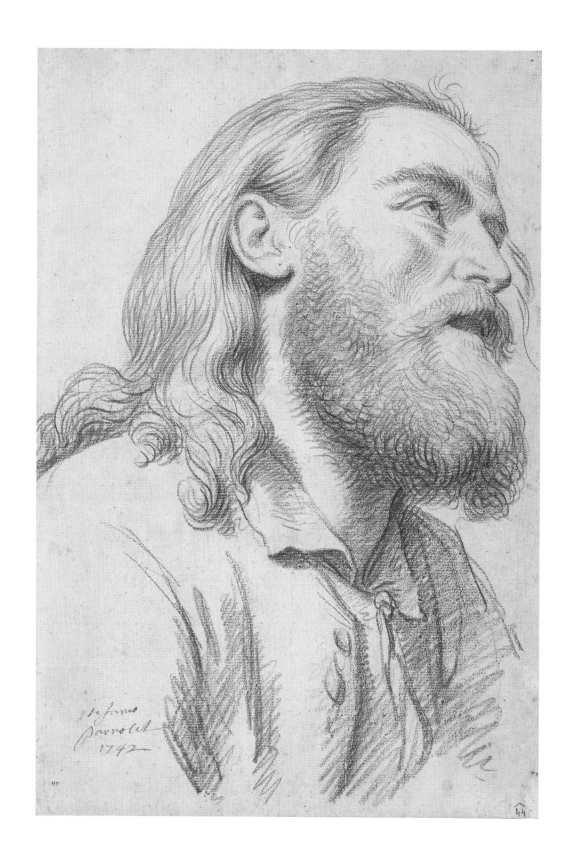

PLATE 30 | *E. Parrocel* (cat. no. 60)

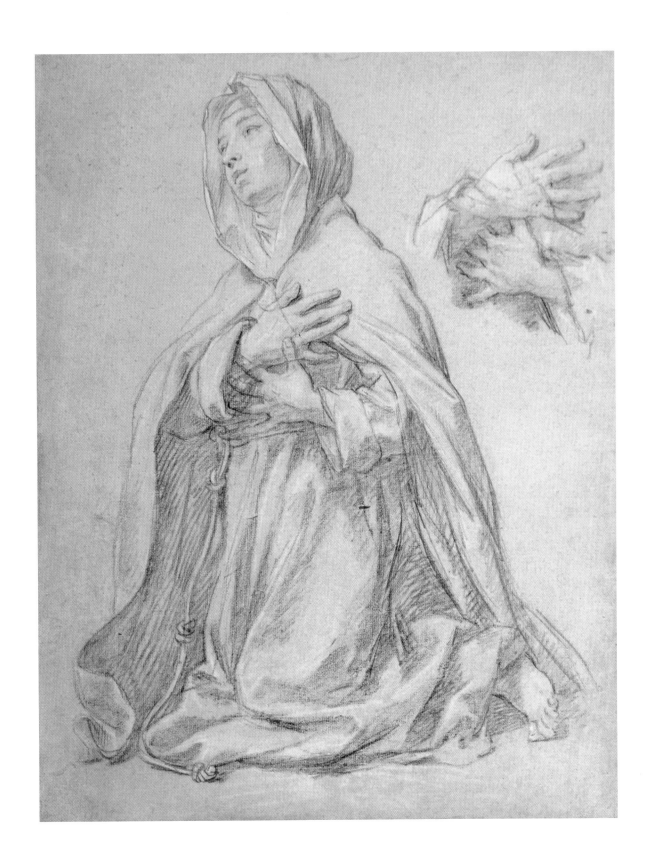

PLATE 31 | *E. Parrocel* (cat. no. 61)

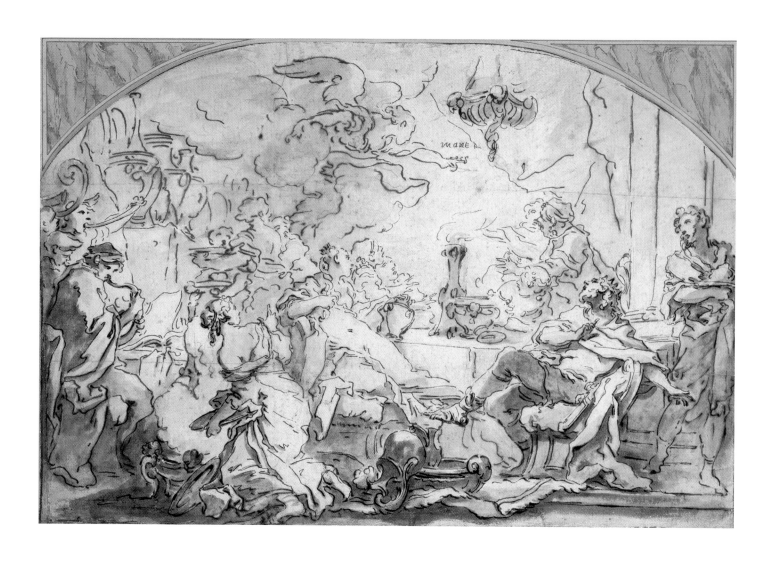

PLATE 32 | *Boucher* (cat. no. 10)

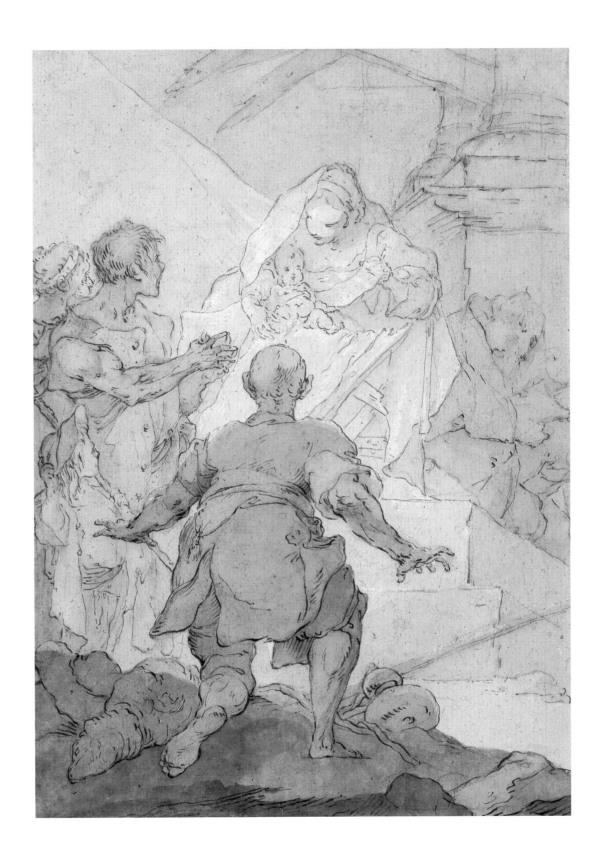

PLATE 33 | *Dandré-Bardon* (cat. no. 33)

77

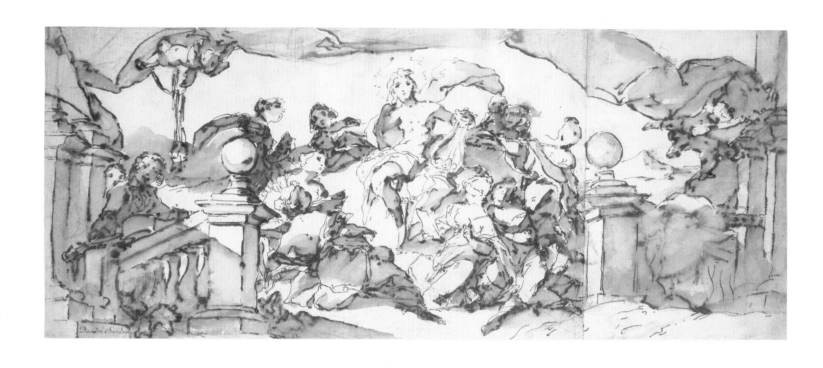

PLATE 34 | *Dandré-Bardon* (cat. no. 36)

PLATE 35 | *Peyrotte* (cat. no. 65)

79

PLATE 36 | *Dandré-Bardon* (cat. no. 35)

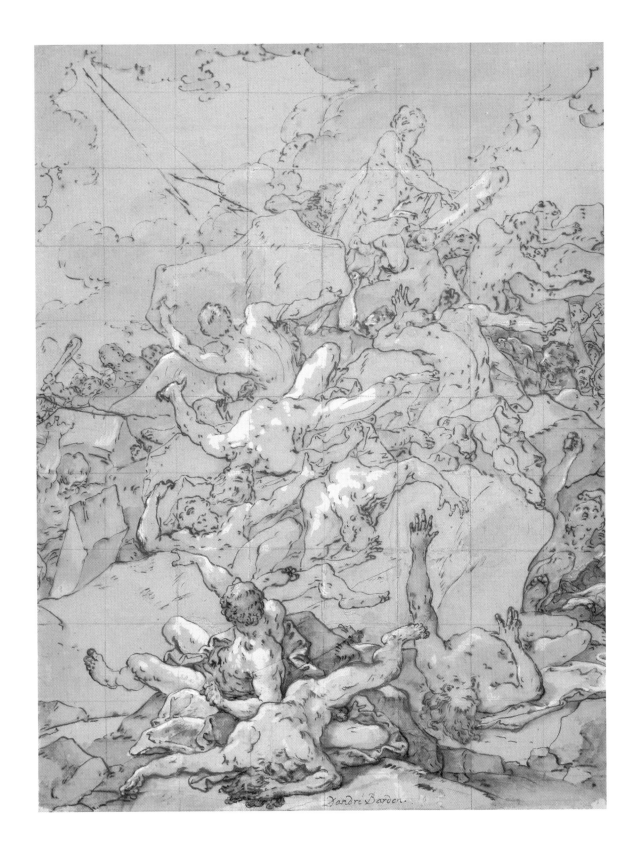

PLATE 37 | *Dandré-Bardon* (cat. no. 34)

81

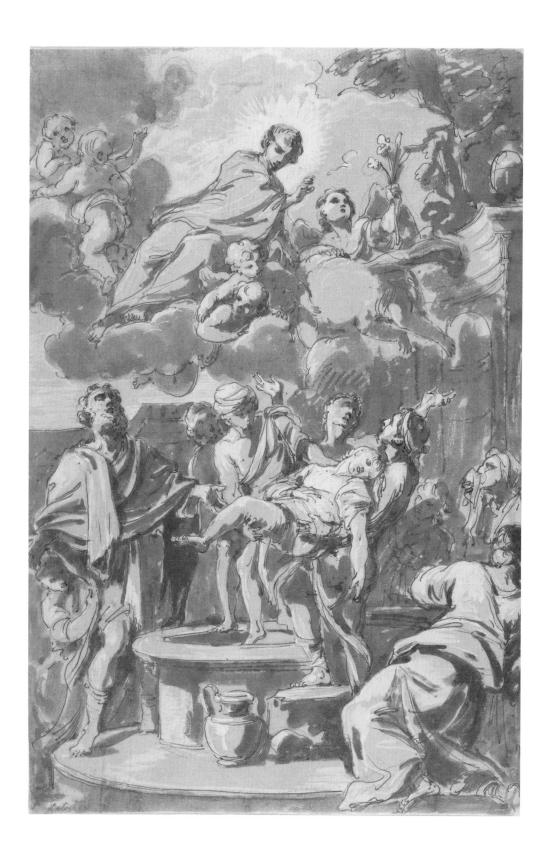

PLATE 38 | *Natoire* (cat. no. 55)

PLATE 39 | *Natoire* (cat. no. 54)

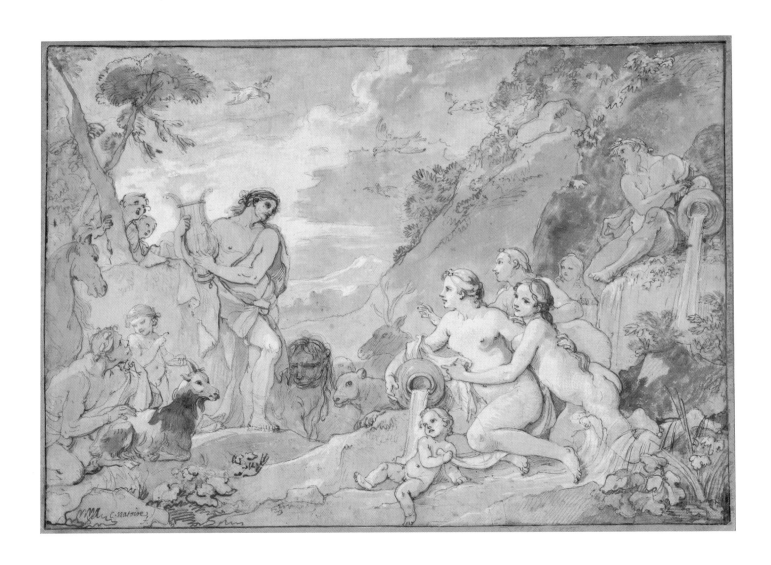

PLATE 40 | *Natoire* (cat. no. 53)

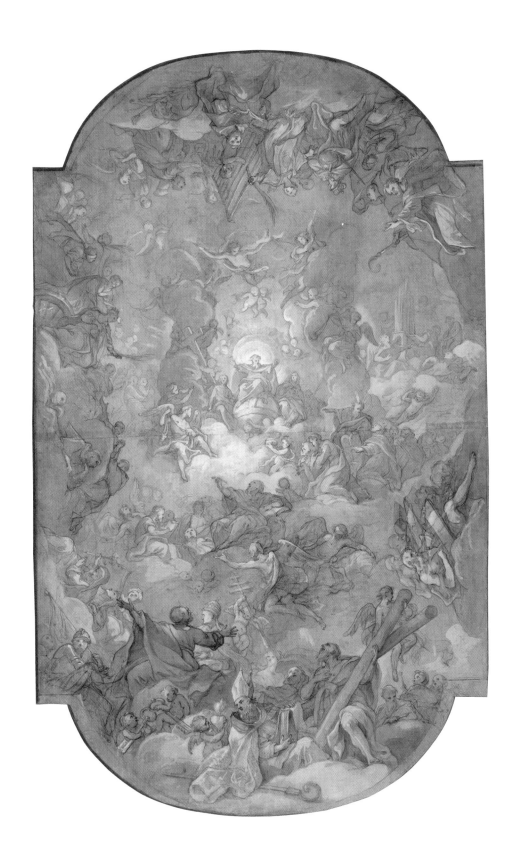

PLATE 41 | *Natoire* (cat. no. 50)

PLATE 42 | *Natoire* (cat. no. 51)

PLATE 43 | *Dumont* (cat. no. 37)

PLATE 44 | *Dumont* (cat. no. 38)

PLATE 45 | *Bouchardon* (cat. no. 3)

89

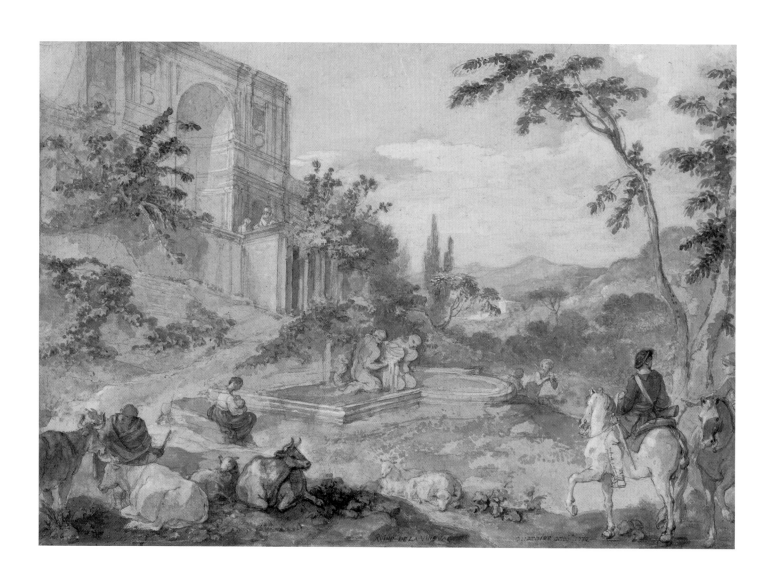

PLATE 46 | *Natoire* (cat. no. 52)

PLATE 47 | *Dumont* (cat. no. 39)

91

PLATE 48 | *Trémolières* (cat. no. 73)

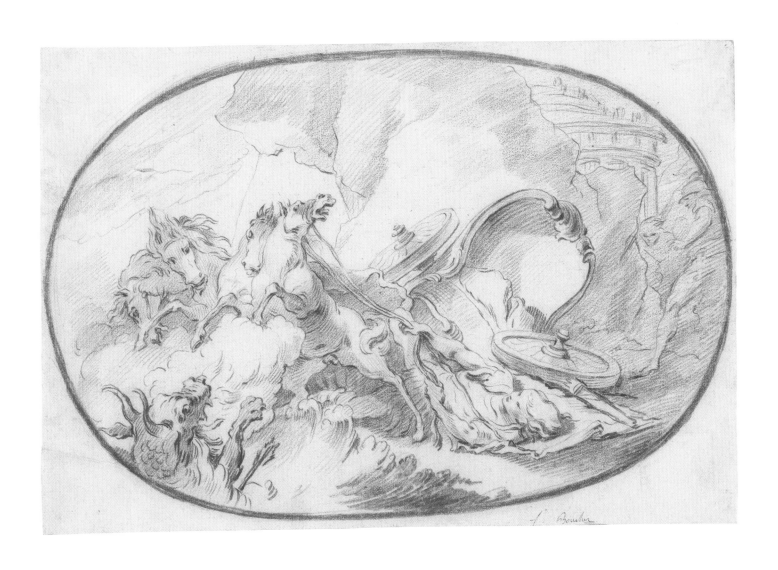

PLATE 49 | *Boucher* (cat. no. 12)

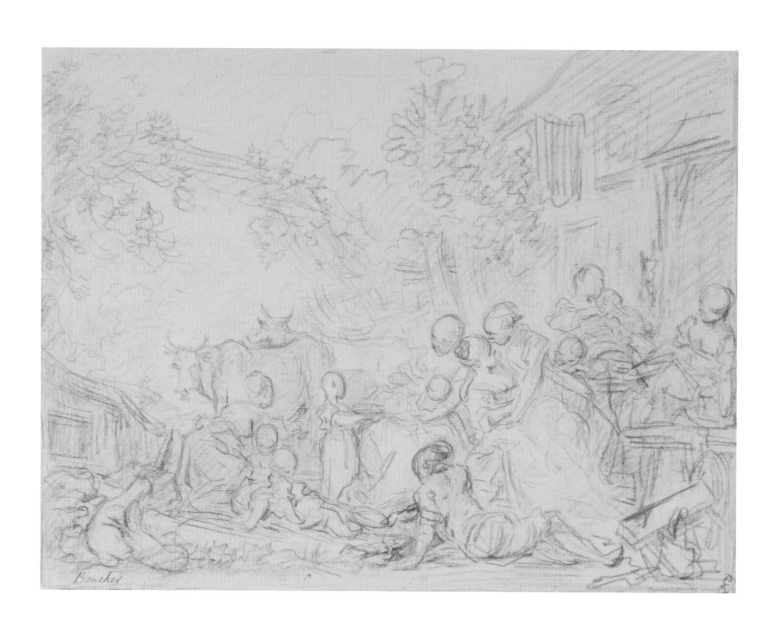

PLATE 50 | *Boucher* (cat. no. 15)

PLATE 51 | *Boucher* (cat. no. 8)

95

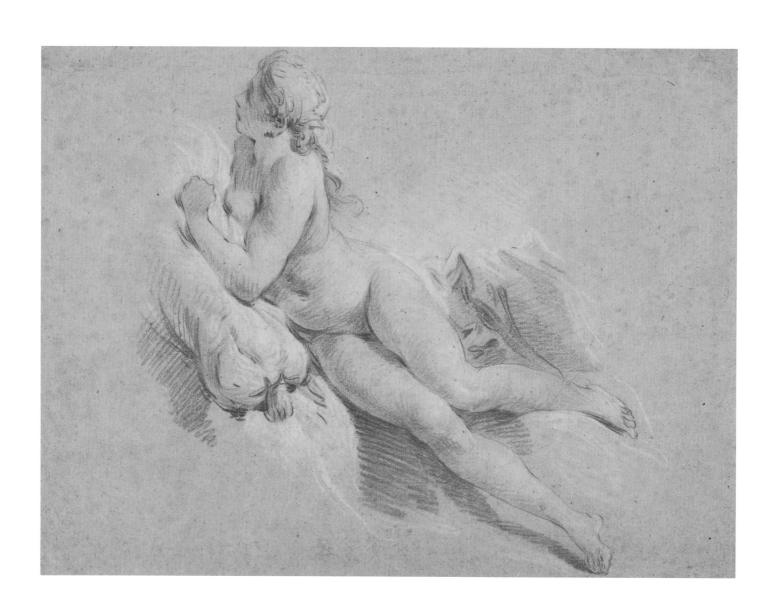

PLATE 52 | *Boucher* (cat. no. 18)

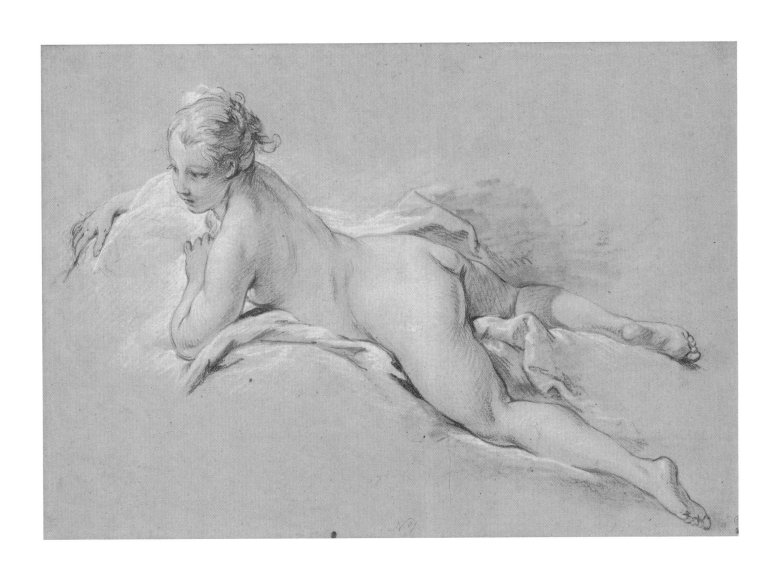

PLATE 53 | *Boucher* (cat. no. 19)

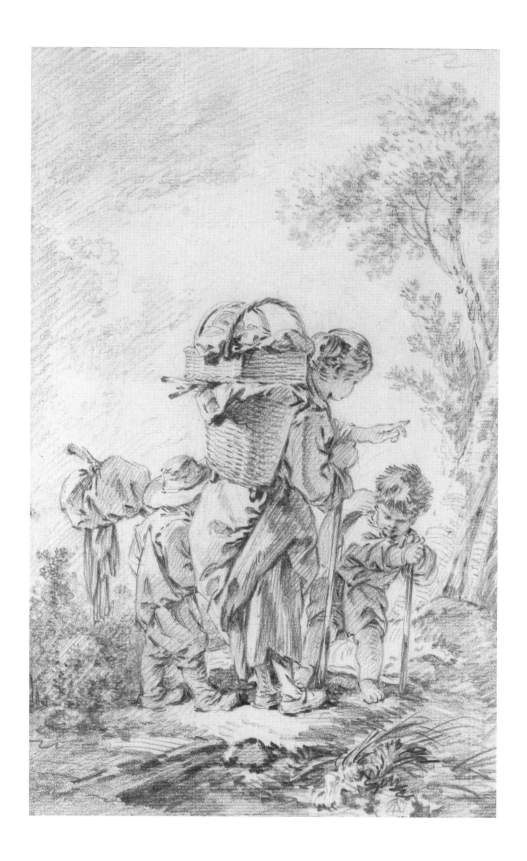

PLATE 54 | *Boucher* (cat. no. 25)

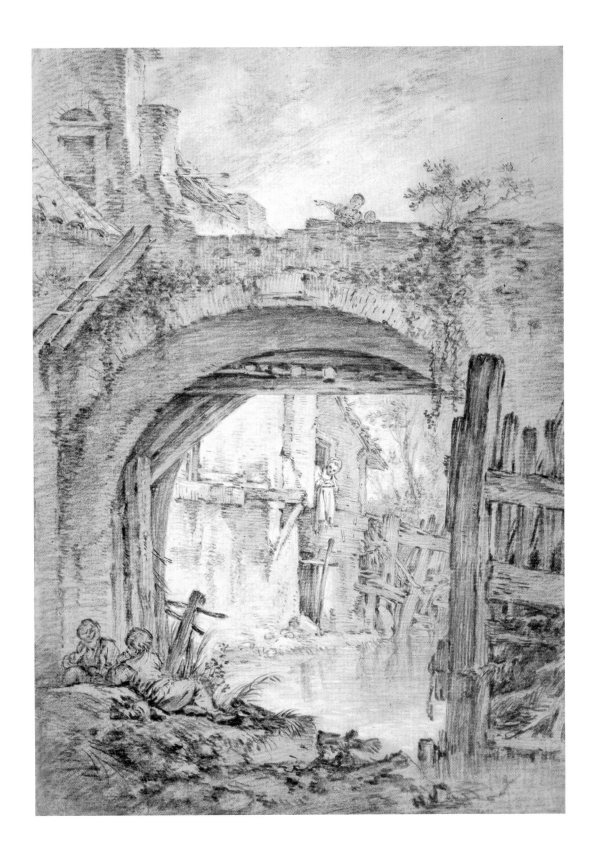

PLATE 55 | *Boucher* (cat. no. 20)

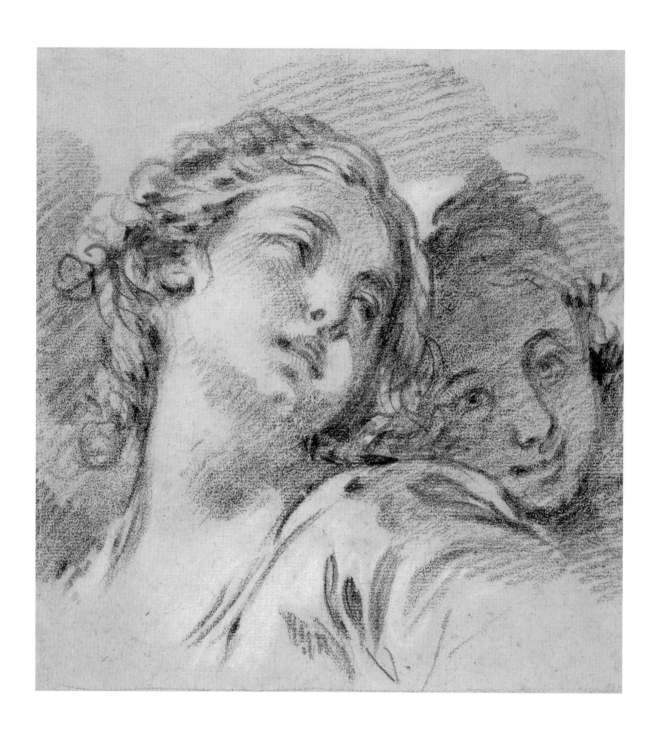

PLATE 56 | *Boucher* (cat. no. 11)

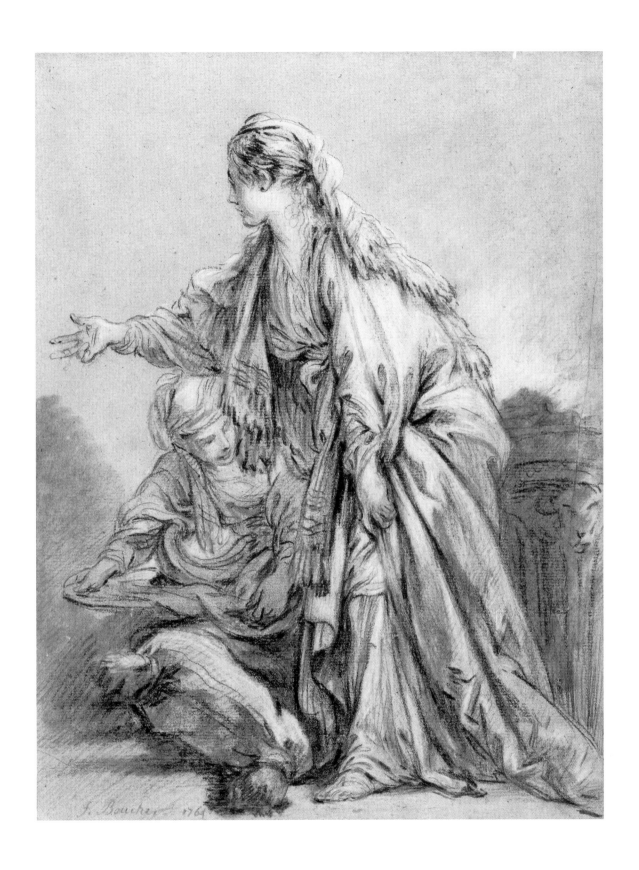

PLATE 57 | *Boucher* (cat. no. 14)

101

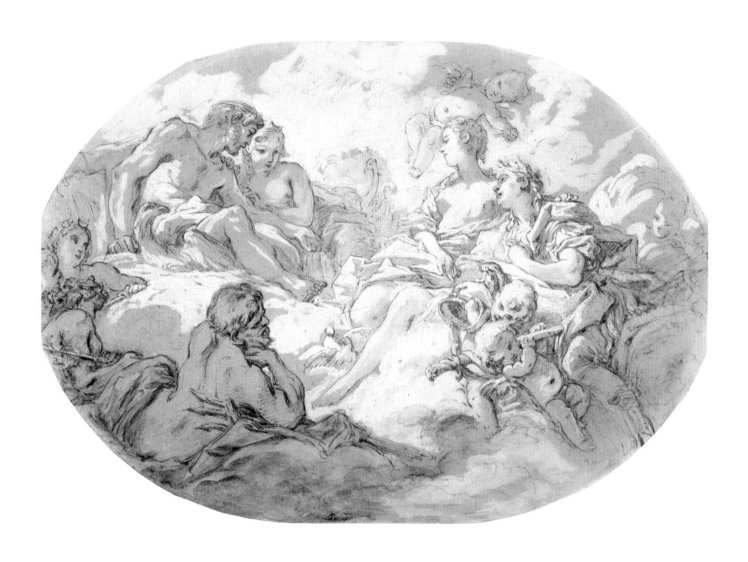

PLATE 58 | *Boucher* (cat. no. 23)

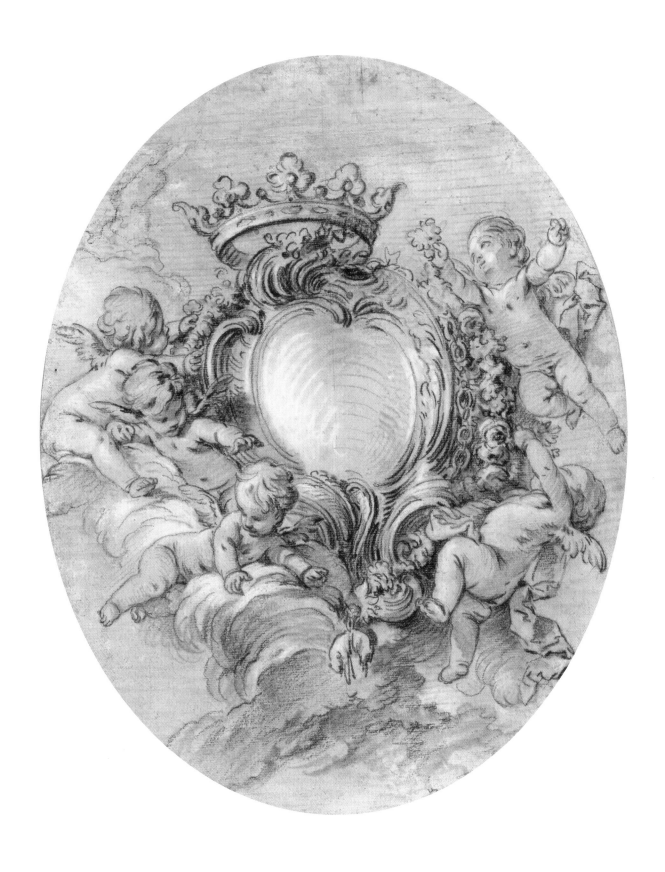

PLATE 59 | *Boucher* (cat. no. 9)

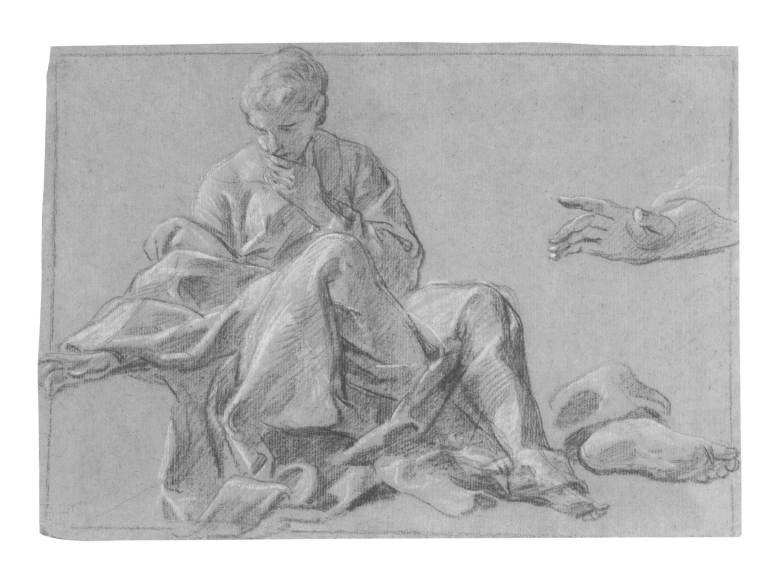

PLATE 60 | *J.-F. Parrocel* (cat. no. 63)

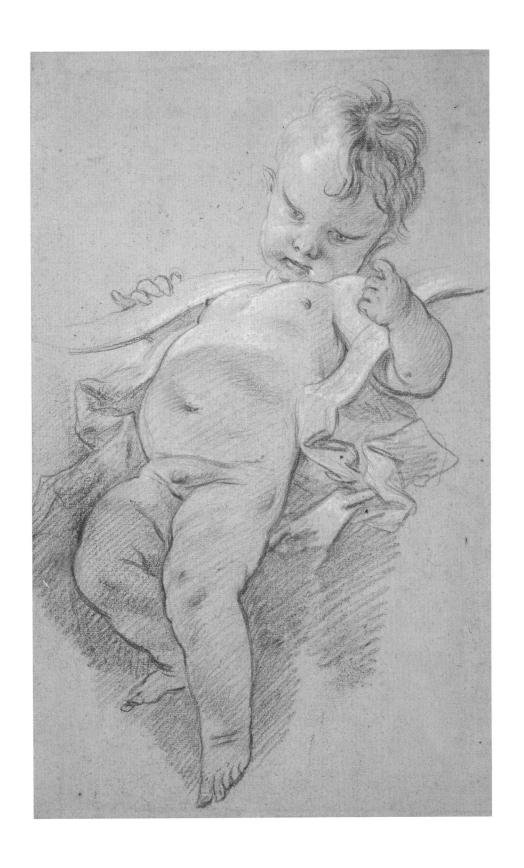

PLATE 61 | *Boucher* (cat. no. 17)

105

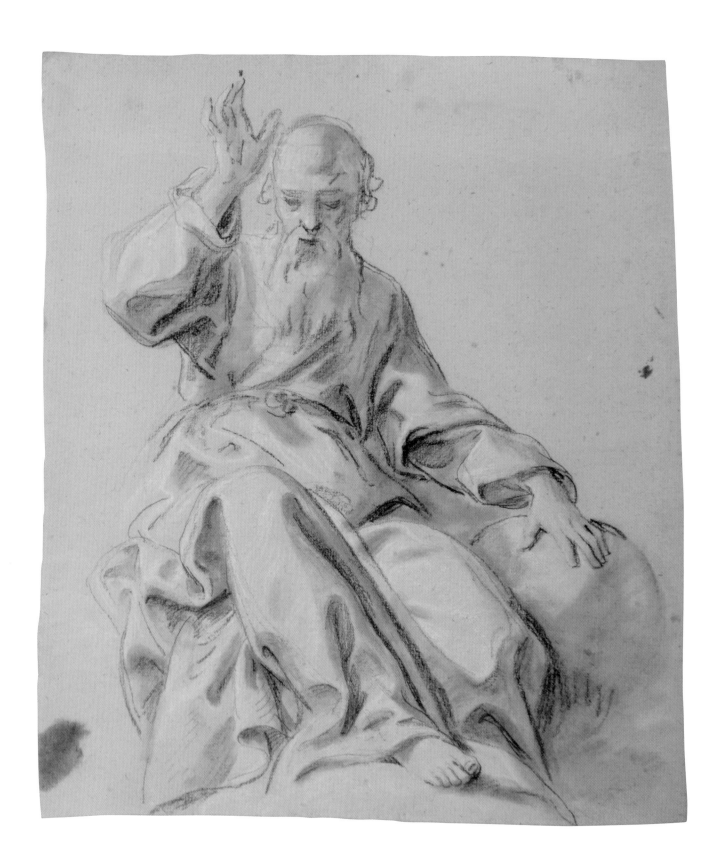

PLATE 62 | *J.-F. Parrocel* (cat. no. 62)

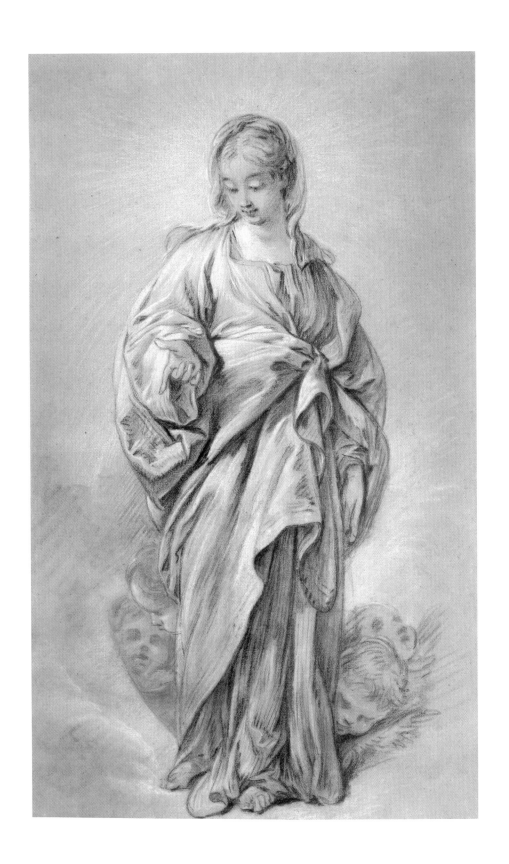

PLATE 63 | *Boucher* (cat. no. 24)

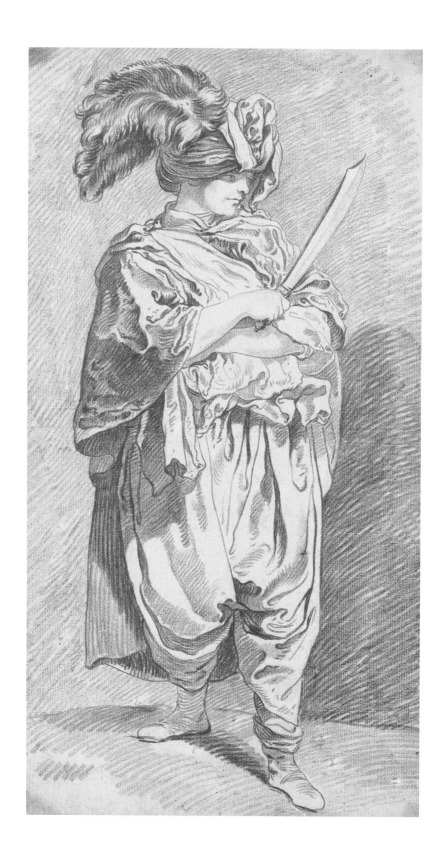

PLATE 64 | *Vanloo* (cat. no. 74)

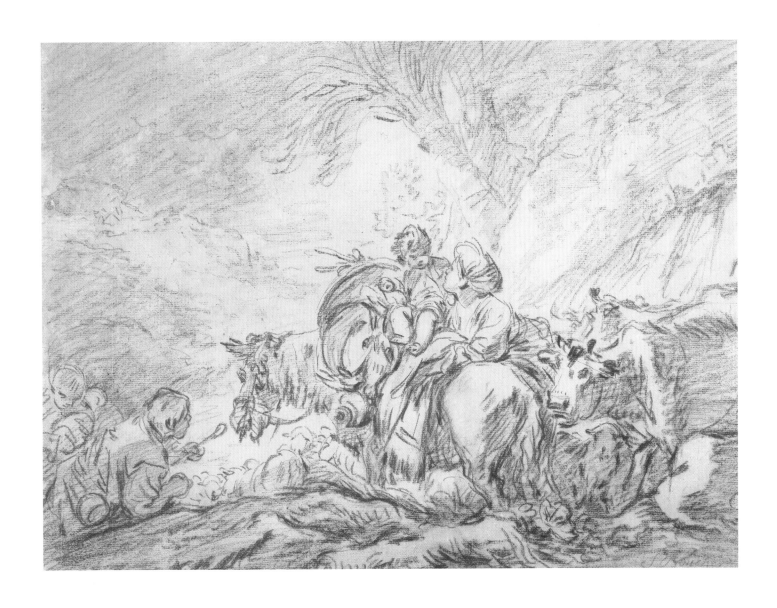

PLATE 65 | *Boucher* (cat. no. 16)

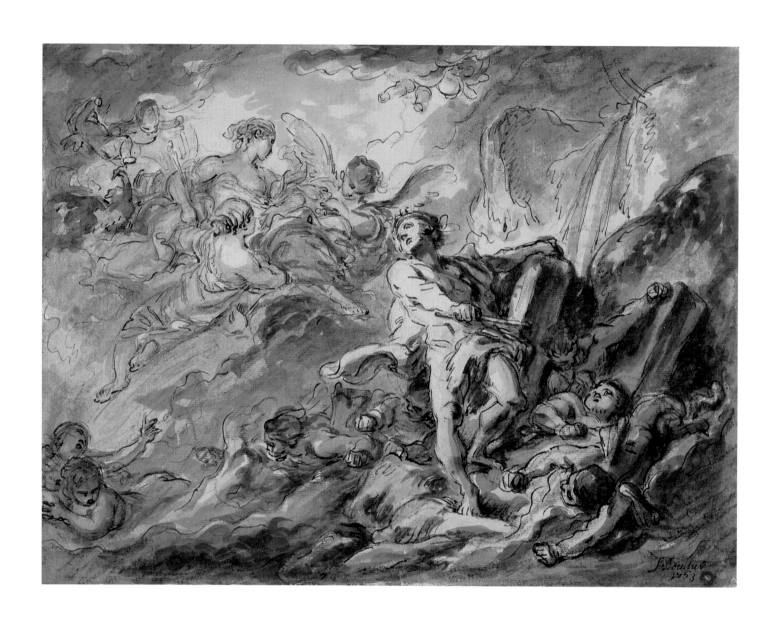

PLATE 66 | *Boucher* (cat. no. 13)

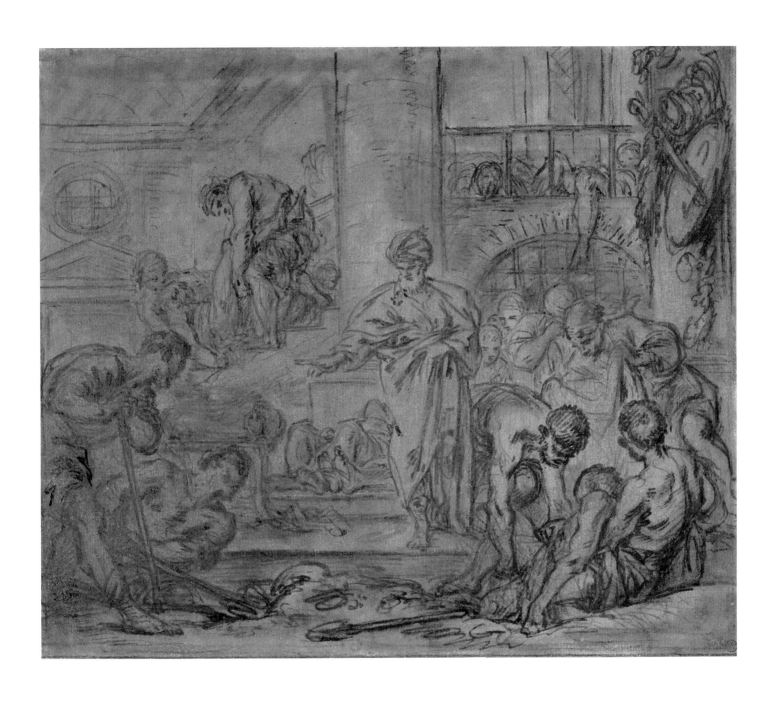

PLATE 67 | *Boucher* (cat. no. 22)

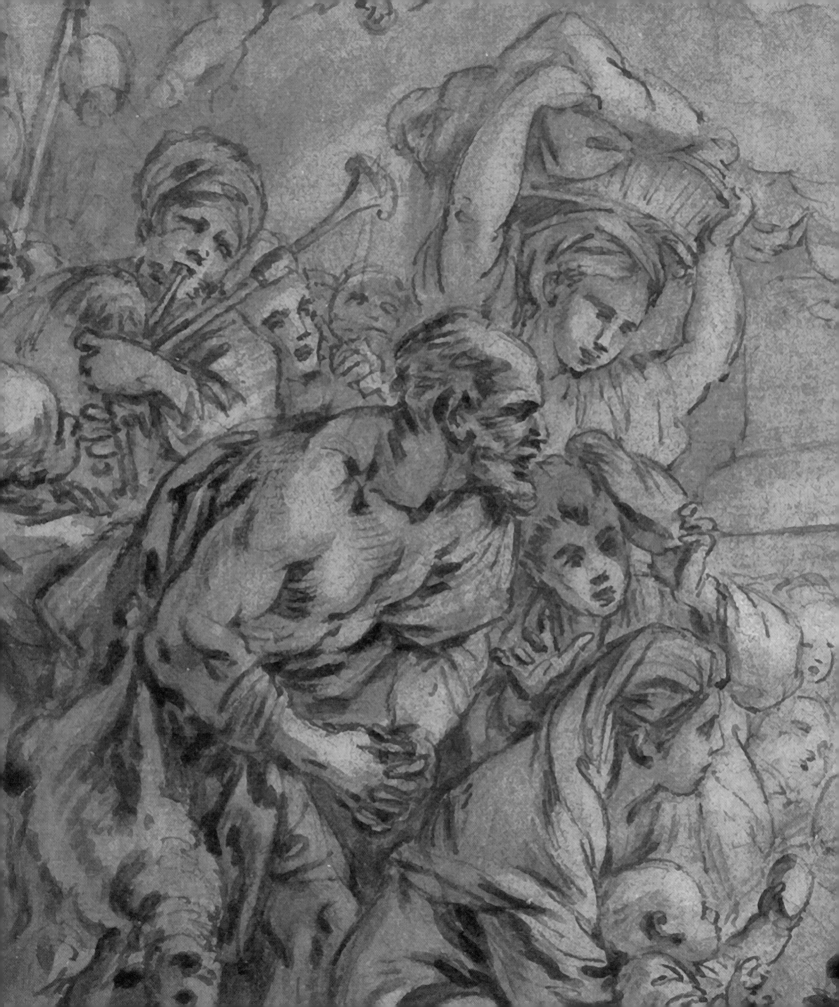

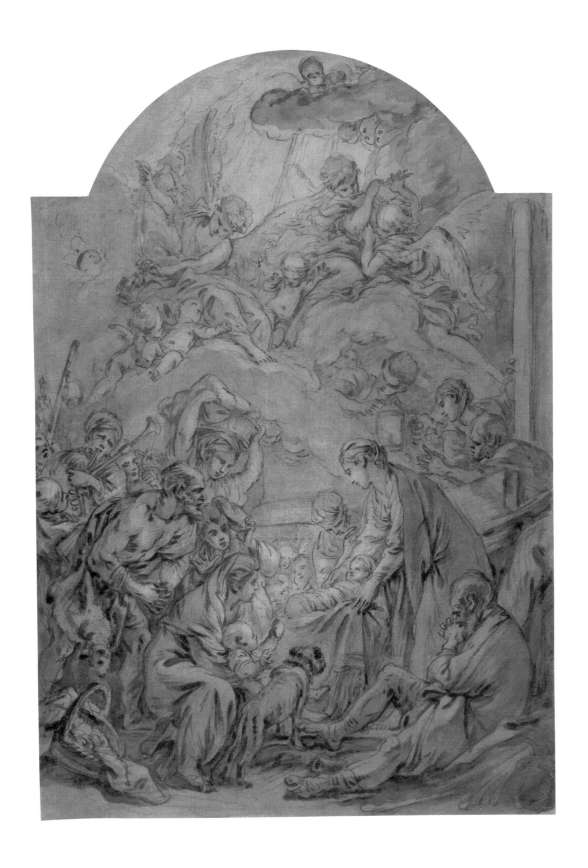

PLATE 68 | *Boucher* (cat. no. 7)

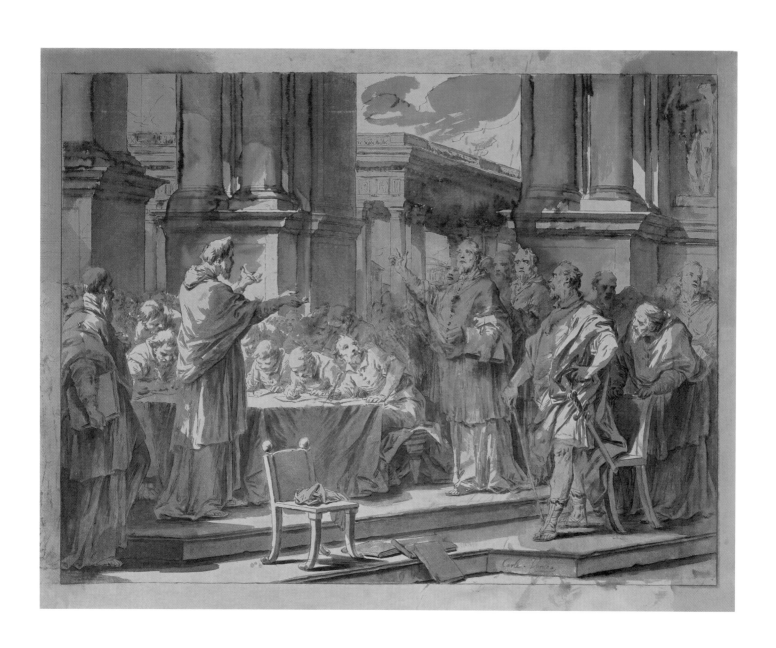

PLATE 69 | *Vanloo* (cat. no. 77)

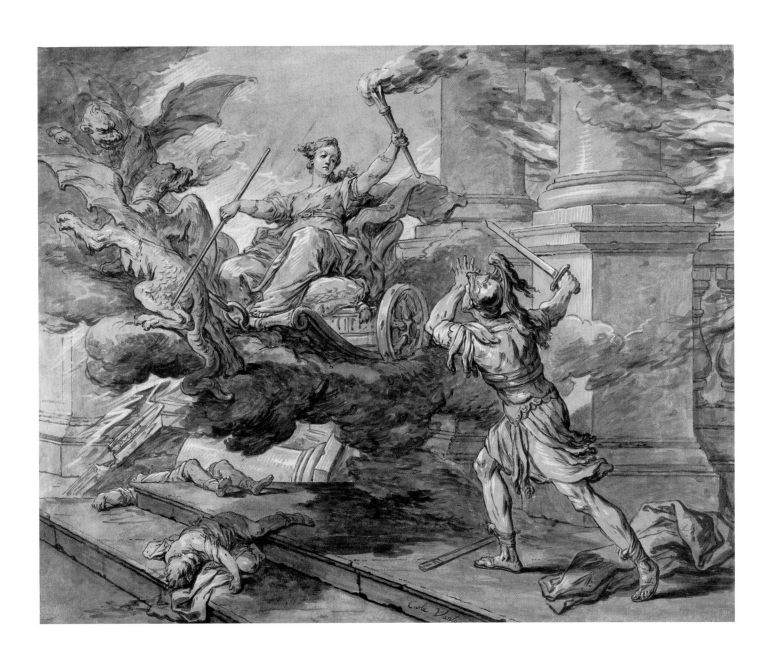

PLATE 70 | *Vanloo* (cat. no. 75)

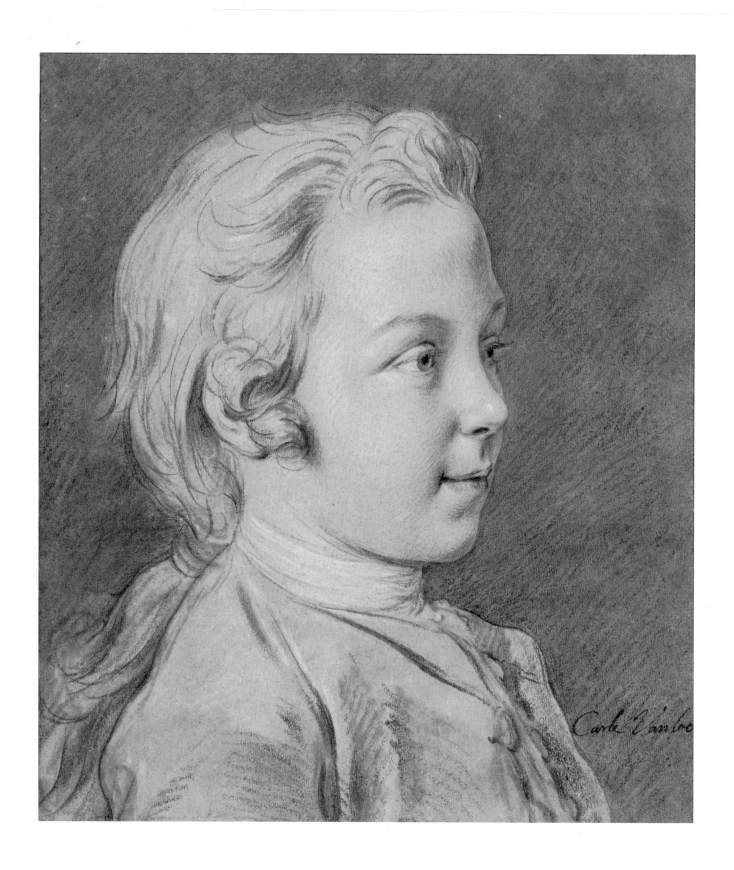

PLATE 71 | *Vanloo* (cat. no. 76)

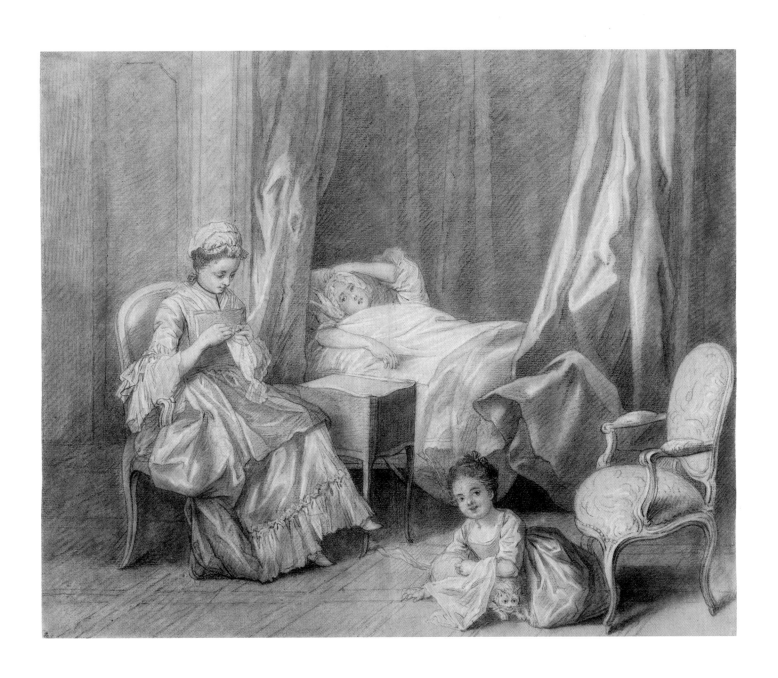

PLATE 72 | *Jeaurat* (cat. no. 43)

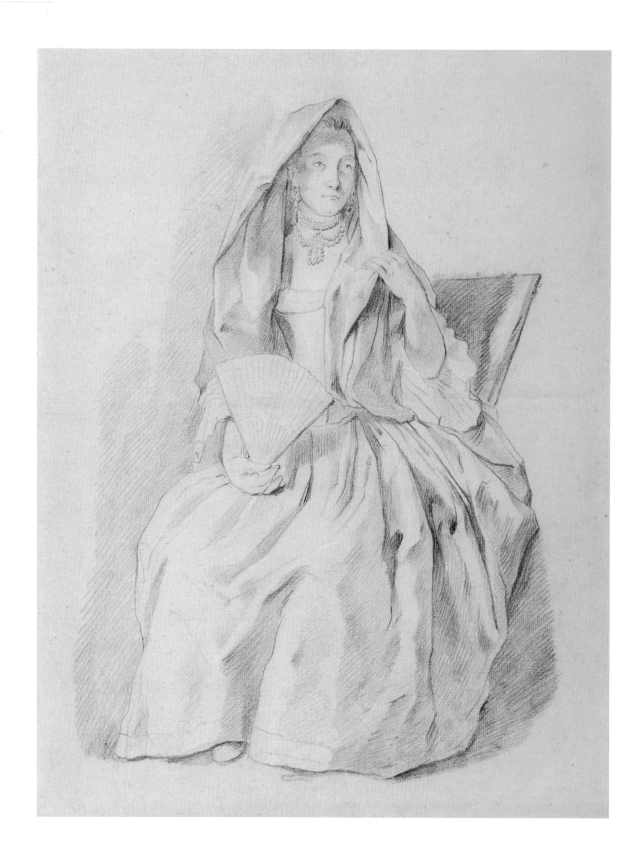

PLATE 73 | *Favray* (cat. no. 40)

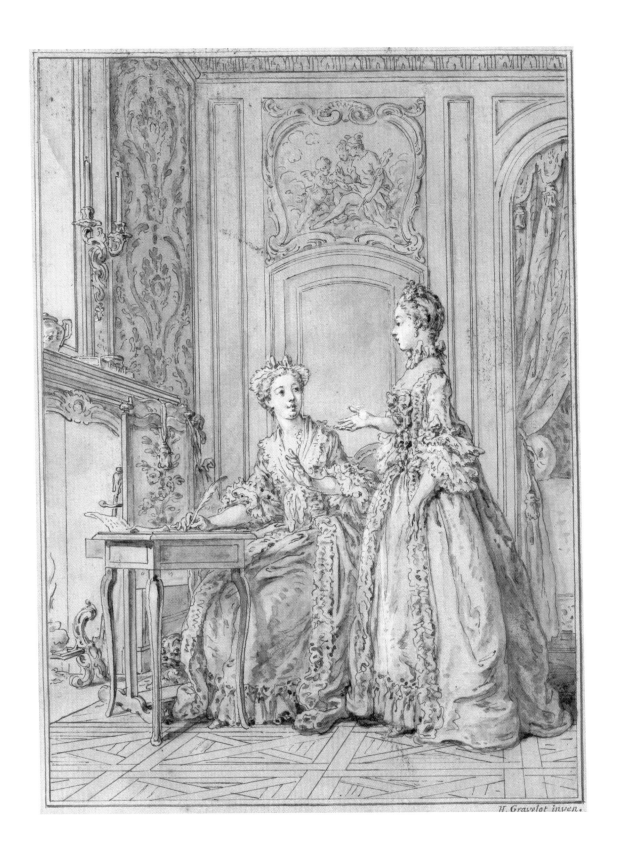

H. Gravelot inven.

PLATE 74 | *Gravelot* (cat. no. 41)

119

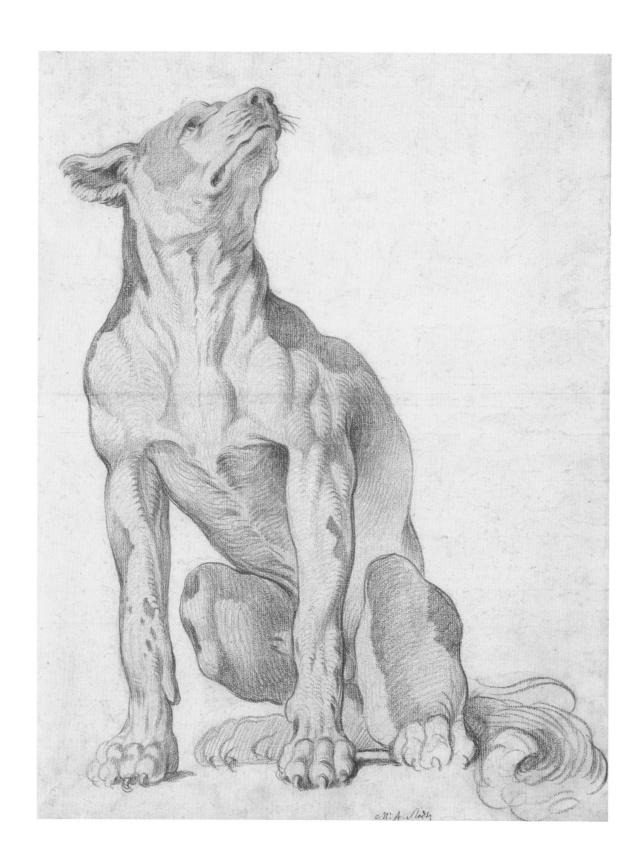

PLATE 75 | *Slodtz* (cat. no. 70)

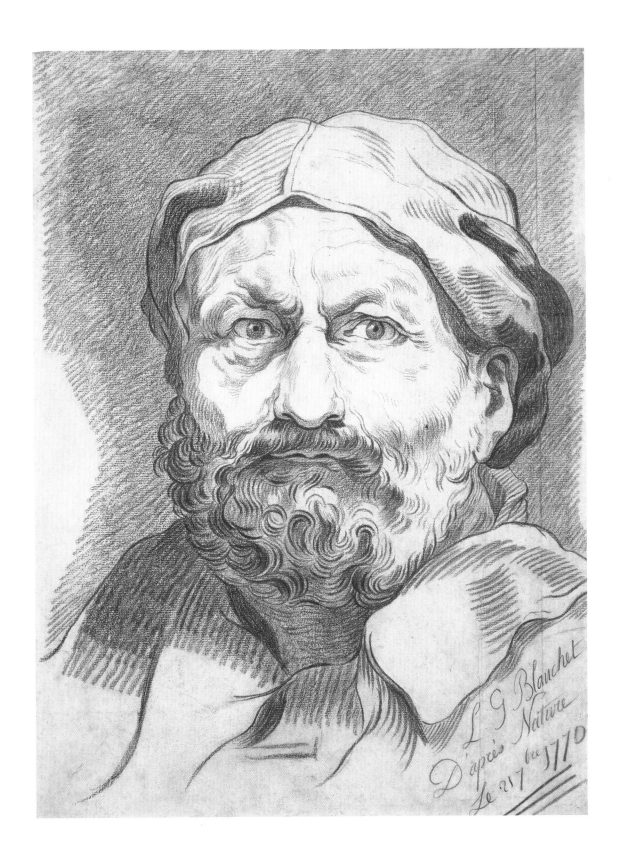

PLATE 76 | *Blanchet* (cat. no. 1)

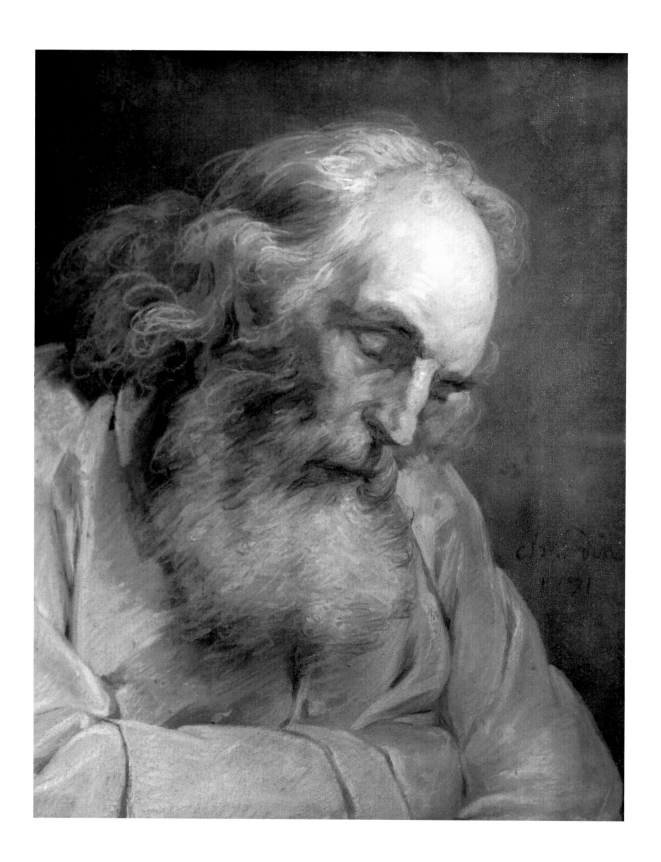

PLATE 77 | *Chardin* (cat. no. 26)

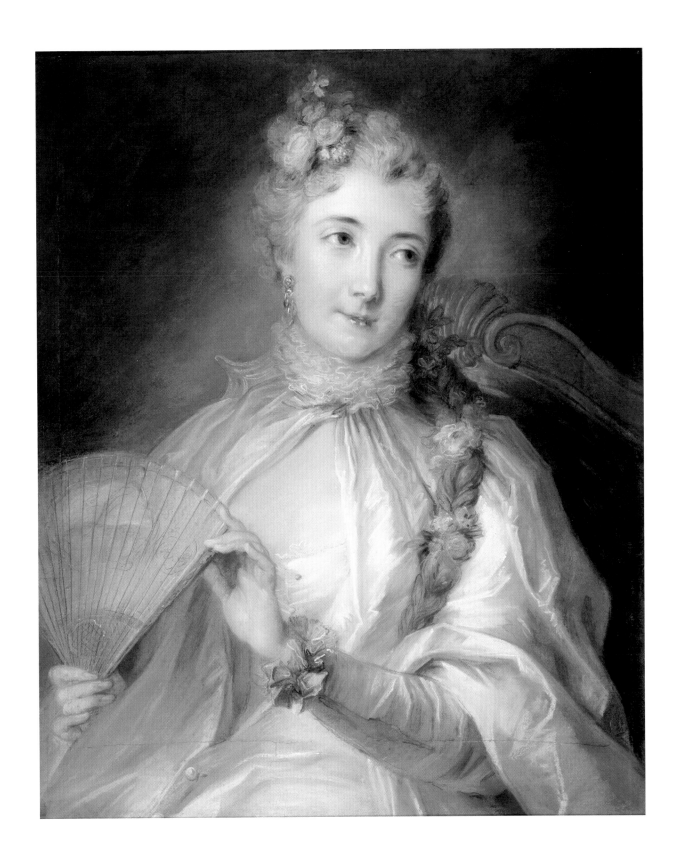

PLATE 78 | *Coypel* (cat. no. 30)

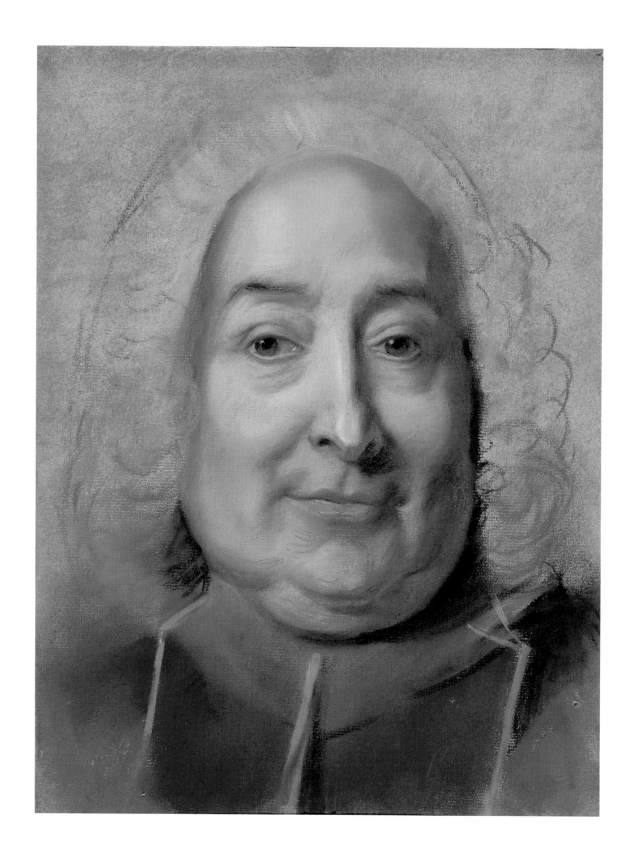

PLATE 79 | *La Tour* (cat. no. 45)

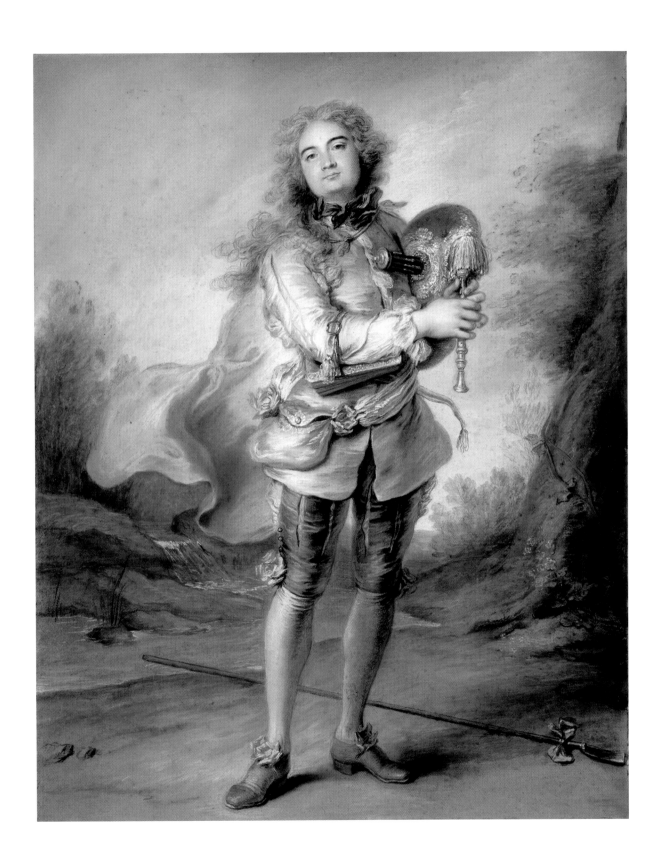

PLATE 80 | *Coypel* (cat. no. 29)

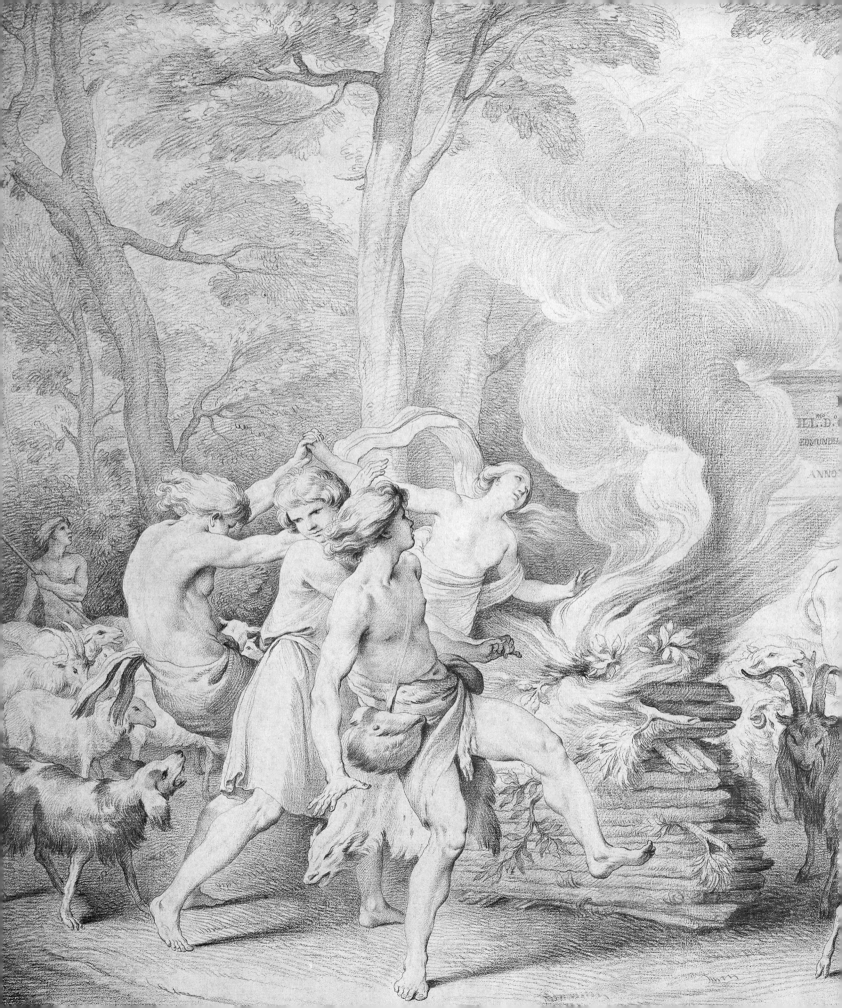

ANNOTATED CHECKLIST OF THE EXHIBITION

LOUIS-GABRIEL BLANCHET
(Paris 1705–1772 Rome)

1 *Head of a Bearded Man*, 1770; verso: *Faint Sketch of a Face*, 1770

Red chalk on tan antique laid paper; 415 × 370 mm

WATERMARK: None
INSCRIPTION: Signed and dated, lower right, red chalk: *L G Blanchet / D'après Nature / Le 21 7bre 1770*
PROVENANCE: Blondeau-Breton-Pradère, Paris; acquired in March 2002, inv. no. D-F-923
EXHIBITIONS: None
LITERATURE: None

PLATE 76

EDME BOUCHARDON
(Chaumont-en-Bassigny 1698–1762 Paris)

2 *Adoration of the Magi*

Red chalk on cream antique laid paper, framing line in brown ink, laid down on a cream card, laid down on remnants of a decorated mount; 304 × 460 mm

WATERMARK: None
INSCRIPTION: Lower right, brown ink: *Bouchardon f.*
PROVENANCE: Possibly Georges Pébereau, Paris (variant of his mark, lower left, black ink: *GP?*); Galerie de La Scala, Paris; acquired in 2000, inv. no. D-F-794
EXHIBITIONS: None
LITERATURE: None

PLATE 24

3 *Medal Design for the Chambre aux Deniers in 1742: Fruges et Cererem Ferunt*

Red chalk on cream antique laid paper, laid down on cream antique laid paper with blue paper borders adhered to face; 210 mm diameter (sight)

WATERMARK: None
INSCRIPTIONS: Around image, red chalk: *FRUGES ET CEREREM FERUNT.*; lower border, red chalk: *CHAMBRE AUX / DENIERS / 1742.*

PROVENANCE: Didier Aaron et Cie, Paris; acquired in 1997, inv. no. D-F-540
EXHIBITIONS: None
LITERATURE: Alvin L. Clark, Jr., with Patrick Murphy in Cambridge et al. 1998. cat. no. A.31, p. 411

PLATE 45

4 *Parilia Festival*, 1737

Red chalk on cream antique laid paper, laid down on off-white card; 439 × 585 mm

WATERMARK: Grapes
INSCRIPTIONS: Center of drawing, red chalk: *PALILIA . / ILL.mo D.o COMITI A CHOLMONDELEY / EDMUNDUS BOUCHARDON SCULPTOR REGIUS / FACIEBAT. / ANNO DOM. MDCCXXXVII.*; bottom center, red chalk: *PELLE PROCUL MORBOS. Ovid. Fast. liv 4.*
PROVENANCE: Possibly Earl of Cholmondeley; sale, London, Sotheby's, 7 July 1999, lot 79; acquired at the sale, inv. no. D-F-709
EXHIBITIONS: None
LITERATURE: Jordan 1985, p. 391

PLATE 25

5 *Seated Male Nude*

Red chalk on cream antique laid paper, with framing line in black ink, laid down on cream antique laid paper with blue paper borders adhered to face; 487 × 390 mm

WATERMARK: None
INSCRIPTIONS: Recto, bottom right, brown ink: *E. Bouchardon*; verso, lower left, stamp, purple ink: *d'ORTHO-CHAMENT / FOURCHAMBAULT / NIÈVE 8E*
PROVENANCE: Private collection, New York; W. M. Brady and Co. Inc., New York; acquired in 1998, inv. no. D-F-625
EXHIBITIONS: None
LITERATURE: Alvin L. Clark, Jr., with Patrick Murphy in Cambridge et al. 1998, cat. no. A.33, p. 411

PLATE 23

6 *Visigoths Attacking Clovis as He Kills Alaric*

Red chalk on cream antique laid paper, partial framing line in
brown ink; 95 × 200 mm

WATERMARK: None
INSCRIPTIONS: None
PROVENANCE: Pierre-Jean Mariette (L.2097), Paris; his sale, Paris,
Basan, 15 November 1775–30 January 1776, part of lot 1132; Jean-
Baptiste Servat or Charles-Philippe Campion, Abbé de Tersan,
Paris; unidentified mark (L.1863a, lower left and lower right);
C. G. Boerner Inc., New York; acquired in 2004, inv. no. D-F-1142a
EXHIBITIONS: None
LITERATURE: Rosenberg and Barthélemy-Labeeuw 2011, vol. 1,
cat. no. F.475, p. 165

PLATE 26

FRANÇOIS BOUCHER
(Paris 1703–1770 Paris)

7 *Adoration of the Shepherds*

Pen with brown ink and brush with brown wash and touches of
blue watercolor over red chalk on cream antique laid paper,
prepared with a red chalk wash, framing line in black ink,
laid down on Japan paper, laid down on a decorated mount;
460 × 320 mm

WATERMARK: Laid down; none visible through mount
INSCRIPTION: Mount, lower right, brown ink: *Fr. Boucher*
PROVENANCE: Baron von Stumm, Berlin; his sale, Berlin,
14–15 March 1922, lot 90; private collection; Michel Gierzod,
Paris; acquired in 2004, inv. no. D-F-1088
EXHIBITIONS: None
LITERATURE: None

PLATE 68

8 *Chief of the Eunuchs*

Black chalk on vellum; 151 × 118 mm

WATERMARK: None
INSCRIPTIONS: None
PROVENANCE: Sale, Paris, Drouot (Artcurial), 26 June 2012, lot 49;
acquired at the sale, inv. no. D-F-1454
EXHIBITIONS: None
LITERATURE: None

PLATE 51

9 *Crowned Rocaille Escutcheon with Putti and the Order of the Golden Fleece*

Black chalk heightened with white chalk on tan antique laid paper,
pricked for transfer, irregular (oval); 523 × 417 mm (extended
57 mm at top)

WATERMARK: None
INSCRIPTIONS: None
PROVENANCE: N. Shelton; sale, London, Sotheby's, 10 December
1968, lot 76; Thomas Agnew and Sons Ltd., London (as of 1975);
Lodewijk Arnold Houthakker, Amsterdam (his mark, L.3893,
lower right); Hazlitt, Gooden and Fox Ltd., London; acquired
in 1993, inv. no. D-F-27
EXHIBITIONS: Versailles 2004, no. 40; New York 2008
LITERATURE: Michael Jaffé in Paris et al. 1976, under cat. no. 6,
p. 5; Laing 1989; Alvin L. Clark, Jr., with Patrick Murphy in
Cambridge et al. 1998, cat. no. A.38, p. 411; Françoise Joulie
in Versailles 2004, cat. no. 40, pp. 90–91; Gail S. Davidson
in New York 2008, p. 54

PLATE 59

10 *Feast of Belshazzar*

Pen and brown ink with brush and brown wash over black chalk,
partially squared in black chalk, on off-white antique laid paper,
framing lines in brown ink, laid down on decorated mount;
281 × 424 mm

WATERMARK: None
INSCRIPTION: Verso, top left, brown ink: *17->*
PROVENANCE: Private collection; sale, New York, Sotheby's,
10 January 1995, lot 172 (as Dandré-Bardon); acquired at the sale,
inv. no. D-F-31
EXHIBITION: Versailles 2004, no. 19
LITERATURE: Alvin L. Clark, Jr., with Patrick Murphy in Cambridge
et al. 1998, cat. no. A.36, p. 411; Françoise Joulie in Paris 2003, p. 32,
fig. 6; Françoise Joulie in Versailles 2004, cat. no. 19, pp. 46–47;
Françoise Joulie in Sydney 2005, under cat. no. 14, p. 111

PLATE 32

11 *Heads of Two Young Ladies*

Black chalk heightened with white chalk on cream antique laid
paper, framing line in black ink; 243 × 226 mm

WATERMARK: None
INSCRIPTIONS: None
PROVENANCE: Comte de Lubersac, Château du Maucreux,
Faverolles; Maurice Loncle, Paris; David Carritt, London;
Galerie Arnoldi-Livie, Munich; acquired in 2001, inv. no. D-F-834
EXHIBITIONS: London 1978, no. 4; Versailles 2004, no. 52
LITERATURE: London 1978, cat. no. 4; Françoise Joulie in
Versailles 2004, cat. no. 52, pp. 114–15

PLATE 56

12 *Hippolytus Thrown from His Chariot*

Red chalk on cream antique laid paper, framing line in red chalk; 262 × 382 mm

WATERMARK: Illegible

INSCRIPTIONS: Recto, signed, lower right, brown ink: *f. Boucher*; verso, lower right, brown ink: *359*

PROVENANCE: A. Latreille, Paris; acquired in 1989, inv. no. D-F-22

EXHIBITIONS: New York and Forth Worth 2003, no. 2; Versailles 2004, no. 14

LITERATURE: Alvin L. Clark, Jr., with Patrick Murphy in Cambridge et al. 1998, cat. no. A.39, p. 411; Alastair Laing in New York and Fort Worth 2003, cat. no. 2, pp. 42–43; Françoise Joulie in Versailles 2004, cat. no. 14, pp. 36–37; Françoise Joulie in Sydney 2005, p. 81

PLATE 49

13 *Juno Commanding Aeolus to Release the Storm Winds*, 1753

Pen and brown ink with brush and brown wash over black chalk on cream antique laid paper, framing line in black ink; 260 × 347 mm

WATERMARK: None

INSCRIPTIONS: Signed and dated, bottom right, brown ink: *f Boucher / 1753*; mount, bottom right, blind stamp *G* (for the mount maker Glomy; L.1119)

PROVENANCE: Probably sale, Paris, Cayeux, 11 December 1776 and the following days, lot 205; probably sale, Paris, Collet, 14 May 1787 and the following days, lot 140; probably sale, Paris, 31 May 1790 and the following days, lot 145; possibly sale, Paris, 15 March 1795 and the following days, lot 22; sale, Paris, Drouot, 27 March 1991, lot 46; sale, London, Sotheby's, 4 July 1994, lot 105; acquired at the sale, inv. no. D-F-28

EXHIBITIONS: Cambridge et al. 1998, no. 61; New York and Fort Worth 2003, no. 75; Versailles 2004, no. 64

LITERATURE: Alastair Laing in New York et al. 1986, under cat. no. 84, p. 326; Alastair Laing in Cambridge et al. 1998, cat. no. 61, pp. 230–31; Sievers 2000, under cat. no. 21, p. 96, fig. 1; Alastair Laing in New York and Fort Worth 2003, cat. no. 75, pp. 196–97; Françoise Joulie in Versailles 2004, cat. no. 64, pp. 138–39

PLATE 66

14 *Lady Attended by a Handmaiden*, 1764

Black chalk heightened with white chalk on discolored blue antique laid paper, framing line in black ink; 360 × 275 mm

WATERMARK: Laid down; none visible through mount

INSCRIPTION: Bottom left, black chalk: *f. Boucher 1764*

PROVENANCE: Sale, Paris, Drouot, 9 December 1992; Didier Aaron et Cie, Paris; acquired in 1995, inv. no. D-F-32

EXHIBITIONS: Cambridge et al. 1998, no. 62; Versailles 2004, no. 60

LITERATURE: Alastair Laing in Cambridge et al. 1998, cat. no. 62, pp. 232–33; Françoise Joulie in Versailles 2004, cat. no. 60, pp. 130–31; Emmanuelle Brugerolles in Paris and Geneva 2006, under cat. no. 41, p. 178

PLATE 57

15 *Large Family Before a Farmstead with Animals*; verso: *Counterproof of a Standing Female*

Black and white chalk on light tan antique laid paper, framing lines in black chalk and black ink; verso: red chalk; 278 × 366 mm

WATERMARK: None

INSCRIPTIONS: Lower left, brown ink: *Boucher*; bottom right: (illegible)

PROVENANCE: Galerie de Bayser, Paris; acquired in 1995, inv. no. D-F-29

EXHIBITIONS: New York and Fort Worth 2003, no. 17; Versailles 2004, no. 23

LITERATURE: Alvin L. Clark, Jr., with Patrick Murphy in Cambridge et al. 1998, cat. no. A.40, p. 411; Alastair Laing in New York and Fort Worth 2003, cat. no. 17, pp. 72–75; Françoise Joulie in Versailles 2004, cat. no. 23, pp. 54–55

PLATE 50

16 *Peasants and Animals in a Landscape*

Brownish-red chalk on cream antique laid paper, drum mounted to cream card, framing line in black ink; 269 × 367 mm

WATERMARK: None

INSCRIPTION: Signed, lower right, red chalk: *f. Boucher*

PROVENANCE: Sale, New York, Sotheby's, 13 January 1988, lot 144; Paul Weis, New York; acquired in 1990, inv. no. D-F-25

EXHIBITION: Versailles 2004, no. 62

LITERATURE: Alvin L. Clark, Jr., with Patrick Murphy in Cambridge et al. 1998, cat. no. A.42, p. 411; Françoise Joulie in Versailles 2004, cat. no. 62, pp. 134–35; Bancel 2008, under cat. no. P.52, p. 120

PLATE 65

17 *Putto*

Red chalk heightened with white chalk on light tan antique laid paper, framing line in black ink, laid down on light tan card, with blue wove paper borders adhered to mount face; 387 × 242 mm

WATERMARK: None

INSCRIPTIONS: Recto, mount, lower right, black ink: *C. OO*; recto, mount, lower right, graphite: *o*; recto, mount, lower left, graphite: (illegible); verso, center, graphite: *132* (encircled) *a (9?)*; verso, lower left, graphite: *adizi* (underlined twice); verso, lower right, graphite: *C*

PROVENANCE: Private collection, Paris; Alain Latreille, Paris; acquired in 1989, inv. no. D-F-19

EXHIBITIONS: None

LITERATURE: Alvin L. Clark, Jr., with Patrick Murphy in Cambridge et al. 1998, cat. no. A.43, p. 411

PLATE 61

18 *Recumbent Female Nude*

Red chalk over red chalk counterproof, heightened with white chalk, on cream antique laid paper; 260 × 352 mm

WATERMARK: None

INSCRIPTIONS: None

PROVENANCE: Alain Latreille, Paris; acquired in 1990, inv. no. D-F-26

EXHIBITION: Florence 2012

LITERATURE: Alvin L. Clark, Jr., with Patrick Murphy in Cambridge et al. 1998, cat. no. A.46, p. 412; Stefania Ricci and Sergio Risaliti in Florence 2012, pp. 52–53, 98

PLATE 52

19 *Recumbent Female Nude*

Red, white, and black chalk on cream antique laid paper; 316 × 462 mm

WATERMARK: None

INSCRIPTION: Lower center, black chalk: *No 1*

PROVENANCE: Major-General the Honorable Sir Charles Greville, K.C.B., London (his mark, L.549, lower right); his nephew, George Guy, 4th Earl of Warwick and 11th Baron Brooke of Beauchamps Court, Warwick Castle, Warwick, Warwickshire (his mark, L.2600, lower right), by descent; his sale, London, Christie's, 20–21 May 1896, lot 48 (as *A Figure Reclining*); Henri Michel-Lévy, Paris; his sale, Paris, Galerie Georges Petit, 12–13 May 1919, lot 45 (as *Mlle Murphy*); A. Mayer, Paris; Mrs. Otto Wertheimer, Paris (as of 1978); Kimbell Art Museum, Fort Worth, 1978; Kimbell Art Museum deaccession via sale, London, Sotheby's, 6 July 1987, lot 4; private collection; sale, New York, Sotheby's, 5 July 2000, lot 57; acquired at the sale via John Morton Morris, inv. no. D-F-800

EXHIBITIONS: Atlanta 1983, no. 75 (as a study for the *Blond Odalisque* of 1751/52); New York and Fort Worth 2003, no. 29; Versailles 2004, no. 41

LITERATURE: Ananoff 1966, cat. no. 502, pp. 140–41, fig. 141; Ananoff and Wildenstein 1976, vol. 1, cat. no. 265/2, p. 380 (as a study for the *Dark-Haired Odalisque* of 1743); Jean-Richard 1978, under cat. no. 1397, p. 335; Ananoff and Wildenstein 1980, under cat. no. 272, p. 107; Pillsbury et al. 1981, p. 90; Eric M. Zafran in Atlanta 1983, cat. no. 75, pp. 147, 157–58; Alastair Laing in New York et al. 1986, under cat. no. 48, pp. 219–20 (as a study for the *Dark-Haired Odalisque* of 1743); Schreiber Jacoby 1986, p. 274, fig. 17; Roland Michel 1987, p. 191 and fig. 223; Alastair Laing in New York and Fort Worth 2003, cat. no. 29, pp. 98–99; Françoise Joulie in Versailles 2004, cat. no. 41, pp. 92–93; Laing 2004, p. 92; Georges Brunel in Sydney 2005, under cat. no. 12, p. 104

PLATE 53

20 *River Landscape with Figures*

Black chalk heightened with white chalk on tan antique laid paper, framing lines in black ink, laid down on cream antique laid paper, drum mounted to cream card; 320 × 229 mm

WATERMARK: None

INSCRIPTION: Verso, center, black chalk: *185 m* (ensquared) / *Bisceau ou / 8 ½ / 8 8 / 10 / 12*

PROVENANCE: Prince Jean Cantacuzène, Bucarest; perhaps his sale, Paris, Drouot (Rheims-Laurin-Rheims), 4–6 June 1969; private collection (unidentified collector's mark, verso); Didier Aaron et Cie, Paris; acquired in 1999, inv. no. D-F-681

EXHIBITIONS: None

LITERATURE: None

PLATE 55

21 *Seated Male Nude with Armor*

Red chalk on cream antique laid paper; 487 × 354 mm

WATERMARK: None

INSCRIPTION: Bottom right, brown ink: *55*

PROVENANCE: Private collection, France; sale, Paris, Drouot, 29 November 1985, lot 11; Thomas Agnew and Sons Ltd., London; acquired in 1989, inv. no. D-F-23

EXHIBITIONS: London 1986, no. 25; London 1989b, no. 7; Cambridge et al. 1998, no. 60; New York and Fort Worth 2003, no. 75; Versailles 2004, no. 37

LITERATURE: Gabrielle Naughton in London 1986, cat. no. 25, pp. 44–45; Gabrielle Naughton in London 1989b, cat. no. 7; Alastair Laing in Cambridge et al. 1998, cat. no. 60, pp. 228–29; Carter Foster in Cleveland and New York 2001, under cat. no. 8, p. 26, fig. 2; Alastair Laing in New York and Fort Worth 2003, cat. no. 75, pp. 196–97; Françoise Joulie in Versailles 2004, cat. no. 37, pp. 84–85

PLATE 22

22 *Tobit Burying the Dead*

Pen and black ink over black chalk, extensively stumped and varnished, on tan antique laid paper, framing line in black chalk, laid down on a decorated mount; 290 × 350 mm

WATERMARK: Laid down; none visible through mount

INSCRIPTION: Mount, lower right, brown ink: *Fr. Boucher*

PROVENANCE: Emile Wauters, Paris (his mark, L.911, lower right, black ink); his sale, Paris, Galerie Charpentier, 24 March 1947; Michel Gierzod, Paris; acquired in 2006, inv. no. D-F-1243

EXHIBITIONS: None

LITERATURE: None

PLATE 67

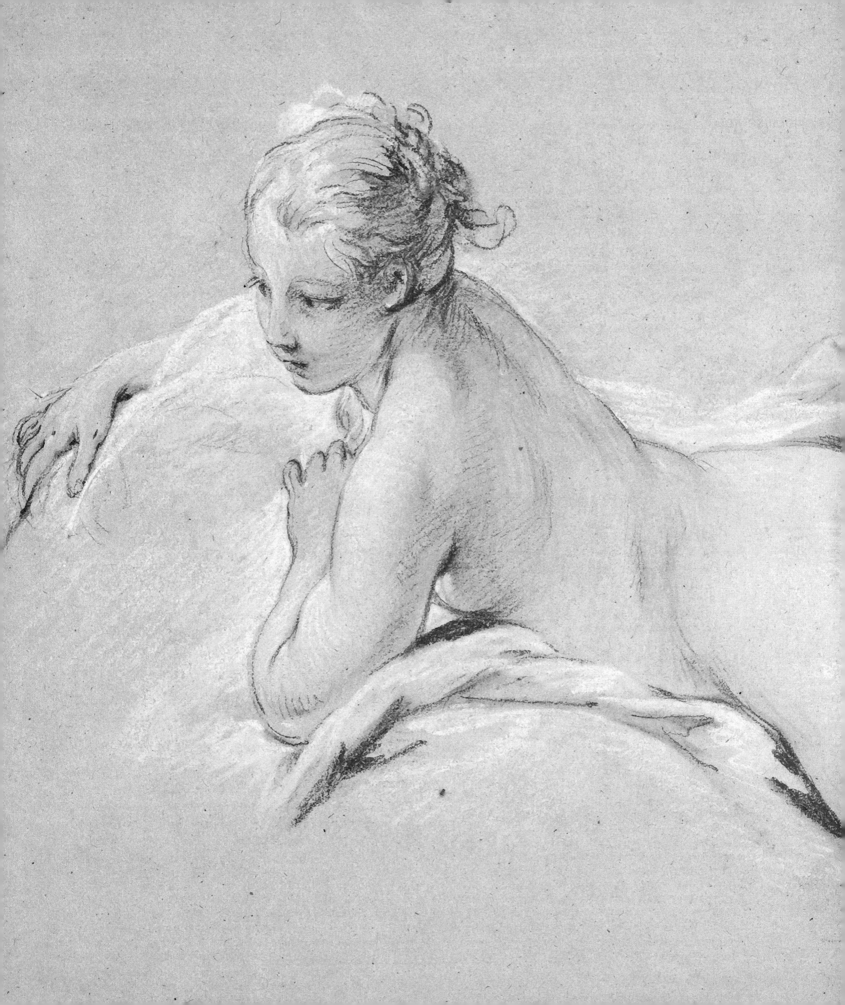

23 *Venus Presenting Aeneas to Jupiter and Juno*

Black chalk, pen with brown ink, brush with brown wash and touches of white gouache on tan antique laid paper; 214 × 305 mm

WATERMARK: None

INSCRIPTIONS: None

PROVENANCE: Claude-Henri Watelet, Paris; his sale, 12 June 1786, lot 167 (?); Boutin (?); Galerie Eric Coatelem, Paris; acquired in 2003, inv. no. D-F-1000

EXHIBITIONS: New York and Fort Worth 2003, no. 73; Versailles 2004, no. 42

LITERATURE: Alastair Laing in New York and Fort Worth 2003, cat. no. 73, pp. 192–93; Eric Coatelem in Paris 2003, pp. 22–23; Françoise Joulie in Versailles 2004, cat. no. 42, pp. 94–95; Gail S. Davidson in New York 2008, p. 54

PLATE 58

24 *Virgin with Angels*

Black chalk heightened with white chalk on tan antique laid paper, framing line in black ink; 510 × 307 mm

WATERMARK: None

INSCRIPTIONS: None

PROVENANCE: Sale, Amsterdam, 11–14 June 1912, lot 35; private collection; sale, Senlis, March 2000; Didier Aaron et Cie, Paris; acquired in 2000, inv. no. D-F-838

EXHIBITION: Versailles 2004, no. 46

LITERATURE: Françoise Joulie in Versailles 2004, cat. no. 46, pp. 102–3; Françoise Joulie in Copenhagen 2013, under cat. no. 87, p. 252

PLATE 63

25 *Young Travelers*

Black chalk on cream antique laid paper, framing line in black ink, laid down on a decorated mount; 295 × 188 mm

WATERMARK: Laid down; none visible through mount

INSCRIPTIONS: None

PROVENANCE: Galerie Monique Martel, Brussels; acquired in 2009, inv. no. D-F-1386

EXHIBITIONS: None

LITERATURE: None

PLATE 54

JEAN-BAPTISTE-SIMÉON CHARDIN
(Paris 1699–1779 Paris)

26 *Bust of an Old Man*, 1771

Pastel on blue paper adhered to canvas; 449 × 370 mm

WATERMARK: Laid down; none visible through mount

INSCRIPTIONS: Signed and dated, lower right, brown pastel: *Chardin / 1771*; signed and dated, upper right, brown pastel: *C 1771 Char*

PROVENANCE: Probably Salon of 1771, under no. 39; perhaps Jacquemin, jeweler to the king; his sale, 26 April 1773, lot 832; Laurent Laperlier; his sale, 11–13 April 1867, lot 58; sale, 19 June 1934, lot 6; sale, 19 June 1968, lot 1; sale, Paris, Drouot, 30 May 1969, lot 3; Galerie Cailleux, Paris; acquired in 1984, inv. no. D-F-49

EXHIBITIONS: Paris 1971, no. 1; Paris 1984, no. 11; Cambridge et al. 1998, no. 53; New York 2011, no. 12

LITERATURE: Bocher 1876, p. 116; Dayot and Vaillat 1907, cat. no. 64; Goncourt 1909, p. 173; Wildenstein 1963, cat. no. 367; Wildenstein 1969, cat. no. 659, p. 224; Cailleux 1971, pp. iii–iv, fig. 2; Pierre Rosenberg in Paris et al. 1979, under cat. nos. 130 and 134, pp. 354, 356; Rosenberg 1983, cat. no. 192; Paris 1984; Rosenberg and McCullagh 1985, cat. no. 27, pp. 46, 49, 58, fig. 11; Rosenberg 1987, p. 116; Roland Michel 1996, pp. 96–98, 224; Pierre Rosenberg in Cambridge et al. 1998, cat. no. 53, pp. 212–13; Catherine Baejter and Marjorie Shelley in New York 2011, cat. no. 12, p. 22

Exhibited in Cincinnati only

PLATE 77

HYACINTHE COLLIN DE VERMONT
(Versailles 1693–1761 Paris)

27 *Feast of the Gods*

Red chalk, with extensive stumping and traces of white chalk on cream antique laid paper, framing line in black ink, laid down on Japan paper, drum mounted to decorated mount; 387 × 490 mm

WATERMARK: Laid down; none visible through mount

INSCRIPTIONS: Recto, lower left, pen and brown ink: *colin de vermont*; verso, upper right, graphite: *8263N (-)*

PROVENANCE: Private collection, France; Jean-Christopher Baudequin at Galerie Ratton et Ladrière, Paris; Galerie Emmanuel Moatti, Paris; acquired in 1995, inv. no. D-F-65

EXHIBITION: Cambridge et al. 1998, no. 44

LITERATURE: Xavier Salmon in Cambridge et al. 1998, cat. no. 44, pp. 192–93

PLATE 12

CHARLES-ANTOINE COYPEL
(Paris 1694–1772 Rome)

28 *Head of Potiphar's Wife*
Black chalk and pastel on discolored blue antique laid paper; 310 × 242 mm

WATERMARK: Laid down; none visible through mount
INSCRIPTION: Across bottom, graphite: *Potiphar* (illegible) *de Joseph*
PROVENANCE: Didier Aaron and Co., New York; acquired in 1994, inv. no. D-F-72
EXHIBITIONS: New York et al. 1993, no. 17; Cambridge et al. 1998, no. 45
LITERATURE: Jill Dienst et al. in New York et al. 1993, cat. no. 17; Lefrançois 1994, cat. no. D76, p. 451; Thierry Lefrançois in Cambridge et al. 1998, cat. no. 45, pp. 194–95

PLATE 16

29 *Portrait of a Nobleman as Daphnis*
Pastel on paper adhered to canvas; 812 × 645 mm

WATERMARK: None
INSCRIPTIONS: None
PROVENANCE: Galerie Leegenhoek, Paris; acquired in 2002, inv. no. D-F-939
EXHIBITION: New York 2011, no. 10
LITERATURE: Catherine Baejter and Marjorie Shelley in New York 2011, cat. no. 10, p. 19

Exhibited in Chapel Hill only

PLATE 80

30 *Seated Young Lady Holding a Fan: Presumed Portrait of Madame Begon de Montfermeil*
Pastel on paper adhered to canvas; 710 × 580 mm

WATERMARK: None
INSCRIPTIONS: None
PROVENANCE: Didier Aaron and Co., London; acquired in 2003, inv. no. D-F-1219
EXHIBITIONS: None
LITERATURE: None

Exhibited in Chapel Hill only

PLATE 78

31 *Self-Portrait*
Black chalk with touches of red chalk on buff antique laid paper, squared; 325 × 265 mm (sight)

WATERMARK: None
INSCRIPTIONS: None
PROVENANCE: Hazlitt, Gooden and Fox Ltd., London; acquired in 1997, inv. no. D-F-482
EXHIBITIONS: None
LITERATURE: Alvin L. Clark, Jr., with Patrick Murphy in Cambridge et al. 1998, cat. no. A.91, p. 414; Thierry Lefrançois in Cambridge et al. 1998, under cat. no. 46, pp. 196–97

PLATE 14

32a *Standing Male Nude with Outstretched Arms*
32b *Four Young Ladies*
Black and white chalk with touches of red chalk on blue antique laid paper, squared with black chalk, laid down on cream antique laid paper, with blue paper strips adhered to face; 412 × 299 mm and 440 × 303 mm

WATERMARK: None
INSCRIPTIONS: None
PROVENANCE: Private collection, France; Galerie de Bayser, Paris; acquired in 1995, inv. nos. D-F-73, D-F-74
EXHIBITION: Cambridge et al. 1998, nos. 46a and b
LITERATURE: Thierry Lefrançois in Cambridge et al. 1998, cat. nos. 46a and b, pp. 196–99

PLATE 15

MICHEL-FRANÇOIS DANDRÉ-BARDON
(Aix-en-Provence 1700–1783 Paris)

33 *Adoration of the Shepherds*
Pen and brown ink with brush and brown wash, heightened with white gouache, over traces of black chalk, on light tan antique laid paper; 405 × 294 mm

WATERMARK: Illegible
INSCRIPTIONS: None
PROVENANCE: Galerie Ratton et Ladrière, Paris; acquired in 1995, inv. no. D-F-77
EXHIBITION: Cambridge et al. 1998, no. 54
LITERATURE: Alvin L. Clark, Jr., in Cambridge et al. 1998, cat. no. 54, pp. 214–15

PLATE 33

34 *Fall of the Giants*

Pen and brown ink with brush and brown wash, heightened with white gouache, and squared with black chalk on light tan antique laid paper; 457 × 356 mm

WATERMARK: None

INSCRIPTION: Signed, bottom center, brown ink: *Dandré Bardon.*

PROVENANCE: Possibly the artist's estate sale, Paris, 1783, lot 59; sale, New York, Sotheby's, January 2000, lot 150; Galerie Eric Coatalem, Paris; acquired in 2000, inv. no. D-F-778

EXHIBITIONS: None

LITERATURE: Rosenberg 2001, cat. no. 49, p. 21

PLATE 37

35 *Kneeling Monk*

Red and white chalk on light tan antique laid paper; 320 × 240 mm

WATERMARK: None

INSCRIPTIONS: Verso, upper center, graphite: *15*; verso, center, graphite: *5* (upside down); verso, lower left, graphite: *99190*; verso, lower right, graphite: *10* (encircled)

PROVENANCE: Galerie de Bayser, Paris; acquired in 2013, inv. no. D-F-1467

EXHIBITIONS: None

LITERATURE: None

PLATE 36

36 *Parnassus*

Pen and brown ink with brush and brown wash over traces of black chalk on two joined pieces of off-white antique laid paper; 198 × 490 mm

WATERMARK: None

INSCRIPTION: Signed, bottom left, brown ink: *Dandré Bardon*

PROVENANCE: Edmond and Jules de Goncourt, Paris; their sale, Paris, 15 February 1897, lot 59; Galerie Paul Prouté S.A., Paris; private collection, United States; Galerie Emmanuel Moatti, Paris; acquired in 1995, inv. no. D-F-339

EXHIBITIONS: None

LITERATURE: Alvin L. Clark, Jr., with Patrick Murphy in Cambridge et al. 1998, cat. no. A.92, p. 415; Rosenberg 2001, cat. no. 26, p. 16

PLATE 34

JACQUES DUMONT, called DUMONT LE ROMAIN
(Paris 1701–1781 Paris)

37 *Male Nude Collapsing Under a Tree*

Red chalk on off-white antique laid paper, framing lines in black chalk; 425 × 520 mm

WATERMARK: None

INSCRIPTIONS: Recto, lower right, red chalk: *J.D.L.R.*; verso, top right corner, graphite: *493893*; verso, right middle, graphite: *7422* (encircled); verso, lower right, graphite: (illegible); verso, lower left, graphite: *113* (encircled)

PROVENANCE: Sale, London, Phillips, 28 October 1997, lot 197; acquired at the sale, inv. no. D-F-531

EXHIBITIONS: None

LITERATURE: Alvin L. Clark, Jr., with Patrick Murphy in Cambridge et al. 1998, cat. no. A.119, p. 416

PLATE 43

38 *Meeting of Samson and the Philistine Woman at Timnah*

Red chalk on off-white antique laid paper, framing lines in red chalk; 272 × 390 mm

WATERMARK: Variant of Gaudriault 730

INSCRIPTIONS: Recto, lower right, brown ink: (illegible) *XVIII Siecle.* (illegible); verso, center left, graphite: *Sebert XVIII siècle E. 12*; verso, lower right, graphite: *30f*

PROVENANCE: Marie-Guillaume-Thérèse de Villenave; her sale, Paris, Alliance des Arts (L.61, twice at bottom left), 1–8 December 1842, lot 120 (as Sebastiano Conca); Jean-Luc Baroni, London; Douwes Fine Art, London; private collection, Paris; sale, Paris, Drouot, 28 March 1990, lot 4 (as Charles-Nicolas Cochin the Younger); Galerie Emmanuel Moatti, Paris; acquired in 1995, inv. no. D-F-324

EXHIBITIONS: London 1980, no. 25 (as Louis de Silvestre); Paris 1992, no. 10; Cambridge et al. 1998, no. 59

LITERATURE: Jean-Luc Baroni in London 1980, cat. no. 25; Emmanuel Moatti in Paris 1992, cat. no. 10; Jean-François Méjanès in Cambridge et al. 1998, cat. no. 59, pp. 226–27; Perrin Stein in New York 1999, under cat. nos. 80–81; Emmanuelle Brugerolles in Sydney 2005, under cat. no. 43, pp. 198–200

PLATE 44

39 *Soldier in Chains Receiving a Book from a Woman Supported by Devils*

Oil on paper, laid down on board; 220 × 290 mm

WATERMARK: None
INSCRIPTIONS: None
PROVENANCE: Nicolas Schwed, Paris; acquired in 2006, inv. no. D-F-1468
EXHIBITIONS: None
LITERATURE: None

PLATE 47

ANTOINE DE FAVRAY
(Bagnolet 1706–1792 Malta)

40 *Lady of Malta*

Black chalk with touches of white chalk on tan antique laid paper; 504 × 400 mm

WATERMARK: None
INSCRIPTIONS: None
PROVENANCE: Galerie Terrades, Paris; acquired in 2012, inv. no. D-F-1466
EXHIBITIONS: None
LITERATURE: None

PLATE 73

HUBERT-FRANÇOIS GRAVELOT
(Paris 1699–1773 Paris)

41 *The Good Mother*

Pen and black ink with brush and brown wash, heightened with white gouache, on buff antique laid paper; 198 × 152 mm

WATERMARK: None
INSCRIPTIONS: Recto, signed, lower right: *H. Gravelot invenit*; recto, bottom center, black ink: *LA BONNE MERE.*; verso, top left, graphite: *PRYZ*
PROVENANCE: Gabriel Terrades, Paris; acquired in 2010, inv. no. D-F-1401
EXHIBITIONS: None
LITERATURE: None

PLATE 74

42 *Scene from Voltaire's "Henriade"*

Pen and black ink with brush and brown wash and touches of red chalk over graphite on cream antique laid paper, framing line in black ink, verso reddened for transfer; 191 × 142 mm

WATERMARK: Illegible
INSCRIPTIONS: None
PROVENANCE: Eddie Tassel, Paris; acquired in 1999, inv. no. D-F-753
EXHIBITIONS: None
LITERATURE: None

PLATE 27

ÉTIENNE JEAURAT
(Paris 1699–1789 Versailles)

43 *The Convalescent*

Red and black chalk highlighted with white chalk on tan antique laid paper, laid down on Japan paper; 392 × 475 mm

WATERMARK: None
INSCRIPTIONS: None
PROVENANCE: Charles-Philippe, Marquis de Chennevières-Pointel, Paris and Bellême (his mark, L.2072, bottom left); Galerie de Bayser, Paris; acquired in 1998, inv. no. D-F-644
EXHIBITIONS: None
LITERATURE: Louis-Antoine Prat and Laurence Lhinares in Paris 2007, cat. no. T.335, pp. 608–9

PLATE 72

JACQUES DE LAJOÜE
(Paris 1687–1761 Paris)

44 *Hunters at Rest*

Pen with black ink and brush with brown and black ink wash and watercolor on cream antique laid paper, framing line in black ink; 233 × 266 mm

WATERMARK: None
INSCRIPTIONS: Verso, upper left, graphite: *4* (underlined) or *L* (underlined); verso, bottom right, black ink: *Lajoue*
PROVENANCE: Galerie Paul Prouté S.A., Paris; acquired in 2006, inv. no. D-F-1276
EXHIBITIONS: None
LITERATURE: None

PLATE 4

MAURICE-QUENTIN DE LA TOUR
(Saint-Quentin 1704–1788 Saint-Quentin)

45 *Charles-Gaspard-Guillaume de Vintimille du Luc, Archbishop of Paris and Duc de Saint-Cloud*

Pastel on paper, laid down on canvas; 355 × 270 mm

WATERMARK: None

INSCRIPTIONS: None

PROVENANCE: Sale, London, Sotheby's, 24 July 2012, lot 82; acquired at the sale, inv. no. D-F-1465

EXHIBITIONS: None

LITERATURE: None

Exhibited in Cincinnati only

PLATE 79

FRANÇOIS LE MOYNE
(Paris 1688–1737 Paris)

46 *Mark Anthony Attempting to Crown Julius Caesar at the Lupercalian Festival*

Black chalk, heightened with white chalk, on discolored blue antique laid paper, framing line in black ink and black chalk, adhered to a decorated mount; 279 × 477 mm

WATERMARK: Laid down; none visible through mount

INSCRIPTIONS: Mount, bottom right, black ink: *Le Moine*; mount, bottom left, graphite: *Collections Mariette, Legroy, Catalogue Lempereur, no 501, de Chennevières, no. 299. — César couronné par les Romains daus un fete lucupercale (Lempereur)*

PROVENANCE: Possibly Pierre-Jean Mariette, Paris; Jean-Denis Lempereur, Paris (his mark, L.1740, bottom right); his sale, Paris, 24 May–28 June 1773, part of lot 501; Charles-Philippe, Marquis de Chennevières-Pointel, Paris and Bellême (his mark, L.2073, bottom left); his sale, Paris, Drouot, 4–7 April 1900, lot 299; sale, London, Sotheby's, 20 June 1986, lot 136; acquired at the sale, inv. no. D-F-180

EXHIBITION: Cambridge et al. 1998, no. 42

LITERATURE: Bordeaux 1984, p. 181 (as lost); Jean-François Méjanès in Cambridge et al. 1998, cat. no. 42, pp. 186–89; Prat 2000, p. 121; Prat 2003, pp. 32, 36; Paris 2007, cat. no. 944, p. 462

PLATE 10

47 *Seated Female Nude*

Black and red chalk, heightened with white chalk, on tan antique laid paper, with blue antique laid paper strips adhered to face, framing lines in black chalk; 334 × 205 mm

WATERMARK: Laid down; none visible through mount

INSCRIPTION: Verso, mount, lower center, black chalk: *g* (encircled)

PROVENANCE: Private collection, London; Thomas Agnew and Sons Ltd., London; acquired in 1996, inv. no. D-F-450

EXHIBITION: Cambridge et al. 1998, no. 41

LITERATURE: Colin A. Bailey in Paris et al. 1991, under cat. no. 24, p. 255; Jean-François Méjanès in Cambridge et al. 1998, cat. no. 41, pp. 184–85

PLATE 9

48 *Seated Male Nude*

Black and white chalk on light tan antique laid paper, laid down on tan antique laid paper, with blue antique laid paper strips adhered to face; 512 × 307 mm

WATERMARK: None

INSCRIPTION: Bottom right, black chalk: *Le Moine*

PROVENANCE: Artemis, Luxembourg; acquired in 2005, inv. no. D-F-1115

EXHIBITIONS: None

LITERATURE: None

PLATE 8

JUSTE-AURÈLE MEISSONNIER
(Turin 1695–1750 Paris)

49 *St. Aignan in Prayer Before an Altar with Two Angels,* 1725

Black chalk heightened with white chalk on blue antique laid paper, framing line in black chalk; 453 × 312 mm

WATERMARK: None

INSCRIPTIONS: None

PROVENANCE: Jean de Jullienne, Paris; his sale, Paris, 30 March 1767, lot 866; Kate Ganz Ltd., London; acquired in 1990, inv. no. D-F-196

EXHIBITIONS: Cambridge et al. 1998, no. 50; London 1989a, no. 24

LITERATURE: Kate Ganz in London 1989a, cat. no. 24; Peter Fuhring in Cambridge et al. 1998, cat. no. 50, pp. 206–7; Fuhring 1999, vol. 2, cat. no. D.4, p. 267 (image reversed), and pp. 168, 266, 369

PLATE 17

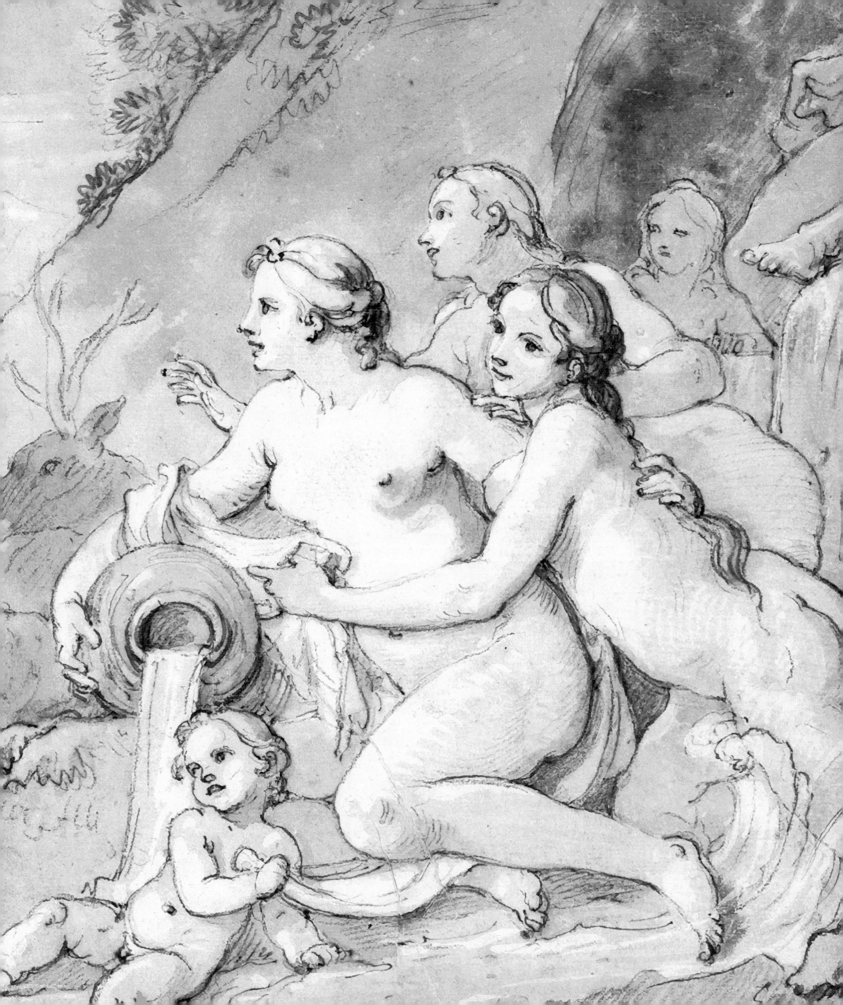

CHARLES-JOSEPH NATOIRE
(Nîmes 1700–1777 Castel Gandolfo)

50 *Ceiling Study for a View of Heaven*

Black chalk with brush and brown wash and black ink, heightened with white gouache, on two sheets of discolored blue antique laid paper; 890 × 559 mm

WATERMARK: Laid down; none visible through mount
INSCRIPTIONS: None
PROVENANCE: Possibly artist's estate sale, Paris, 14 December 1778, as part of lot 302; sale, Saint-Germain-en-Laye, 5 April 1992, lot 96; Galerie Emmanuel Moatti, Paris; acquired in 1993, inv. no. D-F-209
EXHIBITION: Cambridge et al. 1998, no. 56
LITERATURE: Bull 1993, pp. 367–69; Jean-François Méjanès in Cambridge et al. 1998, cat. no. 56, pp. 218–21; Caviglia-Brunel 2004, p. 41; Caviglia-Brunel 2012, cat. no. D.520, pp. 109, 111, 400–401

PLATE 41

51 *Eve*

Red and white chalk on light tan antique laid paper, framing lines in red chalk; 355 × 253 mm

WATERMARK: None
INSCRIPTIONS: None
PROVENANCE: Galerie Jean-François Baroni, Paris; acquired in 1995, inv. no. D-F-333
EXHIBITIONS: None
LITERATURE: Alvin L. Clark, Jr., with Patrick Murphy in Cambridge et al. 1998, cat. no. A.247, p. 425; Caviglia-Brunel 2012, cat. no. D.299, p. 301

PLATE 42

52 *Italian Landscape with the Ruins of the Villa Sacchetti*, 1772

Black chalk, pen and brown ink, and brush with brown wash and watercolor heightened with white gouache on tan antique laid paper, bottom edge made up; 323 × 460 mm

WATERMARK: Laid down; none visible through mount
INSCRIPTIONS: Signed, bottom right, pen and black ink: C. N (reversed) *ATOIRE OCTob.e 1772*; bottom center, pen and black ink: *Ruine DE LA Villa SACHETTI*
PROVENANCE: Sale, Paris, Drouot (Tajan), 22 March 1995, lot 108; acquired at the sale, inv. no. D-F-338
EXHIBITION: Cambridge et al. 1998, no. 58
LITERATURE: Jean-François Méjanès in Cambridge et al. 1998, cat. no. 58, pp. 224–25; Caviglia-Brunel 2012, cat. no. D.659, p. 450

PLATE 46

53 *Orpheus Charming the Nymphs*, 1757

Pen and brown ink and brush with light and dark brown wash, heightened with white gouache, over black chalk on off-white antique laid paper, framing line in brown ink; 299 × 438 mm

WATERMARK: Laid down; none visible through mount
INSCRIPTIONS: Recto, bottom left, pen and brown ink: *C. Natoire / f.*; verso, mount, center, black chalk: *C. Natoire F.*
PROVENANCE: Sale, Paris, 26–27 May 1921, lot 358; Galerie Cailleux, Paris; acquired in 1987, inv. no. D-F-208
EXHIBITIONS: Paris 1983b, no. 43; Cambridge et al. 1998, no. 57
LITERATURE: Boyer 1949, cat. no. 473, p. 87; Paris 1983b, cat no. 43; Jean Cailleux and Marianne Roland Michel in Paris and Geneva 1986; Roland Michel 1987, p. 31; Jean-François Méjanès in Cambridge et al. 1998, cat. no. 57, pp. 222–23; Haverkamp-Begemann et al. 1999, pp. 327–28; Rosenberg 2003, pp. 345–46; Caviglia-Brunel 2012, cat. no. D.534, pp. 406–7, 414

PLATE 40

54 *Sacrifice of Iphigenia*, 1737

Pen and brown ink with brush and gray wash and traces of heightening in white chalk over black chalk on blue antique laid paper, framing lines in black chalk; 254 × 377 mm

WATERMARK: None
INSCRIPTION: Signed and dated, lower left, brown ink: *Natoire. 1737.*
PROVENANCE: Sale, Paris, Drouot, 29 November 1991, lot 14; Nicolas Joly at Galerie Yves Mikaeloff, Paris; acquired in 1996, inv. no. D-F-386
EXHIBITIONS: None
LITERATURE: Boyer 1949, cat. no. 530, p. 92; Alvin L. Clark, Jr., with Patrick Murphy in Cambridge et al. 1998, cat. no. A.249, p. 425; Caviglia-Brunel 2012, cat. no. D.269, p. 285

PLATE 39

CHARLES-JOSEPH NATOIRE
(Nîmes 1700–1777 Castel Gandolfo)
After Giuseppe Passeri (1654–1714)

55 *Miracle of St. Vincent Ferrer*

Pen and brown ink with brush and brown wash heightened with white gouache over traces of black chalk, on light tan antique laid paper; 315 × 214 mm

WATERMARK: None
INSCRIPTIONS: None
PROVENANCE: Frederick Cummings, New York; W. M. Brady & Co. Inc., New York, 1992; Michael Miller–Lucy Vivante Fine Art Inc., New York; acquired in 1997, inv. no. D-F-521

EXHIBITIONS: None
LITERATURE: Alvin L. Clark, Jr., with Patrick Murphy in Cambridge et al. 1998, cat. no. A.250, p. 425; Stein 2000, p. 171; Caviglia-Brunel 2012, cat. no. D.763, pp. 474–77

PLATE 38

JEAN-BAPTISTE OUDRY
(Paris 1686–1755 Beauvais)

56 *Fighting Wolves*

Pen and black ink with brush and black ink wash heightened with white gouache over traces of black chalk on discolored blue antique laid paper, framing line in black ink; 314 × 547 mm

WATERMARK: None
INSCRIPTION: Lower left, brown ink: *J: B: Oudry.*
PROVENANCE: Galerie de Bayser, Paris; acquired in 1998, inv. no. D-F-583
EXHIBITIONS: None
LITERATURE: Alvin L. Clark, Jr., with Patrick Murphy in Cambridge et al. 1998, cat. no. A.258, p. 425

PLATE 5

57 *The Power of Fables*, 1733

Pen and black ink with brush and black ink wash heightened with white gouache on blue antique laid paper, framing lines in pen and black ink with blue and black ink wash; 312 × 257 mm

WATERMARK: None
INSCRIPTION: Signed, lower left, brown ink: *J.B. Oudry / 1733*
PROVENANCE: One of a series of drawings for illustrations to the *Fables* of Jean de La Fontaine bound in two albums sold by the artist to M. de Montenault, c. 1751; de Bure brothers, Paris (by 1828); sale of J. J. de Bure, Paris, 1–18 December 1853, lot 344; Comte Adolphe-Narcisse Thibaudeau, Paris; sale to Félix Solar (in 1856); his sale, Paris, 19 November–8 December 1860, lot 627; Baron Isidore Taylor, Paris; sale to Morgand and Fatout, booksellers, Paris (c. 1876); sale to Émile Pereire, Paris; sale to Louis Olry-Roederer, Reims; his family, by descent; Dr. A. S. W. Rosenbach and the Rosenbach Co., Philadelphia and New York (in 1923); sale to Raphael Esmerian, New York (c. 1946); his sale, Paris, Galliera, 6 June 1973, part 3, lot 46; one album to the British Rail Pension Fund, London, and one album dismembered; private collection; Clovis Whitfield, London; acquired in 1998, inv. no. D-F-654
EXHIBITIONS: None
LITERATURE: Alvin L. Clark, Jr., with Patrick Murphy in Cambridge et al. 1998, cat. no. A.260, p. 426

PLATE 6

58 *Study of a Pumpkin Vine*

Black chalk heightened with white chalk on blue antique laid paper, framing lines in brown ink; 314 × 479 mm

WATERMARK: None
INSCRIPTIONS: Recto, lower right, brown ink: *oudry fecit*; verso, lower right, graphite: *oudry* (illegible); verso, right center, brown ink: *?*
PROVENANCE: Henri Ledoux, Paris (his mark, L.4052, lower right); Colnaghi, London; acquired in 1984, inv. no. D-F-212
EXHIBITIONS: None
LITERATURE: Alvin L. Clark, Jr., with Patrick Murphy in Cambridge et al. 1998, cat. no. A.264, p. 426

PLATE 7

CHARLES PARROCEL
(Paris 1688–1752 Paris)

59 *Lion Hunt*

Red chalk on tan antique laid paper, framing lines in black ink, laid down on a decorated mount; 528 × 763 mm

WATERMARK: None
INSCRIPTIONS: None
PROVENANCE: Sale, Paris, Drouot (Tajan), 4 July 2002, lot 40; acquired at the sale, inv. no. D-F-921
EXHIBITIONS: Amiens and Versailles, no. 63
LITERATURE: Xavier Salmon in Amiens and Versailles, cat. no. 63, pp. 154–55

PLATE 13

ÉTIENNE PARROCEL, called STEFANO LE ROMAIN
(Avignon, Comtat Venaissin 1696–1776 Rouen)

60 *Head of a Bearded Man*, 1742

Red chalk on tan antique laid paper, laid down on tan wove paper; 419 × 280 mm

WATERMARK: None
INSCRIPTIONS: Lower left, black chalk: *Stefano / Parrocel / 1742*; lower left, collector's mark, black ink: *MP*; lower right, black ink: 44 (with ^ above)
PROVENANCE: Marcel Puech, Avignon; sale, Monaco, Christie's, 2 July 1993, lot 66; sale, London, Christie's, 1 July 1997, lot 134; acquired at the sale, inv. no. D-F-631
EXHIBITIONS: None
LITERATURE: None

PLATE 30

61 *Kneeling Saint with a Subsidiary Study of Hands*

Black chalk heightened with white chalk on tan antique laid paper, laid down on cream antique laid paper, with blue antique laid paper strips adhered to face; 482 × 379 mm

WATERMARK: None
INSCRIPTIONS: None
PROVENANCE: Sale, Monaco, Christie's, 20 June 1992, lot 271; sale, Paris, Drouot (Piasa), 22 March 2007, lot 95; acquired at the sale, inv. no. D-F-1335
EXHIBITIONS: None
LITERATURE: None

PLATE 31

JOSEPH-IGNACE-FRANÇOIS PARROCEL
(Avignon, Comtat Venaissin 1704–1781 Paris)

62 *God the Father*

Black chalk heightened with white chalk on tan antique laid paper; 334 × 292 mm

WATERMARK: None
INSCRIPTIONS: None
PROVENANCE: W.M. Brady and Co. Inc., New York; acquired in 1993, inv. no. D-F-225
EXHIBITIONS: None
LITERATURE: Alvin L. Clark, Jr., with Patrick Murphy in Cambridge et al. 1998, cat. no. A.278, p. 427

PLATE 62

63 *Seated Figure with Subsidiary Studies of a Hand and a Foot*

Red and white chalk on tan antique laid paper, framing lines in red chalk; 268 × 397 mm

WATERMARK: None
INSCRIPTIONS: None
PROVENANCE: Gabriel Terrades, Paris; acquired in 2000, inv. no. D-F-812
EXHIBITIONS: None
LITERATURE: None

PLATE 60

JEAN-BAPTISTE-JOSEPH PATER
(Valenciennes 1695–1736 Paris)

64 *Dancing Figure*

Red chalk heightened with white chalk on cream antique laid paper, upper right corner made up; 209 × 135 mm

WATERMARK: None
INSCRIPTIONS: None
PROVENANCE: Thomas Gonzalez, Würzburg; acquired in 2005, inv. no. D-F-1119
EXHIBITIONS: None
LITERATURE: None

PLATE 18

ALEXIS PEYROTTE
(Mazan, Comtat Venaissin 1699–1769 Paris)

65 *Two Men in Chinese Costumes*

Pen and black ink with brush and brown wash on cream antique laid paper; 344 × 238 mm

WATERMARK: None
INSCRIPTIONS: None
PROVENANCE: Gabriel Terrades, Paris; acquired in 2005, inv. no. D-F-1195
EXHIBITIONS: None
LITERATURE: None

PLATE 35

JACQUES-ANDRÉ PORTAIL
(Brest 1695–1759 Versailles)

66 *Musical Interlude*

Black and red chalk, graphite, and brush with brown and gray wash and watercolor heightened with white gouache on off-white antique laid paper; 355 × 280 mm

WATERMARK: None
INSCRIPTIONS: None
PROVENANCE: Didier Aaron and Co., New York; acquired in 2010, inv. no. D-F-1398
EXHIBITIONS: None
LITERATURE: None

PLATE 20

67 *Seated Hunter with a Dead Hare*

Red and black chalk with touches of pen with black and brown ink, heightened with white chalk, on cream antique laid paper, prepared with a thin cream ground; 426 × 364 mm

WATERMARK: Laid down; none visible through mount
INSCRIPTION: Mount, bottom center, graphite: *16/*
PROVENANCE: Mlle Seheult, great-niece of the artist, Nantes (in 1855); Beaudenon de Lamaze, Paris; his sale, Paris, Galerie Charpentier, 22 June 1938, lot 23; London, Sotheby's, 30 June 1986, lot 164; acquired at the sale, inv. no. D-F-249
EXHIBITION: Cambridge et al. 1998, no. 49
LITERATURE: Salmon 1996, cat. no. 46, pp. 7, 21, 73, 89; Xavier Salmon in Cambridge et al. 1998, cat. no. 49, pp. 204–5

PLATE 19

68 *Young Lady Performing Needlework*

Red and black chalk over graphite, lightly stumped and heightened with red chalk, on cream antique laid paper, partial framing lines in black ink; 329 × 278 mm

WATERMARK: None
INSCRIPTIONS: None
PROVENANCE: Sale, Bergerac, 21 September 1997; Galerie de Bayser, Paris; acquired in 1998, inv. no. D-F-582
EXHIBITION: Cambridge et al. 1998, no. 48
LITERATURE: Xavier Salmon in Cambridge et al. 1998, cat. no. 48, pp. 202–3

PLATE 21

JEAN RESTOUT THE YOUNGER
(Rouen 1692–1768 Paris)

69 *Pygmalion and Galatea*

Pen and black ink wash and black chalk heightened with gouache on three joined pieces of tan antique laid paper, with additional flap for compositional option on left side, partial framing lines in black chalk, laid down on a decorated mount; 409 × 583 mm (380 × 195 mm, additional flap)

WATERMARK: Laid down; none visible through mount
INSCRIPTIONS: None
PROVENANCE: Galerie Eric Coatalem, Paris; acquired in 2000, inv. no. D-F-782
EXHIBITION: Paris 2000
LITERATURE: Eric Coatalem in Paris 2000; Gouzi 2000, cat. no. D.81 bis, p. 375

PLATE 11

RENÉ-MICHEL, called MICHEL-ANGE SLODTZ
(Paris 1705–1764 Paris)
After Annibale Carracci (1560–1609)

70 *Seated Dog Looking Upward*

Red chalk on cream antique laid paper, laid down; 451 × 350 mm

WATERMARK: None
INSCRIPTION: Signed (?), bottom center, brown ink: *M. A. Slodtz*
PROVENANCE: Louis-Alexandre Aubé, Chevalier de Damery, Paris (his mark, L.2862, bottom right); L. Berger (his mark, not in Lugt, lower left); Galerie Cailleux, Paris; acquired in 1994, inv. no. D-F-266
EXHIBITIONS: None
LITERATURE: Alvin L. Clark, Jr., with Patrick Murphy in Cambridge et al. 1998, cat. no. A.330, p. 430; Scherf 2003, p. 353

PLATE 75

PIERRE-HUBERT SUBLEYRAS
(Saint-Gilles-du-Gard 1699–1749 Rome)

71 *Moses and the Brazen Serpent*

Black chalk with traces of white chalk on blue antique laid paper, framing line in black chalk; 351 × 459 mm

WATERMARK: None
INSCRIPTIONS: None
PROVENANCE: Charles Gasc, Paris (his mark, L.543); Galerie Emmanuel Moatti, Paris; acquired in 1994, inv. no. D-F-270
EXHIBITIONS: None
LITERATURE: Alvin L. Clark, Jr., with Patrick Murphy in Cambridge et al. 1998, cat. no. A.331, p. 430

PLATE 28

PIERRE-HUBERT SUBLEYRAS
(Saint-Gilles-du-Gard 1699–1749 Rome)
After Benedetto Luti (1666–1724)

72 *Kneeling Ecclesiastic*

Black chalk heightened with traces of white chalk on off-white antique laid paper, framing lines in black ink; 356 × 249 mm

WATERMARK: None
INSCRIPTION: Lower left, brown ink: *Subleyras*
PROVENANCE: Jean-Denis Lempereur, Paris (his mark, L.1740, lower right); sale, Paris, Drouot, 24 January 1980, lot 295; Galerie Heim, Paris; private collection, Avignon; sale, Paris, 16 July 1987, lot 9; Frederick J. Cummings, New York; acquired in 1990, inv. no. D-F-269
EXHIBITIONS: None
LITERATURE: Alvin L. Clark, Jr., with Patrick Murphy in Cambridge et al. 1998, cat. no. A.332, p. 430

PLATE 29

PIERRE-CHARLES TRÉMOLIÈRES
(Chôlet 1703–1739 Paris)

73 *Hagar and the Angel*

Red chalk on cream antique laid paper; 332 × 240 mm

WATERMARK: None
INSCRIPTION: Verso, upper left, graphite: *No 1*
PROVENANCE: Gabriel Terrades, Paris; acquired in 2010, inv. no. D-F-1406
EXHIBITIONS: None
LITERATURE: None

PLATE 48

CHARLES-ANDRÉ, called CARLE VANLOO
(Nice 1705–1765 Paris)

74 *Fantasy Figure*

Brown chalk on cream antique laid paper, framing lines in brown and black ink; 556 × 295 mm

WATERMARK: Laid down; none visible through mount
INSCRIPTIONS: None
PROVENANCE: Private collection, Paris; Nicolas Joly at Galerie Yves Mikaeloff, Paris; acquired in 1997, inv. no. D-F-510
EXHIBITIONS: Paris 1996b, no. 11; Cambridge et al. 1998, no. 63
LITERATURE: Nicolas Joly in Paris 1996b, cat. no. 11, p. 28; Jean-François Méjanès in Cambridge et al. 1998, cat. no. 63, pp. 234–35

PLATE 64

75 *Mademoiselle Clairon as Medea Fleeing from Jason*

Pen and brown ink with brush and two tones of brown wash, heightened with white gouache on tan antique laid paper; 638 × 805 mm

WATERMARK: Laid down; none visible through mount
INSCRIPTION: Signed, bottom right, pen and brown ink: *Carle Vanloo*
PROVENANCE: Jean-Claude-Gilles Colson, called Bellecourt, Paris (as of 1765); Chevalier, Paris; sale, Paris, 26–27 November 1779, lot 46; Charles-Paul-Jean-Baptiste de Bougevin Vialart de Saint-Morys, Paris; his sale, Paris, 1–23 February 1786, lot 346; sale, Paris, 17–22 December 1787, lot 131; Gabriel Terrades at Galerie Grunspan, Paris (in 1996); private collection, London; Hazlitt, Gooden and Fox Ltd., London (in 1997); acquired in 1997, inv. no. D-F-476
EXHIBITIONS: Paris, Salon of 1757, no. 8; Paris 1996a; Cambridge et al. 1998, no. 66; Paris 2010, no. 70; Houston 2011, no. 47
LITERATURE: Fréron 1757, letter 15, 31 August 1757, p. 338; Anonymous 1757, p. 159; Dandré-Bardon 1765, p. 66; Réau 1938, p. 66; Diderot—Seznec—Adhémar 1957, vol. 1, p. 39; Marie-Catherine Sahut in Nice et al. 1977, cat. no. 457a (as a lost drawing), p. 149; Marie-Catherine Sahut in Cambridge et al. 1998, cat. no. 66, pp. 240–43; Christophe Leribault in Paris 2010, cat. no. 70, pp. 254–56; Christophe Leribault in Houston 2011, cat. no. 47, p. 106

PLATE 70

76 *Portrait of the Artist's Son*

Black chalk heightened with white chalk on tan antique laid paper, framing line in black ink; 355 × 315 mm

WATERMARK: Laid down; none visible through mount
INSCRIPTION: Signed, bottom right, pen and black ink: *Carle Vanloo*
PROVENANCE: Sale, Paris, Drouot, 17 November 1950, lot 75; sale, Paris, Drouot, 12–13 November 1952, lot 61; Jean-Pierre Selz, Paris; acquired in 1987, inv. no. D-F-278
EXHIBITION: Cambridge et al. 1998, no. 64
LITERATURE: Marie-Catherine Sahut in Nice et al. 1977, cat. nos. 482a and 482b (as lost, but known through an engraving), p. 153; Marie-Catherine Sahut in Cambridge et al. 1998, cat. no. 64, pp. 236–37

PLATE 71

77 Saint Augustine Disputing with the Donatistes

Pen and brown ink and brown wash on cream antique laid paper; 519 × 669 mm

WATERMARK: None

INSCRIPTION: Signed, lower right, brown ink: *Carle. Vanloo* (last five letters underlined)

PROVENANCE: Galerie Talabardon, Paris; acquired in 2000, inv. no. D-F-809

EXHIBITIONS: None

LITERATURE: None

PLATE 69

JEAN-ANTOINE WATTEAU
(Valenciennes 1684–1721 Nogent-sure-Marne)

78 Seated Couple

Red chalk on cream antique laid paper; 191 × 183 mm (extended additional 21 mm on decorative mount at top)

WATERMARK: Laid down; none visible through mount

INSCRIPTIONS: None

PROVENANCE: Perhaps Jules-Robert August, Paris; perhaps his sale, Paris, Drouot, 28–31 May 1850, one of the undescribed groups of Watteau (lots 100–103); Baron Louis-Auguste de Schwiter, Paris (his mark, L.1768, lower left); his sale, Paris, Drouot, 20–21 April 1883, lot 171; Henri Michel-Lévy, Paris; Louis Cartier, Paris; his son, Claude Cartier, Paris, by descent; his sale, Monte Carlo, Sotheby's, 26 November 1979, lot 519; private collection; sale, New York, Sotheby's, 10 January 1995; acquired at the sale, inv. no. D-F-304

EXHIBITION: Cambridge et al. 1998, no. 35

LITERATURE: Morgan Grasselli 1993, cat. no. 10, p. 116, and p. 119, fig. 19; Rosenberg and Prat 1996, vol. 2, cat. no. 470, p. 784; Margaret Morgan Grasselli in Cambridge et al. 1998, cat. no. 35, pp. 170–71

PLATE 3

79 Standing Man in Persian Costume Seen from Behind

Red chalk on cream antique laid paper; 322 × 133 mm

WATERMARK: Laid down; none visible through mount

INSCRIPTION: Verso of mount, bottom left, brown ink: *Watteau*

PROVENANCE: General de la Villestreux; A. Danlos (in 1901); sale, Paris, Drouot, 15 April 1946, lot 119; Marcel Boussac, Paris; Boussac family, by descent; Didier Aaron et Cie, Paris; acquired in 1995, inv. no. D-F-305

EXHIBITION: Cambridge et al. 1998, no. 34

LITERATURE: Parker and Mathey 1957, vol. 2, cat. no. 580, p. 313; Margaret Morgan Grasselli in Washington et al. 1984, under cat. no. 49, p. 112; Roland Michel 1984, pp. 133–34; Morgan Grasselli 1987, p. 170; Rosenberg and Prat 1996, vol. 1, cat. no. 285, pp. 448–49; Margaret Morgan Grasselli in Cambridge et al. 1998, cat. no. 34, pp. 168–69

PLATE 2

80 Studies of a Seated Woman and a Hand

Black and red chalk on off-white antique laid paper; 158 × 116 mm

WATERMARK: Laid down; none visible through mount

INSCRIPTION: Mount, bottom right, blind mark of mount maker E. Mans (L.878b)

PROVENANCE: Perhaps Jean de Jullienne, Paris; perhaps Francesco Maria Nicolò Gaburri, Florence; sale, London, Sotheby's, 27 April 1927, lot 53; sale, Paris, Charpentier, 8 December 1953, lot 28; Paul Cailleux, Paris (his stamp, lower right, black ink); Galerie Cailleux, Paris; acquired in 1984, inv. no. D-F-302

EXHIBITIONS: Paris 1968, no. 50; Paris and Geneva 1978, no. 65; Cambridge et al. 1998, no. 36

LITERATURE: Parker and Mathey 1957, vol. 2, cat. no. 595, p. 314; Marianne Roland Michel in Paris 1968, cat. no. 50; Marianne Roland Michel in Paris and Geneva 1978, cat. no. 65, p. 95; Pierre Rosenberg in Washington et al. 1984, p. 357; Boerlin-Brodbeck 1987, p. 163n2; Schreiber Jacoby 1987, pp. 257–58n36; Rosenberg and Prat 1996, vol. 1, cat. no. 328, p. 526; Margaret Morgan Grasselli in Cambridge et al. 1998, cat. no. 36, pp. 172–73

PLATE 1

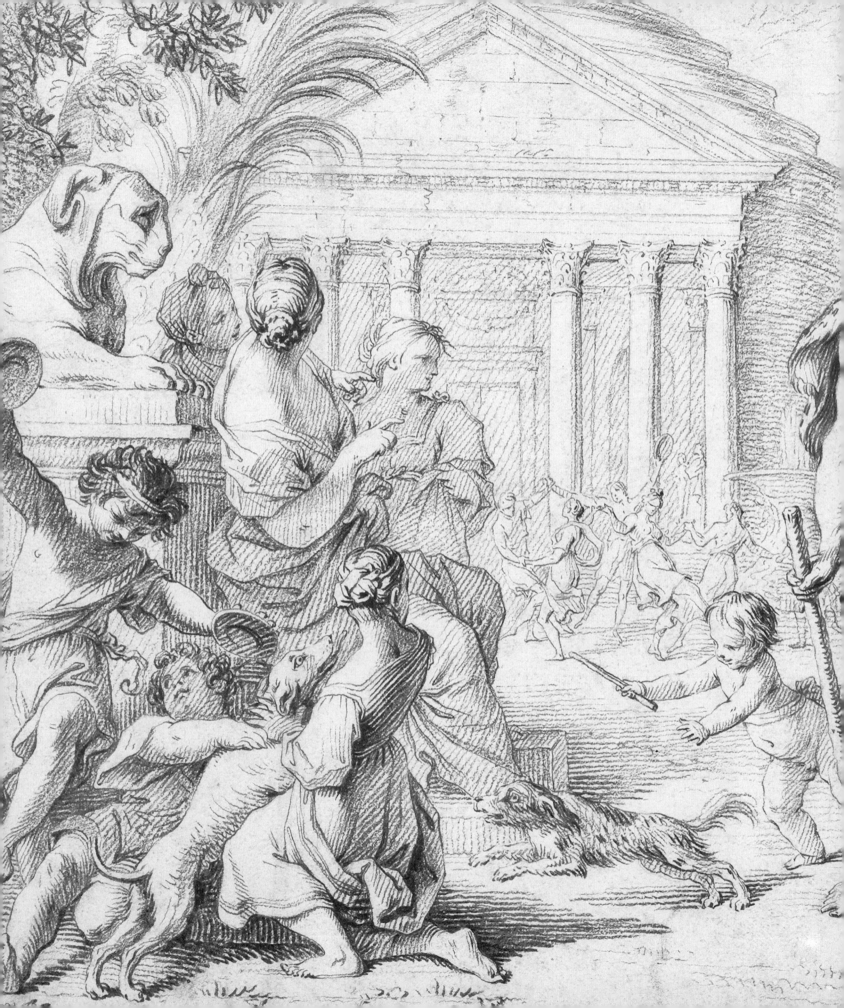

SELECTED BIBLIOGRAPHY

Algarotti 1769 ♦ Francesco Algarotti, *Essai sur le peinture et sur l'Académie de France, établie à Rome*, Paris, 1769

Amiens 1997 ♦ Amiens, Musée de Picardie, *Dessins français des XVIIIe et XIXe siècles du Musée de Picardie*, 1997–98, cat. by Sylvain Boyer

Amiens and Versailles 1995 ♦ Amiens, Musée de Picardie—Versailles, Musée National des Châteaux de Versailles et de Trianon, *Versailles: Les chasses exotiques de Louis XV*, 1996, cat. by Xavier Salmon et al.

Ananoff 1966 ♦ Alexandre Ananoff, *L'oeuvre dessiné de François Boucher (1703–1770): Catalogue raisonné*, Paris, 1966

Ananoff and Wildenstein 1976 ♦ Alexandre Ananoff and Daniel Wildenstein, *François Boucher*, 2 vols., Lausanne and Paris, 1976

Ananoff and Wildenstein 1980 ♦ Alexandre Ananoff and Daniel Wildenstein, *L'opera completa di Boucher*, vol. 100 of *Classici dell'Arte*, Milan, 1980

Anonymous 1707 ♦ "Prix distribuez par Mr Mansard, à l'Académie de Peinture et de Sculpture," *Le Mercure Galant* (Jan. 1707): 382–89

Atlanta 1983 ♦ Atlanta, High Museum of Art, *The Rococo Age*, 1983, cat. by Eric M. Zafran with Jean-Luc Bordeaux

Bailey 2000 ♦ Colin Bailey, "An Early Masterpiece by Boucher Rediscovered: *The Judgment of Susannah* in the National Gallery of Canada," *National Gallery of Canada Review* 1 (2000): 11–34, 101–13

Bancel 2008 ♦ André Bancel, *Jean-Baptiste Deshays, 1729–1765*, Paris, 2008

Bean and Turčić 1986 ♦ Jacob Bean and Lawrence Turčić, *15th–18th Century French Drawings in The Metropolitan Museum of Art*, New York, 1986

Bell 2010 ♦ Esther Bell, "Charles Coypel: Painting and Performance in Eighteenth-Century France," Ph.D. diss., Institute of Fine Arts, New York University, 2010

Berckenhagen 1970 ♦ Ekhart Berckenhagen, *Die Französischen Zeichnungen der Kunstbibliothek Berlin*, Berlin, 1970

Bjurström 1976 ♦ Per Bjurström, *French Drawings: Sixteenth and Seventeenth Century*, vol. 2 of *Drawings in Swedish Public Collections*, Stockholm, 1976

Bjurström 1982 ♦ Per Bjurström, *French Drawings: Eighteenth Century*, vol. 4 of *Drawings in Swedish Public Collections*, Stockholm, 1982

Bjurström 1986 ♦ Per Bjurström, *French Drawings: Nineteenth Century*, vol. 5 of *Drawings in Swedish Public Collections*, Stockholm, 1986

Blunt 1945 ♦ Anthony Blunt, *The French Drawings in the Collection of His Majesty the King at Windsor Castle*, Oxford, 1945

Bocher 1876 ♦ Emmanuel Bocher, *Jean-Baptiste-Siméon Chardin* (1876), vol. 3 of *Les gravures françaises du XVIIIe siècle*, Paris, 1875–82

Boerlin-Brodbeck 1987 ♦ Yvonne Boerlin-Brodbeck, "La figure assise dans un paysage," in *Antoine Watteau (1684–1721): Le peintre, son temps, et sa légende*, ed. by François Moreau and Margaret Morgan Grasselli, Paris and Geneva, 1987, 163–71

Bordeaux 1984 ♦ Jean-Luc Bordeaux, *François Le Moyne (1688–1737) and His Generation*, Neuilly-sur-Seine, 1984

Boyer 1949 ♦ Ferdinand Boyer, "Catalogue raisonné de l'oeuvre de Charles Natoire," *Archives de l'art français* 21 (1949): 31–107

Bull 1993 ♦ Duncan Bull, "Review: Salon du dessin de collection," *The Burlington Magazine* 135 (May 1993): 367–69

Burns 2007 ♦ Thea Burns, *The Invention of Pastel Painting*, London, 2007

Caillet 1928 ♦ Robert Caillet, *Alexis Peyrotte, peintre et dessinateur du roi*, Paris, 1928

Cailleux 1971 ♦ Jean Cailleux, "Three Portraits in Pastel and Their History," *L'art du dix-huitième siècle*, supplement in *The Burlington Magazine* 27 (Nov. 1971): ii–vi

Cambridge et al. 1998 ♦ Cambridge, Fogg Art Museum, Harvard University Art Museums—Toronto, Art Gallery of Ontario—Paris, Musée Jacquemart-André—Edinburgh, National Gallery of Scotland—New York, National Academy Museum and School of Fine Arts—Los Angeles, Los Angeles County Museum of Art, *Mastery and Elegance: Two Centuries of French Drawings from the Collection of Jeffrey E. Horvitz*, 1998–2000, cat. ed. by Alvin L. Clark, Jr., et al.

Cavalier 2002 ♦ Odile Cavalier, *L'empire de Mars et des Muses: La collection du marquis de Calvière, lieutenant-général des armées du roi, 1693–1777*, Avignon, 2002

Caviglia-Brunel 2004 ♦ Susanna Caviglia-Brunel, "Des finalités du dessin chez Charles-Joseph Natoire," *Revue de l'art* 143 (2004): 35–48

Caviglia-Brunel 2012 ♦ Susanna Caviglia-Brunel, *Charles-Joseph Natoire*, Paris, 2012

Caylus 1732 ♦ Anne-Claude-Philippe de Tubières, comte de Caylus, *Discours sur les desseins*, Paris, 1732, reprinted in *Revue universelle des arts* 9 (1859): 317–23

Chol 1987 ♦ Daniel Chol, *Michel-François Dandré-Bardon, ou l'apogée de la peinture en Provence au XVIIIe siècle*, Aix-en-Provence, 1987

Clark and Morgan Grasselli 2012 ♦ Alvin L. Clark, Jr., and Margaret Morgan Grasselli, "Jean-François Méjanès," *Master Drawings* 50, no. 3 (2012): 409

Cleveland and New York 2001 ♦ Cleveland, The Cleveland Museum of Art—New York, Dahesh Museum, *French Master Drawings from the Collection of Muriel Butkin*, 2001, cat. by Carter E. Foster

Compère 2000 ♦ Marie-Madeleine Compère, *Les collèges français, 16e–18e siècles*, Paris, 2000

Copenhagen 2013 ♦ Copenhagen, Gl Holtegaard, *François Boucher: Fragments of a World Picture*, 2013, cat. by Françoise Joulie

Cornu 1912 ♦ Paul Cornu, ed., *Correspondance des directeurs de l'Académie de France à Rome avec les surintendants des bâtiments*, Paris, 1912

Courajod 1874 ♦ Louis Courajod, *Histoire de l'École des Beaux-Arts au XVIIIe siècle: L'École Royale des Elèves Protégés*, Paris, 1874

Coypel 1729 ♦ Charles Coypel, "Lettre de M. Ch. Coypel, de l'Académie Royale de Peinture & Sculpture, au Reverend Père de la Tour, superieur general de la Congrégation de l'Oratoire, au sujet d'un tableau de 40. Pieds de haut sur 32. De large, nouvellment placé," *Mercure de France* (June 1729): 1290–96

Coypel 1730 ♦ Charles Coypel, "Discours sur la nécessité de recevoir des avis, prononcé dans une Conférence de l'Académie Royale de Peinture et de Sculpture le quatriéme Novembre 1730," in *Oeuvres*, Slatkine Reprints, Geneva (1971): 51–88

Dandré-Bardon 1765 ♦ Michel-François Dandré-Bardon, *Essai sur la sculpture, suivi d'un catalogue des artistes les plus fameux de l'école française*, 2 vols., Paris, 1765

Darmstadt 2007 ♦ Darmstadt, Hessisches Landesmuseum Darmstadt, Graphishe Sammlung, *Dessins français du Musée de Darmstadt: XVIe, XVIIe, et XVIIIe siècles*, 2007, cat. by Dominique Cordellier et al.

Dayot and Vaillat 1907 ♦ Armand Dayot and Léandre Vaillat, *L'oeuvre de J. B. S. Chardin et J. H. Fragonard*, Paris, 1907

de Piles 1708 ♦ Roger de Piles, *Cours de peintures par principes*, Paris, 1708

Diderot and d'Alembert 1751 ♦ Denis Diderot and Jean le Rond d'Alembert, eds., *Encyclopédie, ou dictionnaire raisonné des sciences, des arts et des métiers, par une société de gens de lettres*, 1751–72, 17 vols., ed. by Robert Morrissey, University of Chicago: Artfl Encyclopédie Project (spring 2013 edition), http://encyclopedie.uchicago.edu

Diderot—Seznec—Adhémar 1957 ♦ Denis Diderot, *Salons*, 4 vols., ed. by Jean Seznec and Jean Adhémar, Oxford, 1957–67

Dijon and London 2004 ♦ Dijon, Musée Magnin—London, The Wallace Collection, *Boucher et les peintres du nord*, 2004–5, cat. by Françoise Joulie

Fahy et al. 2005 ♦ Everett Fahy et al., *The Wrightsman Pictures*, New York, 2005

Florence 2012 ♦ Florence, Museo Salvatore Ferragamo, *Marilyn*, 2012–13, cat. ed. by Stefania Ricci and Sergio Risaliti

Fréron 1757 ♦ Elie-Catherine Fréron, "Exposition des ouvrages de peinture, de sculpture, et de gravure," *L'année litteraire* 15 (31 Aug. 1757): 333–52

Fuhring 1999 ♦ Peter Fuhring, *Juste-Aurèle Meissonnier: Un genie du rococo 1695–1750*, 2 vols., Turin, 1999

Furcy-Raynaud 1903 ♦ Marc Furcy-Raynaud, "Correspondance de M. Marigny avec Coypel, Lépicié, et Cochin" (1903), *Nouvelles archives de l'art français*, 3rd ser., 20, no. 1 (1904): 1–302

Garnier 1989 ♦ Nicole Garnier, *Antoine Coypel, 1661–1722*, Paris, 1989

Goncourt 1909 ♦ Edmond and Jules de Goncourt, *L'art du dix-huitième siècle*, 9th ed., Paris, 1909

Gougenot 1767 ♦ Abbé Louis Gougenot, "Vie de M. Galloche, peintre et chancelier de l'Académie Royale de Peinture et de Sculpture," in vol. 2 of *Mémoires inédits sur la vie et les ouvrages des membres de l'Académie Royale de Peinture et de Sculpture, publiés d'après les manuscrits conservés a l'École Impérial des Beaux-Arts* (1767), ed. by Louis Dussieux, Edouard Soulié, Philippe de Chennevières, Paul Mantz, and Anatole de Montaiglon, Paris, 1854, 289–307

Gouzi 2000 ♦ Christine Gouzi, *Jean Restout, 1692–1768: Peintre d'histoire à Paris*, Paris, 2000

Hattis 1977 ♦ Phyllis Hattis, *Four Centuries of French Drawings in the Fine Arts Museums of San Francisco*, San Francisco, 1977

Hattori 2003 ♦ Cordelia Hattori, "The Drawings Collection of Pierre Crozat (1665–1740)," in *Collecting Prints and Drawings in Europe, c. 1500–1750*, ed. by Christopher Baker, Caroline Elam, and Genevieve Warwick, Aldershot, UK, and Burlington, VT, 2003, 173–82

Haverkamp-Begemann et al. 1999 ♦ Egbert Haverkamp-Begemann et al., *Fifteenth- to Eighteenth-Century European Drawings in the Robert Lehman Collection: Central Europe, The Netherlands, France, England*, vol. 7 of *The Robert Lehman Collection*, New York, 1999

Henry 2002 ♦ Christophe Henry, "Aux sources du style: L'imitation et le culte des grands maîtres dans la peinture française du XVIIIème siècle (1708–1799)," Ph.D. diss., Université de Paris I Panthéon-Sorbonne, 2002

Houston 2011 ♦ Houston, Museum of Fine Arts, *Antiquity Revived: Neoclassical Art in the Eighteenth Century*, 2011, cat. by Guillaume Faroult et al.

Hyde 2006 ♦ Melissa Hyde, *Making Up the Rococo: François Boucher and His Critics*, Los Angeles, 2006

Jamieson 1930 ♦ Irene Jamieson, *Charles-Antoine Coypel, premier peintre de Louis XV et auteur dramatique*, Paris, 1930

Jean-Richard 1978 ♦ Pierrette Jean-Richard, *L'oeuvre gravé de François Boucher dans la collection Edmond de Rothschild*, vol. 1 of *Inventaire général des gravures, École française*, Paris, 1978

Jordan 1985 ♦ Marc Jordan, "Edme Bouchardon: A Sculptor, a Draughtsman and His Reputation in Eighteenth-Century France," *Apollo* (June 1985): 388–94

Laing 1989 ♦ Alastair Laing, "A Group of Boucher's Designs for Coach Panels," in vol. 1 of *Design into Art: Drawings for Architecture and Ornament: The Lodewijk Houthakker Collection*, ed. by Peter Fuhring, New York, 1989, 116–21

Laing 2004 ♦ Alastair Laing, "Naked Effrontery," *Art News* (Jan. 2004): 92, 94

Launay 1991 ♦ Élisabeth Launay, *Les frères Goncourt: Collectionneurs de dessins*, Paris, 1991

Lee 1940 ♦ Rensselaer W. Lee, "Ut Pictura Poesis: The Humanistic Theory of Painting," *Art Bulletin* 22, no. 4 (Dec. 1940): 197–269

Lefrançois 1994 ♦ Thierry Lefrançois, *Charles Coypel, peintre du roi (1694–1752)*, Paris, 1994

Legrand 1997 ♦ Catherine Legrand with Varena Forcione, Véronique Goarin, and Catherine Scheck, *De Pagnest à Puvis de Chavannes*, vol. 13 of *Inventaire général des dessins, École française*, Paris, 1997

Lepicié 1737 ♦ Nicolas-Bernard Lepicié, "Review of the Salon of 1737," *Le Mercure Galant* (Sept. 1737)

Lépicié 1752 ♦ François-Bernard Lépicié, "Vie d'Antoine Coypel," in vol. 2 of *Vies des premiers peintres du roi*, Paris, 1752, 1–41

Lichtenstein and Michel 2009 ♦ Jacqueline Lichtenstein and Christian Michel, *Les Conférences au temps de Jules Hardouin-Mansart*, vol. 3 of *Conférences de l'Académie Royale de Peinture et de Sculpture*, Paris, 2009

Lodève 2008 ♦ Lodève, Musée de Lodève, *Dessins du Musée Atger: Chefs-d'oeuvre d'une collection*, 2008, cat. by Maïthé Vallès-Bled with Hélène Lorblanchet

London 1978 ♦ London, Artemis, *Eighteenth Century French Paintings, Drawings and Sculpture*, 1978, cat. by David Carritt Ltd.

London 1980 ♦ London, Baroni Gallery, *Master Drawings*, 1980, cat. by Jean-Luc Baroni

London 1986 ♦ London, Thos. Agnew and Sons Ltd., *From Claude to Géricault: The Arts in France, 1630–1830*, 1986, cat. by Gabrielle Naughton

London 1989a ♦ London, Kate Ganz Ltd., *Master Drawings*, 1989, cat. by Kate Ganz

London 1989b ♦ London, Thos. Agnew and Sons Ltd., *Master Drawings*, 1989, cat. by Gabrielle Naughton

London 2001 ♦ London, Hermitage Rooms, Somerset House, *French Drawings and Paintings from the Hermitage: Poussin to Picasso*, 2001, cat. by Timothy Clifford et al.

London 2004 ♦ London, The Wallace Collection, *François Boucher: Seductive Visions*, 2004–5, cat. by Jo Hedley

London and Edinburgh 2010 ♦ London, The Wallace Collection—Edinburgh, National Gallery of Scotland, *Poussin to Seurat: French Drawings from the National Gallery of Scotland*, 2010, cat. by Michael Clarke

London and Glasgow 2008 ♦ London, The Wallace Collection—Glasgow, Hunterian Art Gallery, University of Glasgow, *Boucher and Chardin: Masters of Modern Manners*, 2008, cat. ed. by Anne Dulau

Los Angeles 2006 ♦ Los Angeles, Getty Research Institute, Getty Center, *Rethinking Boucher*, 2006, cat. ed. by Melissa Hyde and Mark Ledbury

Lyon and Lille 2000 ♦ Lyon, Musée des Beaux-Arts—Lille, Palais des Beaux-Arts, *Settecento: Le siècle de Tiepolo peintures italiennes du XVIIIe siècle exposées dans les collections publiques françaises*, 2000–2001, cat. ed. by Arnauld Brejon de Lavergnée and Philippe Durey

Maral 2011 ♦ Alexandre Maral, *La Chapelle Royale de Versailles: Le dernier grand chantier de Louis XIV*, Paris, 2011

Mariette 1750 ♦ Pierre-Jean Mariette, *Abécédario de P.J. Mariette et autres notes inédits de cet amateur* (c. 1750), published posthumously as five vols. of *Archives de l'art français*, vols. 2 (1), 4 (2), 6 (3), 8 (4), and 10 (5), ed. by Philippe de Chennevières and Anatole de Montaiglon, Paris, 1851–60

Marseille 2001 ♦ Marseille, Château Borély, *Maurice et Pauline Feuillet de Borsat collectionneurs: Dessins français et étrangers du XVIIe au XIXe siècle*, 2001, cat. by Marianne Roland Michel

Massé 1752 ♦ Jean-Baptiste Massé, "Lettre de M. Massé, peintre du roi … à M. le Président Haudiqué, exécuter testamentaire de feu M. Coypel, ecuyer, premier peintre du roi," *Le Mercure de France* (Aug. 1752): 147–57

Mathews 1994 ♦ Annie-Christine Daskalakis Mathews, "An Exceptional Allegorical Portrait by Jean-Baptiste Lemoyne," *Metropolitan Museum Journal* 29 (1994): 99–109

Méjanès 2001 ♦ Jean-François Méjanès, "Un exercice hors règlement: Bloemaert, Boucher et Subleyras … mais pas Natoire," in *Mélanges en hommage à Pierre Rosenberg: Peintures et dessins en France et en Italie XVIIe–XVIIIe siècles*, ed. by Anna Ottani Cavina, Jean-Pierre Cuzin, Michel Laclotte, et al., Paris, 2001, 298–315

Mérot 2003 ♦ Alain Mérot, ed., *Les Conférences de l'Académie Royale de Peinture et de Sculpture au XVIIe siècle*, 2nd. ed., Paris, 2003

Michel 2004 ♦ Christian Michel, "Le goût pour le dessin en France aux XVIIe et XVIIIe siècles: De l'utilisation à l'étude désintéressée," *Revue de l'art* 143 (2004): 27–34

Montaiglon 1875 ♦ Anatole de Montaiglon, ed., *Procès verbaux de l'Académie Royale de Peinture et de Sculpture (1648–1792)*, 10 vols., Paris, 1875–92

Montpellier 1996 ♦ Montpellier, Bibliothèque Interuniversitaire de Montpellier, *Petits et grands maîtres du Musée Atger: Cent dessins français des 17ème et 18ème siècles*, 1996, cat. by Christiane and Pierre Nicq

Montpellier 2010 ♦ Montpellier, Musée Fabre, *Le trait en majesté: Dessins français du XVIIe siècle au Musée Fabre*, 2010, cat. by Michel Hilaire et al.

Montpellier and Strasbourg 2000 ♦ Montpellier, Musée Fabre—Strasbourg, Musées de Strasbourg, *Sébastien Bourdon, 1616–1671: Catalogue critique et chronologique de l'oeuvre complet*, 2000-2001, cat. by Jacques Thuillier et al.

Morgan Grasselli 1987 ♦ Margaret Morgan Grasselli, "The Drawings of Antoine Watteau: Stylistic Development and Problems of Chronology," 2 vols., Ph.D diss., Harvard University, 1987

Morgan Grasselli 1993 ♦ Margaret Morgan Grasselli, "Eighteen New Drawings by Antoine Watteau: A Chronological Study," *Master Drawings* 31, no. 2 (1993): 103–27

Nantes 2011 ♦ Nantes, Musée des Beaux-Arts, *Le théâtre des passions, 1697–1759: Cléopâtre, Médée, Iphigénie*, 2011, cat. by Pierre Rosenberg et al.

New York 1999 ♦ New York, The Metropolitan Museum of Art, *Eighteenth-Century French Drawings in New York Collections*, 1999, cat. by Perrin Stein and Mary Tavener Holmes

New York 2005 ♦ New York, The Metropolitan Museum of Art, *French Drawings: Clouet to Seurat*, 2005, cat. by Perrin Stein with Martin Royalton-Kisch

New York 2008 ♦ New York, Cooper-Hewitt National Design Museum, *Rococo: The Continuing Curve, 1730–2008*, 2008, cat. by Sarah Coffin et al.

New York 2009 ♦ New York, The Metropolitan Museum of Art, *Raphael to Renoir: Drawings from the Collection of Jean Bonna*, 2009, cat. ed. by Stijn Alsteens et al.

New York 2011 ♦ New York, The Metropolitan Museum of Art, *Pastel Portraits: Images of Eighteenth-Century Europe*, 2011, cat. by Katherine Baetjer and Marjorie Shelley [adapted from *The Metropolitan Museum of Art Bulletin* 68, no. 4 (spring, 2011)]

New York 2013 ♦ New York, The Metropolitan Museum of Art, *Artists and Amateurs: Etching in Eighteenth-Century France*, 2013, cat. by Perrin Stein et al.

New York and Edinburgh 1987 ♦ New York, The Drawing Center—Edinburgh, The National Gallery of Scotland, *The Art of Drawing in France, 1400–1900: Drawings from the Nationalmuseum, Stockholm*, 1987, cat. by Per Bjurström

New York and Fort Worth 2003 ♦ New York, The Frick Collection—Fort Worth, Kimbell Art Museum, *The Drawings of François Boucher*, 2003–4, cat. by Alastair Laing

New York and Ottawa 1999 ♦ New York, The Frick Collection—Ottawa, National Gallery of Canada, *Watteau and His World: French Drawing from 1700 to 1750*, 1999–2000, cat. by Alan P. Wintermute with Colin B. Bailey et al.

New York et al. 1986 ♦ New York, The Metropolitan Museum of Art—Detroit, Detroit Institute of Arts—Paris, Galeries Nationales du Grand Palais, *François Boucher, 1703–1770*, 1986, cat. by Alastair Laing et al.

New York et al. 1990 ♦ New York, National Academy of Design—Fort Worth, Kimbell Art Museum—Ottawa, National Gallery of Canada, *Masterful Studies: Three Centuries of French Drawings from the Prat Collection*, 1990–91, cat. by Pierre Rosenberg

New York et al. 1993 ♦ New York, Didier Aaron Inc.—Paris, Didier Aaron et Cie—London, Didier Aaron Ltd., with Kate de Rothschild, *Master Drawings*, 1993, cat. by Jill Dienst et al.

Nice 2000 ♦ Nice, Musée des Beaux-Arts, *Les Van Loo, fils d'Abraham*, 2000–2001, cat. by Jean-François Mozziconacci et al.

Nice et al. 1977 ♦ Nice, Musée des Beaux-Arts—Clermont-Ferrand, Musée Bargoin—Nancy, Musée des Beaux-Arts, *Carle Vanloo, premier peintre du roi (Nice, 1705–Paris, 1765)*, 1977, cat. by Marie-Catherine Sahut with Pierre Rosenberg

Ottawa and Caen 2011 ♦ Ottawa, National Gallery of Canada—Caen, Musée des Beaux-Arts de Caen, *Drawn to Art: French Artists and Art Lovers in 18th-Century Rome*, 2011–12, cat. ed. by Sonia Couturier

Ottawa et al. 2004 ♦ Ottawa, National Gallery of Canada—Victoria, Art Gallery of Greater Victoria—Edmonton, Edmonton Gallery, *French Drawings from the National Gallery of Canada*, 2004–5, cat. by Sonia Couturier

Parfaict 1767 ♦ Claude Parfaict, *Dictionnaire des théâtres de Paris …* (1767), 7 vols., Slatkin Reprints, Geneva, 1967

Paris 1968 ♦ Paris, Galerie Cailleux, *Watteau et sa generation*, 1968, cat. by Marianne Roland Michel

Paris 1971 ♦ Paris, Galerie Cailleux, *Trente pastels, gouaches et aquarelles du XVIIIe siècle*, 1971, cat. by Jean Cailleux

Paris 1983a ♦ Paris, Musée du Louvre, Pavillon de Flore, Cabinet des Dessins, *Les collections du comte d'Orsay: Dessins du Musée du Louvre*, 1983, cat. by Jean-François Méjanès

Paris 1983b ♦ Paris, Galerie Cailleux, *Rome 1760–1770: Fragonard, Hubert Robert et leurs amis*, 1983, cat. by Jean Cailleux and Marianne Roland Michel

Paris 1984 ♦ Paris, Galerie Cailleux, *Le dessin en couleurs, aquarelles, gouaches, pastels*, 1984, cat. by Marianne Roland Michel

Paris 1989 ♦ Paris, École Nationale Supérieure des Beaux-Arts, *Maîtres français 1550–1800: Dessins de la donation Mathias Polakovits à l'École des Beaux-Arts*, 1989, cat. by Natalie Coural

Paris 1992 ♦ Paris, Galerie Moatti, *Dessins anciens*, 1992, cat. by Emmanuel Moatti

Paris 1996a ♦ Paris, Hôtel Georges V, *Salon du dessin 1996*, 1996

Paris 1996b ♦ Paris, Galerie Yves Mikaeloff, *Dessins et peintures anciens*, 1996, cat. by Nicolas Joly

Paris 2000 ♦ Paris, Galerie Eric Coatalem, *Dessins*, 2000, cat. by Eric Coatalem

Paris 2003 ♦ Paris, Musée du Louvre, *François Boucher hier et aujourd'hui*, 2003, cat. by Françoise Joulie and Jean-François Méjanès

Paris 2007 ♦ Paris, Musée du Louvre, *La collection Chennevières: Quatre siècles de dessins français*, 2007, cat. by Louis-Antoine Prat and Laurence Lhinares

Paris 2010 ♦ Paris, Musée du Louvre, *L'Antiquité rêvée: Innovations et résistances au XVIIIe siècle*, 2010–11, cat. by Guillaume Faroult et al.

Paris 2012 ♦ Paris, Musée Jenisch Vevey, *La tentation du dessin: Une collection particulière*, 2012, cat. by Dominique Radrizzani and Emmanuelle Neukomm

Paris and Avignon 2007 ♦ Paris, École Nationale Supérieure des Beaux-Arts—Avignon, Musée Calvet, *Une dynastie de peintres: Les Parrocel*, no. 9 of *Carnets d'Études*, 2007–8, cat. by Emmanuelle Brugerolles

Paris and Geneva 1978 ♦ Paris, Galeries Cailleux—Geneva, Galeries Cailleux, *Sanguines: Dessins français du dix-huitième siècle*, 1978, cat. by Marianne Roland Michel et al.

Paris and Geneva 1986 ♦ Paris, Galeries Cailleux—Geneva, Galeries Cailleux, *Artistes en voyage au XVIIIe siècle*, 1986, cat. by Marianne Roland Michel

Paris and Geneva 2006 ♦ Paris, École Nationale Supérieure des Beaux-Arts—Geneva, Musée d'Art et d'Histoire, *Suite française: Dessins de la collection Jean Bonna*, 2006–7, cat. by Emmanuelle Brugerolles with Joëlla de Couëssin

Paris and New York 1993 ♦ Paris, Musée du Louvre—New York, The Pierpont Morgan Library, *French Master Drawings from The Pierpont Morgan Library*, 1993–94, cat. by Cara Dufour Denison

Paris et al. 1976 ♦ Paris, Galerie Heim—Lille, Palais des Beaux-Arts—Strasbourg, Musée des Beaux-Arts, *Cent dessins français du Fitzwilliam Museum, Cambridge*, 1976, cat. by Michael Jaffé

Paris et al. 1979 ♦ Paris, Galeries Nationales du Grand Palais—Cleveland, Cleveland Museum of Art—Boston, Museum of Fine Arts, Boston, *Chardin, 1699–1779*, 1979, cat. by Pierre Rosenberg

Paris et al. 1991 ♦ Paris, Galeries Nationales du Grand Palais—Philadelphia, Philadelphia Museum of Art—Fort Worth, Kimbell Art Museum, *The Loves of the Gods: Mythological Painting from Watteau to David*, 1991, cat. by Colin A. Bailey with Carrie A. Hamilton

Paris et al. 1995 ♦ Paris, Musée du Louvre—Edinburgh, National Gallery of Scotland—Oxford, Ashmolean Museum, *Dessins français de la collection Prat: XVIIe–XVIIIe–XIXe siècles*, 1995, cat. by Pierre Rosenberg

Paris et al. 2001 ♦ Paris, École Nationale Supérieure des Beaux-Arts—Geneva, Musée d'Art et d'Histoire—New York, The Frick Collection, *Le dessin en France au XVIIe siècle: Dans les collections de L'École des Beaux-Arts*, 2001–2, cat. by Emmanuelle Brugerolles with Joëlla de Couëssin

Parker and Mathey 1957 ♦ Karl Theodore Parker and Jacques Mathey, *Antoine Watteau: Catalogue complet de son oeuvre dessiné*, 2 vols., Paris, 1957

Philadelphia et al. 2006 ♦ Philadelphia, Arthur Ross Gallery, University of Pennsylvania—Sarasota, John and Mable Ringling Museum of Art—Northampton, Smith College Museum of Art, *The Early Modern Painter-Etcher*, 2006, cat. ed. by Michael Cole et al.

Pierre 1788 ♦ Jean-Baptiste-Marie Pierre, "Letter from Pierre, premier peintre du roi, to Abel-François Poisson de Vandières, Marquis de Marigny, directeur-général, bâtiments du roi" (25 May 1788), in Marc Furcy-Raynaud, "Correspondance de M. de Marigny avec Coypel, Lépicié et Cochin," *Nouvelles archives de l'art français*, 3rd ser., 22 (1906): 1–320

Pillsbury et al. 1981 ♦ Edmond Pillsbury et al., *Kimbell Art Museum: Handbook of the Collection*, Fort Worth, 1981

Prat 2000 ♦ Louis-Antoine Prat, "The Marquis de Chennevières and His Collection of French Drawings," *Master Drawings* 38, no. 2 (summer 2000): 117–23

Prat 2003 ♦ Louis-Antoine Prat, "Philippe de Chennevières, Néile Jacquemart-André et Jeffrey E. Horvitz: Trois collections de dessins d'artistes français," in colloquium proceedings, École du Louvre, *Dessins français aux XVIIe et XVIIIe siècles* (1999), ed. by Nicolas Sainte Fare Garnot, Paris, 2003, 21–36

Princeton 1977 ♦ Princeton, Princeton University Art Museum, *Eighteenth-Century French Life-Drawing: Selections from the Collection of Mathias Polakovits*, 1977, cat. by James Henry Rubin

Réau 1938 ♦ Louis Réau, "Carle Vanloo (1705–1765)," *Archives de l'art français* 19 (1938): 7–96

Rennes 2012 ♦ Rennes, Musée des Beaux-Arts de Rennes, *Dessins de la collection Christian et Isabelle Adrien*, 2012, cat. by Francis Ribemont and Laurence Imbernon

Riccoboni 1728 ♦ Luigi Riccoboni, *Histoire du theatre italien, depuis la decadence de la comedie latine; avec un catalogue des tragedies & comedis italiennes imprimées depuis l'an 1500. jusqu'à l'an 1660. & une dissertation sur la tragedie moderne. Avec des figures qui représentent leurs differens habillemens*, Paris, 1728

Roland Michel 1984 ♦ Marianne Roland Michel, *Watteau: An Artist of the Eighteenth Century*, London, 1984

Roland Michel 1987 ♦ Marianne Roland Michel, *Le dessin français du XVIIIe siècle*, Paris, 1987

Roland Michel 1996 ♦ Marianne Roland Michel, *Chardin*, New York, 1996

Rolland 2012 ♦ Christine Rolland, *Autour des Van Loo: Peinture, commerce des tissus et espionnage en Europe (1250–1830)*, Mont-Saint-Aignan Cedex, 2012

Rondel 1914 ♦ Auguste Rondel, "Alceste, comédie inédite de Charles Coypel," *La revue du XVIIIe siècle* 2 (Apr.–June 1914): 175–86

Rosenberg 1976 ♦ Pierre Rosenberg, "Sebastiano Ricci et la France: À propos de quelques textes anciens," in colloquium proceedings, *Sebastiano Ricci e il suo tempo* (1975), Milan, 1976, 122–26

Rosenberg 1983 ♦ Pierre Rosenberg, *Chardin: Tout l'oeuvre peint*, Milan and Paris, 1983

Rosenberg 1987 ♦ Pierre Rosenberg, "Chardin Studies," review of *Chardin*, by Phillip Conisbee, *The Burlington Magazine* 129, no. 1007 (Feb. 1987): 116–18

Rosenberg 1999 ♦ Pierre Rosenberg, "Tiepolo e Dandré-Bardon," *Arte Veneta* 53 (1999): 101–5

Rosenberg 2000 ♦ Pierre Rosenberg, *From Drawing to Painting: Poussin, Watteau, Fragonard, David & Ingres*, Princeton, 2000

Rosenberg 2001 ♦ Pierre Rosenberg, *Michel-François Dandré-Bardon (1700–1778)*, no. 12 of *Cahiers du dessin français*, Paris, 2001

Rosenberg 2003 ♦ Pierre Rosenberg, "À propos de Natoire," in colloquium proceedings, École du Louvre, *Dessins français aux XVIIe et XVIIIe siècles* (1999), ed. by Nicolas Sainte Fare Garnot, Paris, 2003, 345–50

Rosenberg 2004a ♦ Pierre Rosenberg, "Paris-Venise, ou plutôt Venise-Paris: 1715–1723," in colloquium proceedings, École du Louvre and Istituto Veneto di scienze, lettere ed arti, *Venise en France: La fortune de la peinture vénitienne des collections royales jusqu'au XIXe siècle* (2002), ed. by Gennaro Toscano, Paris, 2004, 99–113

Rosenberg 2004b ♦ Pierre Rosenberg, *Passion for Drawing: Poussin to Cézanne, Works from the Prat Collection*, Alexandria, VA, 2004

Rosenberg and Barthélemy-Labeeuw 2011 ♦ Pierre Rosenberg and Laure Barthélemy-Labeeuw, *Les dessins de la collection Mariette: École française*, 2 vols., Milan, 2011

Rosenberg and Lesur 2013 ♦ Pierre Rosenberg and Nicolas Lesur, *Pierre Subleyras (1699–1749)*, no. 17 of *Cahiers du dessin français*, Paris, 2013

Rosenberg and McCullagh 1985 ♦ Pierre Rosenberg and Suzanne Folds McCullagh, "The Supreme Triumph of the Old Painter: Chardin's Final Work in Pastel," *The Art Institute of Chicago's Museum Studies* 12, no. 1 (1985): 43–59

Rosenberg and Prat 1996 ♦ Pierre Rosenberg and Louis-Antoine Prat, *Jean-Antoine Watteau: Catalogue raisonné des dessins*, 2 vols., Milan, 1996

St. Petersburg 1999 ♦ St. Petersburg, The State Hermitage Museum, *Le dessin français du XVIIe siècle dans les collections du Musée de l'Ermitage*, 1999, cat. by Irina Novosselskaya

Salmon 1996 ♦ Xavier Salmon, *Jacques-André Portail (1695–1759)*, no. 10 of *Cahiers du dessin français*, Paris, 1996

Salmon 2001 ♦ Xavier Salmon, *Trésors cachés: Chefs-d'oeuvre du Cabinet d'Arts Graphiques du Château de Versailles*, Paris, 2001

Scherf 2003 ♦ Guilhem Scherf, "Un sculpteur qui dessine: Michel-Ange Slodtz," in colloquium proceedings, École du Louvre, *Dessins français aux XVIIe et XVIIIe siècles* (1999), ed. by Nicolas Sainte Fare Garnot, Paris, 2003, 351–66

Schreiber Jacoby 1986 ♦ Beverly Schreiber Jacoby, *François Boucher's Early Development as a Draughtsman, 1720–1734*, New York and London, 1986

Schreiber Jacoby 1987 ♦ Beverly Schreiber Jacoby, "Watteau and Gabburri," in *Antoine Watteau (1684–1721): Le peintre, son temps, et sa légende*, ed. by François Moreau and Margaret Morgan Grasselli, Paris and Geneva, 1987, 255–58

Schreiber Jacoby 2001 ♦ Beverly Schreiber Jacoby, "Newly Discovered Early Chalk Drawings by Boucher," *Master Drawings* 39, no. 3 (fall 2001): 300–306

Sievers 2000 ♦ Ann H. Sievers, *Master Drawings from the Smith College Museum of Art*, New York, 2000

Stein 2000 ♦ Perrin Stein, "Copies and Retouched Drawings by Charles-Joseph Natoire," *Master Drawings* 38, no. 2 (summer 2000): 167–86

Stein 2001 ♦ Perrin Stein, "A Newly Discovered Pastel by Charles Coypel," *The Burlington Magazine* 143, no. 1177 (Apr. 2001): 220–23

Sydney 2005 ♦ Sydney, Art Gallery of New South Wales, *Boucher, Watteau and the Origin of the Rococo: An Exhibition of 18th-Century Drawings from the Collection of the École Nationale Supérieure des Beaux-Arts, Paris* (2004), cat. ed. by Emmanuelle Brugerolles. English edition of *Boucher et l'art rocaille dans les collections de L'École des Beaux-Arts*, cat. transl. by Geoffrey Capner et al., 2005

Sydney 2010 ♦ Sydney, Art Gallery of New South Wales, *David to Cézanne: Master Drawings from the Prat Collection*, 2010, cat. by Peter Raissis

Tillerot 2010 ♦ Isabelle Tillerot, *Jean de Jullienne et les collectionneurs de son temps: Un regard singulier sur le tableau*, vol. 37 of *Passages/Passagen: Centre Allemand d'Histoire de l'Art Deutches Forum für Kunstgeschichte*, Paris, 2010

Tours 2001 ♦ Tours, Musée des Beaux-Arts de Tours, *Dessins XVe–XXe siècle: La collection du Musée de Tours*, 2001, cat. by Philippe Le Leyzour

Versailles 2004 ♦ Versailles, Musée Lambinet, *Esquisses, pastels et dessins de François Boucher dans les collections privées*, 2004, cat. by Françoise Joulie

Washington and Chicago 1973 ♦ Washington, DC, National Gallery of Art—Chicago, The Art Institute of Chicago, *François Boucher in North American Collections: One Hundred Drawings*, 1973–74, cat. by Regina Shoolman Slatkin

Washington et al. 1981 ♦ Washington, DC, National Gallery of Art—New York, National Academy of Design—Minneapolis, The Minneapolis Institute of Arts—Malibu, J. Paul Getty Museum, *French Master Drawings from the Rouen Museum from Caron to Delacroix*, 1981, cat. by Pierre Rosenberg and François Bergot

Washington et al. 1984 ♦ Washington, DC, National Gallery of Art—Paris, Galeries Nationales du Grand Palais—Berlin, Schloss Charlottenburg, *Antoine Watteau, 1684–1721*, 1984, cat. by Margaret Morgan Grasselli et al.

Weimar et al. 2005 ♦ Weimar, Stiftung Weimarer Klassik und Kunstsammlungen—New York, The Frick Collection—Paris, Musée Jacquemart-André, *From Callot to Greuze: French Drawings from Weimar*, 2005, cat. by David Mandrella et al.

Whiteley 2000 ♦ Jon Whiteley, *French School*, vol. 7 of *Catalogue of the Collection of Drawings in the Ashmolean Museum*, Oxford, 2000

Wildenstein 1963 ♦ Georges Wildenstein, *Chardin*, 2nd ed., Zurich, 1963

Wildenstein 1969 ♦ Georges Wildenstein, *Chardin*, 3rd rev. and aug. ed. by Daniel Wildenstein, Zurich, 1969